INSPIRING LEARNING IN GALLERIES

enquire about
learning in galleries

CONTENTS

FOREWORD

Marjorie Allthorpe-Guyton
Director, Visual Arts
Arts Council England

Gallery education in the UK is a uniquely important but undervalued resource. Through the work of practitioners and of *engage*, the National Association for Gallery Education, practice in this country has an international reputation. Learning in the gallery has grown vigorously as a professional practice over the last ten years and has sharpened its experimental, provocative and progressive edge. It has close relationships with museum education but there are important differences, particularly in the co-option of concepts of capital, personalisation and of communities of practice. The groundbreaking significance of the *enquire* programme is that it builds on the expansion of the field over the last ten years and brokers unprecedented partnerships between sectors, organisations and practitioners. It has brought together expertise in museums and heritage studies, in art and design teaching in higher education and schools, and visual arts organisations with reference to broader concepts from the social sciences. It works in the spaces between art, artists, curators, educators, institutions, formal and informal education. In this respect alone, it begins to deliver Arts Council England priorities for the visual arts and for its wider agenda.

Broadening and deepening engagement with the visual arts and with visual culture is at the heart of Turning Point, Arts Council England's new ten year strategy for contemporary art. Research demonstrates that there are increased audiences for and participation in the visual arts. However, only a third of organisations have specialist education staff and the average number of dedicated staff is just one person. There are some 1200 organisations programming contemporary art and *engage* has a membership of 500 organisations across heritage and the arts. There is high activity but low funding; education is only 4% of total expenditure for visual arts organisations. Many do not have the capacity to evaluate and reflect on the impact of their gallery education work.

The *enquire* programme of research, part of the Museums and Galleries Education Programme, funded by Department for Education and Skills (DFES) and Department for Culture, Media and Sport (DCMS), is providing robust evidence from within the practice of the transformational power of learning in the gallery for young people. It is demonstrating that this particular context, of mutually dependent collaborative learning for educators and young people, or 'scaffolding', encourages sharing and teamwork, self determination and self worth. The role of the artist is harnessed to help young people take risks, to value their own making and to re-conceptualise the process of learning as positive for them. It helps them to see 'art' as a body of practices and to open up new meanings. It also underlines the significance of external sites for learning. The three clusters of partners show differing approaches and methodologies which broadly align to the Contemporary Gallery Education framework. Their research findings endorse this model and show that the complexities of gallery education offer rich rewards, for young people and for those who engage with them on equal terms.

INTRODUCTION

Jane Sillis
Director, *engage*

Vivienne Reiss
Senior Visual Arts Officer
Arts Council England

enquire is the manifestation of the ambition and aspirations of practitioners within gallery education and aims to build capacity for more and increasingly effective work in the future. It focuses on the education programmes of galleries which work with contemporary art and artists and builds on a wealth of diverse practice developed by artists, galleries, schools and others working with young people over nearly three decades.

However, there has been a paucity of data describing how young people learn in galleries which *enquire* seeks to address. The original impetus for a programme of research about learning in contemporary art galleries came from a Visual Arts Learning task group that was convened by Arts Council England (ACE). This group includes arts professionals from ACE, Creative Partnerships, *engage*, Sainsbury Centre for the Visual Arts, Tate, and Visual Arts and Galleries Association (VAGA). Aiming to build on good practice in the sector, it proposed a research programme developed through a number of clusters of galleries and visual arts organisations working with higher education institutions to draw on different fields of expertise.

Professional development was seen as key to the success of the programme with teachers, educators, artists, and young people being equipped to become 'researchers'. The overall aim of *enquire* was 'to explore and identify the conditions for maximising the transformative potential of gallery education for young people'. It was anticipated that the evidence gathered would focus on young people's acquisition of formal and informal knowledge and skills and thus enable galleries to develop informed strategies to support young people's learning.

Partnerships have also been crucial to *enquire* and have developed between galleries, schools and HEIs, which are sustainable and have resulted in other initiatives. Partnerships have not been limited to the cluster members and have embraced other initiatives established through Creative Partnerships and the Museum, Libraries and Archives Council.

Compelling evidence has been amassed of what and how young people learn in galleries. The programme has also demonstrated the impact of working with artists, the enormous value of working in partnership, the role of the gallery educator as a broker for partnerships, and the place of the gallery as a hub of cultural education and a site for learning.

It is an important function of this publication to share what has been learnt with others working in the field and with decision makers. It is a valuable tool for the sector in providing evidence of learning and the conditions for learning and lays a foundation for further research. Commissioned by the government, *enquire* coincides with a range of current initiatives relating to education, culture, employment and the economy. These include vocational qualifications, Education Outside the Classroom, the concept of a Cultural Offer, Every Child Matters and Extended School Services. With the creative industries the fastest growing element in the British economy, there is increasing interest in developing a creative workforce and the skills that will enable today's young people to find employment.

The *enquire* research findings demonstrate that contemporary art galleries and artists are a powerful resource to support young people's learning and indicate some of the ways in which the sector can contribute to these agendas.

The *enquire* programme has been made possible because of the enthusiasm and hard work of all of those involved, in particular: Barbara Taylor, *enquire* Programme Director, the *enquire* coordinators, *enquire* cluster members including HEIs, galleries, artists, teachers and partner organisations and the young people who took part.

KEY FINDINGS

Barbara Taylor
enquire Programme Director

Each cluster research report includes detailed findings and recommendations. There follow key points from across the programme.

The learning benefits of engaging with contemporary art and with artists include:

Acquiring and developing skills:

– valuing subjectivity and experimentation,

– using mistakes as an aid to reflection and greater understanding,

– taking a critical view of own work and that of others,

– actively appraising own work and attitudes to contemporary art,

– acquiring knowledge, skills (conceptual and practical) and techniques,

– increased familiarity with and ability to use the experience of making art, viewing art and visiting art galleries,

– increased understanding of the role of art in professional, social, economic and personal life and the possible employment benefits of engaging with art.

Working collaboratively with peers and adults and the associated skills:

– ability to work with others including skills in negotiation, dialogue, listening, and understanding and respecting the views of others,

– valuing discussion and making use of ideas from adults and peers,

– increased social interaction.

Increased engagement, motivation, self-esteem and confidence:

– greater engagement with and enthusiasm for making art, that can extend to and connect with other areas of life and work,

– developing and valuing own opinions,

– increased control and ownership of own work.

Important factors that facilitate this learning are:

– collaborative partnerships between gallery educators, artists and teachers who bring different skills and experience to projects,

– the role of the gallery educator as broker, facilitator, mediator, negotiator and administrator / manager,

– opportunities for children and young people to work outside the time constraints and conventions of the school, in different spaces,

– opportunities for them to work outside labels and judgements applied in school.

These factors enable the development of communities of practice in new sites of learning whereby children and young people work alongside artists and their teachers, sharing experience and mutual engagement in common activities;

– the involvement of an artist provides a fresh dynamic and professional credibility which influences the young people's attitude to art and the art making process,

– collaboration and mutual learning between the professionals is evident,

– the children and young people revise and re-negotiate their relationship with their peers and adults,

– individuals experience opportunities for role change in a new context that can open up new ways of seeing their own potential.

Effective projects involve:

– children and young people working together and alongside adults involving collaboration, negotiation, dialogue and mutual respect,

– giving students autonomy and responsibility for their own work,

– risk-taking, discussion and review in groups with knowledgeable, supportive adults,

Professional development for gallery educators, artists and teachers

The cluster model of collaborative working between gallery educators, artists and teachers is demonstrated to be an effective mechanism to:

– identify training needs and provide relevant formal and non-formal learning,

– provide valuable peer support and potential career development,

– share skills and understand different professional perspectives,

– jointly investigate their practice, and provide a practical means of developing understanding, testing ideas and improving delivery for children and young people.

Research in gallery education

In the first phase of *enquire* the three research projects were undertaken over a period of eighteen months. They have revealed that:

– investigating learning through gallery education is complex and can be researched using different methodologies and frameworks,

– communities of critical enquirers benefit from the contribution of different skills and experience,

– the methodologies employed and the impact on the participants relate to a wide range of public agenda and areas of academic interest,

– time needs to be invested in planning to develop the appropriate questions and methodology and to ensure that all participants understand and are committed to the process,

– to achieve a proper understanding of the learning benefits research needs to follow participants' progress over a longer period and take into account a range of other factors and influences.

Advocacy

enquire has found that in order to effectively promote gallery education to schools:

– it is important to invest time initially to create mutual understanding and expectations, and in joint planning,

– successful partnerships lay the foundation for long term relationships.

Through the *enquire* programme:

– teachers have become advocates within their own schools and in local networks,

– head teachers have become convinced of the learning benefits,

– gallery educators have developed greater understanding of the process and learning benefits and have become more articulate and confident advocates and negotiators with schools.

Recommendations

Based on the research findings and the experience of the clusters, the following recommendations are made. These recommendations are the view of *engage* and not necessarily the views of the *enquire* partners and HEIs. While the research has been carried out and the recommendations apply to England, they could be applied to work with galleries and young people in Wales and Scotland.

Developing and improving the Cultural Offer of contemporary galleries

enquire demonstrates that relatively simple measures could enable contemporary art galleries and artists to further contribute to art and cross-curricular education, support the delivery of the Cultural Offer and assist in implementing Every Child Matters more effectively.

– Investment needs to be made in galleries to give them the capacity to further develop partnerships with schools and youth organisations to support the delivery of the National Curriculum, Extended School Services and the new 14-19 Creative and Media Diploma.

– Regional or area peer groups of gallery educators, artists, teachers and youth workers should be established to support professional development, research and share good practice.

– Peer groups could also collaborate and pool resources, disseminate good practice, coordinate and promote the service offered across a range of visual arts organisations (including artist groups), and form partnerships with other youth, education and arts agencies and providers.

– The value and impact of regional clusters would be greater if facilitated by a coordinator, supported by funders and partner agencies such as Arts Council England, Creative Partnerships and the Museums, Libraries and Archives Council.

– Regional peer groups would build on the network of more than 1,000 *engage* members who are part of nine area groups across England (there are separate groups in Wales and Scotland). The area groups and members are supported by *engage* work in four key areas: professional development, research, advocacy and dissemination of practice.

Effective practice

To facilitate learning through engagement with contemporary art, education projects should aim to:

– provide first hand access to works of art,

– enable artists to work closely with teachers, youth workers and other professionals,

– use galleries and other spaces as places of learning,

– develop communities of practice where participants work collaboratively alongside knowledgeable, supportive adults,

– incorporate time for planning, review and revision,

– provide opportunities for the participants to exhibit their work publicly.

Professional development

Workforce development should be implemented to improve delivery in two main ways;

– through formal and non-formal learning opportunities for gallery educators and related professions,

– career development for gallery educators.

Formal and non-formal learning:

– peer groups of professionals should be developed and supported to provide formal and informal CPD,

– research and collaborative projects should be recognised and supported as a productive form of CPD,

– gallery educators should share and develop strategies, as should artists, teachers and other professionals.

Career development for gallery educators:

– the key role of the gallery educator and the skills required to develop partnerships should be recognised and supported in terms of status, remuneration and training,

– formal, validated training through HEIs should be an important element,

– CPD should include administrative and managerial skills.

Research

Further research should be undertaken to investigate learning in galleries and through the visual arts. Future research should:

– allow greater planning time,

– ensure that all members of the research team are fully involved,

– enable more longitudinal study of the impact on participants,

– include research into the experience of artists and teachers,

– investigate other factors that are influencing participants' learning.

The *enquire* research findings and the Contemporary Gallery Education framework should continue to be tested alongside other methodologies such as the Generic Learning Outcomes as the basis for developing increasingly effective practice and appropriate evaluative tools for gallery education.

THE ENQUIRE PROGRAMME: COMMUNITIES OF CRITICAL ENQUIRERS

This section outlines the context for *enquire*, provides the aims and objectives, and describes the structure, partners and participants and the programme. It then discusses the cluster model, developing communities of critical enquirers and the associated formal and non-formal learning.

Barbara Taylor
enquire Programme Director

Contents

Section

04

The enquire programme:
communities of
critical enquirers

enquire: inspiring
learning in galleries

Introduction

> Over two years the cluster has evolved from an initial grouping of five disparate venues and arts organisations with a shared interest in learning, to a tight local network of colleagues, working together to test innovative ideas and formulate models for best practice in gallery education.
> North East coordinator

The aim of *enquire* has been to build capacity amongst galleries exhibiting contemporary art, artists and teachers to provide more and increasingly effective learning opportunities for children and young people. Capacity has been interpreted to include:

– developing a better understanding of the learning benefits to children and young people of engaging with contemporary art and artists,

– developing an understanding of the conditions for learning to take place,

– professional development for gallery educators, artists and teachers,

– advocacy.

Between November 2004 and March 2006, *enquire* has developed three 'clusters', or action research teams, of galleries and colleagues in HEIs working with artists and teachers on programmes of activities with children and young people. Action research is a broad term and each cluster has developed its own hybrid model but the basic principles that informed each are set out on page 18.

Over three thousand children and young people from primary and secondary schools, pupil referral units and youth clubs have worked on projects with artists, involving a wide range of cultural experiences, different media, techniques and ideas. Projects have included the selection and appointment by children themselves of an artist in residence in a primary school for a year, young people visiting the studios of painters, sculptors, a blacksmith and animator, young people from an excluded unit at a technical college working in a gallery one day a week for a year, students at a secondary school exploring 'what is an artist?' through textiles, ceramics, mail, live art and video and a summer holiday project with a photographer.

These activities have been the focus for research, professional development and advocacy. These strands have been inextricably intertwined and are difficult to separate. Also, a great deal of information has been produced, not all of which can be included in this publication. The programme of projects is fully documented on www.en-quire.org and the research findings and reports are included from page 44. This section of the report describes the background to *enquire* and how it was structured. It explores the development and impact of the 'cluster' as a concept and the continuous professional development (CPD) inherent to the *enquire* models for 'communities of critical enquirers'.

As Strategic Commissioning will continue into 2008 this report documents progress to date, at one point in an ongoing research programme, and is one contribution to a growing body of research in gallery education.

Context

enquire reflects the government's interest in galleries and museums as a learning resource. The Department for Culture, Media and Sport (DCMS) and Department for Education and Skills (DfES) share a vision that everyone should have the opportunity to learn from and enjoy what galleries and museums have to offer. Furthermore, this vision is an important element in a wider government agenda for education including 'Every Child Matters', 'Youth Matters', The Children Act' and the Extended School Day, and growing interest in the concept of creativity as a key factor in successful personal and economic development.

Over the last ten years there have consequently been a series of DCMS and DfES initiatives including the Museums and Galleries Education Programme funded by the DfES until March 2004, and the DCMS Museums and Galleries Education Challenge Fund, which ran from 1999-2001 and focused on building capacity in local and regional museums. As part of the Museums, Libraries and Archives Council's (MLA) Renaissance in the Regions programme, DCMS and DfES have supported regional 'hub' museums in the nine regions in 2003-06 to develop capacity. The DCMS and DfES also fund Creative Partnerships, the government's creativity programme for schools and young people, managed by the Arts Council.

In April 2004, the DCMS and DfES announced a joint investment over 2004-06 to strengthen the capacity of museums and galleries to support children and young people's education. *enquire* is one strand of 'Strategic Commissioning for Museum and Gallery Education', working with galleries that programme contemporary art. The other strands are:

- continued support for 12 DCMS-sponsored national museums and galleries and the British Library to work with regional museums and other partners on education projects,

- support for non-Renaissance in the Regions museums, led by each regional MLA, which complements work being delivered by the regional hubs,

- a secondment programme for teachers and gallery / museum educators, delivered through *engage* and MLA: 'Watch this Space' and 'Learning Links'.

The overarching aim of Strategic Commissioning is to strengthen the capacity amongst galleries and museums to devise and deliver effective learning opportunities for an increasing number of children and young people.

It is important to acknowledge that *enquire* is by no means the only research that has been undertaken into the learning associated with gallery education, however, the context within the government's Strategic Commissioning programme has given *enquire* a particular significance and profile.

The *enquire* structure

The *enquire* programme started in Autumn 2004 and the first phase was completed in March 2006. Initially funded for 18 months, the programme has been extended and will continue up to March 2008.

It was designed as a research programme with the aim 'to explore and identify the conditions for maximising the transformative potential of gallery education for young people' and had the following objectives:

- to create additional gallery education provision for children and young people,

- to promote continuing professional development for all learners, both gallery professionals and partner agency staff,

- to enhance methodologies for supporting individual and personalised learning, and for sustaining and replicating site-specific innovative education projects within common frameworks and agreed standards,

- to explore implications for the learner of the concept of cultural entitlement in the context of the art gallery and its wider cultural framework and to look at issues of brokerage,

- to enable and support diverse practices and opportunities for a range of cultural experiences,

- to develop the role of the artist as educator and creative facilitator,

- to explore the value of risk-taking, innovation and experiment.

The definition of learning set out in the London cluster research report effectively describes how the process of learning is understood across the *enquire* consortium:

> The London cluster defines learning as a social and transformative process. This understanding posits learning as something that is constructed by individuals in interaction with others and their environment; put simply, learning is a social process through which people make meaning from experience (Vygotsky 1978). This understanding contrasts with traditional definitions of learning where it is theorised as a process of the acquisition, assimilation and application of knowledge. In this latter definition knowledge is something objective, something that experts (teachers) can pass on to novices (students) through a process that Paulo Freire terms the 'banking system', one that he believes is counter-productive (1990). In contrast, when learning is theorised as a constructive process the learner is recognised as the maker of meaning and the teacher as the person who constructs learning situations to make this process possible. This is not just a facilitative role but a creative and collaborative one (see page 46).

Section

04

The enquire programme:
communities of
critical enquirers

enquire: inspiring
learning in galleries

Galleries across England were invited to outline proposals for projects with other galleries in their area with a higher education institute as a research partner, to form a 'cluster' or research team. Applications to take part in enquire were received from 19 potential clusters – representing at least 55 galleries, nine non-gallery agencies and over 20 higher education institutions (HEIs). In November 2004 three clusters were selected and invited to work on the research programme.

enquire posed the question: 'What are the conditions for enabling learning in the gallery context?' Each cluster has worked collaboratively to identify its focus within this research question and to develop a research methodology to investigate learning and the conditions for learning through gallery education projects with children and young people. Each of the three clusters appointed a coordinator and the programme has benefited from several 'critical friends' that have contributed valuable additional expertise and advice. Details about the initial research approach and the projects carried out can be found at www.en-quire.org and the final research reports from the three clusters are contained in this publication.

Each cluster has developed differently due to the different approaches of the galleries, their original interest in taking part in enquire, the local contexts for their work, the time available for planning, and the different needs of the professional participants. Also, the three particular departments within the universities have different research experience, interests and methodologies – art and design education; culture studies, continuing education and arts management; and cultural policy. (This demonstrates in itself that the reference points that inform gallery education are very broad.) The variety of approaches within enquire and the autonomy of the clusters made progress slow at times but has had the advantage of enabling locally appropriate programmes of research and professional development, and has tested different approaches to research, within different research disciplines.

> Nannette Aldred (Lecturer in Continuing Education and the main contact with Sussex University) drew together a number of academics from across departments to create a steering-group with the aim of exploring the enquire research question. This proved extremely valuable and enabled the cluster to tap into a rich seam of expertise and provided valuable insights into possible lines of enquiry, possible research methods and how a research project is developed within a university.
> South East coordinator

Programme and participants

The participating galleries have been very varied, including large institutions such as Baltic and the Whitechapel, local authority museums and galleries such as the Laing and Towner and a number of small independent galleries, some artist-run. However, they all programme temporary exhibitions of contemporary art and work closely with artists.

The participants have come from a wide range of social and cultural backgrounds. In particular, the London cluster has worked extensively with schools in some of the most deprived boroughs in the country, and where a group may include young people from up to 13 different ethnic backgrounds.

The projects have been equally diverse in engaging teachers and the young people in different media and approaches to art including drawing, sculpture, installation, video, textiles, ceramics, live and performance art.

The cluster model

Although enquire has developed three core clusters there has actually been a more complex network of different 'clusters'. The entire enquire programme has involved a consortium of gallery educators, researchers, critical friends and cluster coordinators. The consortium has comprised three clusters of gallery educators and researchers working with a coordinator. Planning, delivering and reviewing the projects with children and young people has been collaborative, through further clusters of gallery educators, teachers and artists. And of course each project has involved these teams plus the participating young people – who have sometimes been collaborators as well as beneficiaries.

In enquire the distinction between those delivering and those learning or benefiting has been difficult to make and this is one of its real strengths – and probably underestimated at the inception. Through investigating learning amongst young people a considerable amount of formal and non-formal learning has taken place, to the benefit of the gallery educators, researchers, artists and teachers. The 'cluster', in all its different forms, has proved a potent vehicle for learning at all levels, effective in offering professional development and increasing capacity among all the participants, and as a means of advocacy.

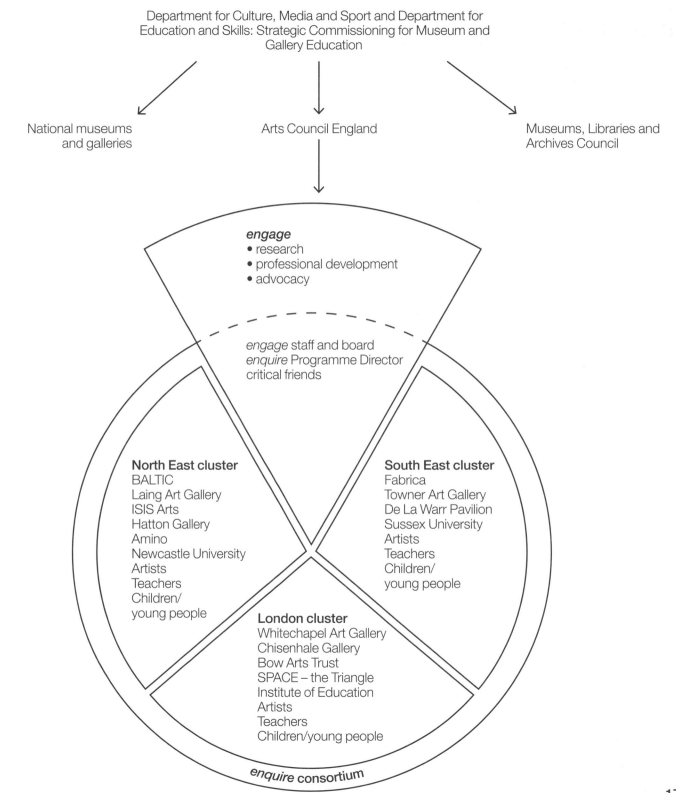

Department for Culture, Media and Sport and Department for Education and Skills: Strategic Commissioning for Museum and Gallery Education

National museums and galleries

Arts Council England

Museums, Libraries and Archives Council

engage
- research
- professional development
- advocacy

engage staff and board
enquire Programme Director
critical friends

North East cluster
BALTIC
Laing Art Gallery
ISIS Arts
Hatton Gallery
Amino
Newcastle University
Artists
Teachers
Children/
young people

South East cluster
Fabrica
Towner Art Gallery
De La Warr Pavilion
Sussex University
Artists
Teachers
Children/
young people

London cluster
Whitechapel Art Gallery
Chisenhale Gallery
Bow Arts Trust
SPACE – the Triangle
Institute of Education
Artists
Teachers
Children/young people

enquire consortium

Section
04

The enquire programme:
communities of
critical enquirers

enquire: inspiring
learning in galleries

Professional development

The programme has been informed and stimulated by three seminars for the *enquire* consortium. Each provided a vital opportunity for the members of each cluster to meet, report progress and compare methodologies and experience. Each also focused on a particular issue, with invited speakers. The first, in May 2005, concentrated on action research with contributions from Professor Mary Stuart, Dr Sara Bragg and Dr Janet Summerton from Sussex University who have all been involved in carrying out research in the social sciences. This established an understanding about the principles of action research which Janet Summerton listed as:

– a decision to investigate current practice with a view to improving it,

– exploring the multiplicity of practice and perceptions,

– reaching collective agreement,

– learning from each other,

– acting as critical friends and helping each other to evaluate practice.

The list culminated with 'becoming a community of critical enquirers', which sums up this approach to research and is the concept that has become central to *enquire*.

The second, in November 2005, looked at professional learning, with a lecture by Professor Michael Eraut (1), who has researched non-formal learning in the workplace, particularly amongst nurses and accountants. His research has revealed that people acquire considerably more of the skills and experience necessary for their work in non-formal ways, 'on the job', rather than through formal training. This is largely unrecognised at policy level or in companies and organisations, although non-formal learning could be facilitated in simple ways by managers.

At the last seminar, in March 2006, Dr Carey Jewitt (2) presented some of her research into gathering and analysing visual data to investigate learning. This underlined the issues encountered during the programme about capturing the learning that is taking place in galleries and encouraged the consortium to consider different ways of collecting data in future.

Each of the clusters has also offered formal CPD to meet the particular needs of its participant galleries, artists, researchers and teachers. This has included a series of workshops on learning to learn creatively, a seminar about communities of practice (3) workshops run by CEMEA (4), workshops in action research methodologies and training in practical skills such as Excel and video editing. Other resources have been developed to support professional development: *Learning in the Gallery: context, process, outcomes* by Emily Pringle (5) (commissioned by the Arts Council, published by *enquire*), a review of research and a bibliography on social and cultural capital from Newcastle University, and an overview of research by Michael Eraut with a bibliography by Judith Furner. All of these resources can be downloaded from www.en-quire.org.

However, the most valuable learning for those working on *enquire* has been non-formal, and has resulted from working collaboratively to develop, deliver and review projects. The participants all work to some extent in isolated or specific situations. Artists often work alone in studio practice, gallery educators in small organisations are usually the only member of staff with an education brief, and teachers can feel isolated by pressures of timetable and paperwork, or neglect their own creative development. Academic staff in universities may not be regularly engaged in the field and *enquire* has recognised the different roles and contributions of the dedicated researcher and the practitioner.

> CPD was perhaps most vital to the teachers and freelance artists, who are often lacking in organisational support to develop their practice, to re-train. One of the teachers who took in CPD events said, 'my learning curve has been drawn and extended'.
> North East coordinator

Different communities of critical enquirers have developed:

– gallery educators in each cluster,

– the gallery educators and HEI researcher in each cluster,

– small teams of artists, teachers and gallery educators working collaboratively,

– the entire *enquire* consortium.

The nature of the teamwork and collaborations has varied but the experience has led to consistent learning benefits and professional development. The list below and the anecdotal evidence have been drawn together by the Programme Director and the three cluster coordinators through observation and discussion, from cluster meetings, research diaries and reports. The full coordinators' reports on each cluster's learning can be found at www.en-quire.org

Sharing ideas, experience and skills

Gallery education is a relatively new profession where people are developing new ways of working, often in small organisations, with very limited resources. The gallery educators welcomed and benefited from the opportunity to work with colleagues in different galleries in order to exchange skills, and experience.

> As gallery educators we met regularly to discuss problems, share successes and review practice which contributed to our professional development in a way attending courses may not have done.
> London coordinator

Further benefits included the use of other gallery spaces, an expanded range of exhibitions and access to staff with different technical or artistic expertise.

> The close proximity of the galleries (in London) was a distinct advantage, enabling the teams to use each other's spaces for school visits, workshops and meetings. This was particularly useful during the 18 months of the project as the organisations were able to offer mutual support between exhibitions and extend the range of contemporary practice encountered by students.
> London coordinator

> Although the North East cluster will not continue with the *enquire* programme in the same team in phase 2 (2006-07), partnership working between the venues is now established, and will continue in future projects. Judy Thomas from BALTIC said that their partnership working with Amino was 'fluid and successful'. Jean Taylor from Hatton Gallery will be using expertise in new media and live art gleaned from Amino's Ben Ponton; and Becky Davies at the Laing is planning to contact ISIS Arts as a resource for information on a wide range of education and production issues.
> North East coordinator

Teachers and artists learnt through collaborating with the gallery educators and working together on projects.

> It emerged that often teachers will replicate learning activities introduced to them by artists in workshop sessions. It is interesting to note that the idea of 're-training the trainer', an objective discussed often by the North East cluster, occurred naturally as a consequence of organic action research.
> North East coordinator

> As a result of working with an artist on *enquire*, the teacher (NQT in 2005) has taken on the role of Key Stage 3 Art Coordinator and has already implemented a policy that ensures all pupils will have contact with an artist.
> London coordinator

A number of teaching resources have also been produced as part of *enquire* including a resource pack written by artist Sarah Carne and teacher Victoria McLaughlin who worked with the Whitechapel Art Gallery, and a BALTIC web resource on live art (www.balticmill.com/index).

Peer support and advice

The cluster model has provided gallery educators with a pool of support and advice, particularly for those that do not have colleagues working in education within their own institution.

> There has been a strong impulse to create a peer network among gallery educators working in Towner, De La Warr and Fabrica for a number of years. *enquire* has been hugely successful in developing networks of peer support. Furthermore, the three seminars developed a strong sense of community, creating opportunities for gallery educators to develop relationships both inside and outside of formal structured sessions, not just between members of the same cluster but among the whole consortium. *enquire* provided not only a wider community of people to work with locally but a peer group of gallery educators who one 'could pick up the phone and talk to nationally' and who work in a range of venues.
> South East coordinator

The peer group has been valuable where the cluster has involved gallery educators with different levels and types of experience, sometimes providing mentoring for those who were less experienced.

Section
04

The enquire programme:
communities of
critical enquirers

enquire: inspiring
learning in galleries

When problems arose during projects or an artist/teacher relationship became challenging we were able to support one another and suggest solutions within a confidential environment.
London coordinator

The advantages of working collaboratively extended into all the different research teams.

The researcher who worked with the South East cluster on the second phase research worked with the cluster as a peer rather than an expert in action research. At first this was unsettling as the cluster was looking to her for a lead but ultimately it proved very empowering as the cluster took ownership of the action research process. Also, the process of exploring the action research extended the peer network among artists and teachers. Meeting together in an informal discursive environment fostered relationships between artist and teachers.
South East coordinator

Several of the teachers said they were confronted by their own professional restrictions or habitual methods of teaching art. The sustained and self-reflective nature of *enquire* made this explicit and led to a review of their teaching practice. This was not an easy or comfortable process and the support of the rest of the team was recognised as a key element in reconciling the difficulties.
London coordinator

Joint discussion and review to evaluate and develop work, gaining trust and confidence to try out new ideas and take risks
Teachers have acknowledged the value of an opportunity to review and reflect on their teaching and have often re-discovered their own skills and creativity.

… (Head of Art) described how the project had at first undermined her confidence as it highlighted the safe pattern of teaching she had fallen into. However, with the team's support she was able to overcome this and rejuvenate her teaching methods to include more risk-taking and discourse within the class.
London coordinator

Having the freedom to relax and approach the art curriculum in a new and more innovative way is a good experience. I … will focus on making it happen for all the students I teach.
London teacher

The action research model allowed participants to critically review learning progression and outcomes of the ongoing projects. The group of artists, teachers and gallery educators unanimously recognised the need for Term 3 projects to be more challenging. As a result, the programmes were reconfigured, allowing all involved to increase the breadth of their learning and take greater risks.
London coordinator

It became clear at that meeting how similar the development process was for all involved. The restriction imposed by the classroom space and layout, compared to the flexibility of the gallery was highlighted by everyone. The necessity for breaking out of the classroom mould, particularly in terms of encouraging critical discussion amongst the pupils, was acknowledged by all gallery educators, teachers and artists.
London coordinator

Gallery educators have been able to compare practice, to gain experience and confidence to implement ideas and to promote their work within their own organisation.

enquire enabled them to work experimentally, with a social focus rather than an aesthetic one. The projects were devised for the positive impact they would have on young people's learning – physical outcomes were not necessarily a priority. Flexibility of funding was important – Becky Davies from the Laing expressed particularly the benefit of freedom to plan projects without tie-ins to specific exhibitions, venues or artists. The testing of ideas around the experiential quality for the young people was paramount to all of the projects.
North East coordinator

Learning about other professions, how to work with others and forge successful partnerships
Collaborative working has proved a practical means of learning about different professional contexts and practices. Both positive and negative experiences have contributed to learning and the development of strategies to use in the future.

Section

04

The enquire programme:
communities of
critical enquirers

enquire: inspiring
learning in galleries

An important element of the projects was the development of partnerships between artists and teachers as peer professionals.

The partnership between artists, teachers, gallery educators and academic researchers has enabled the London cluster to share good practice, review current provision and consolidate the offer made to secondary schools. All the schools involved are located in the east London Boroughs of Tower Hamlets, Newham and Hackney; areas with some of the highest levels of economic and social deprivation in England.
London coordinator

It has been a very difficult relationship with the research teacher. Issues – the teacher has very low expectations of the pupils, constantly expressing worry that his group would not be able to sustain discussion groups. We have constantly proved him wrong in the length and the quality of discussion the class is capable of having.
South East gallery educator

We are also experiencing difficulty in the teacher's attitude to the artist – he treats us all like student teachers and constantly compares us to his current student teacher. The teacher has shown that he does not value the project by not being present at the beginning of lessons and not acknowledging the artist and team with his class. It has taken until week six to develop any form of team teaching. Reasons: poor communication – both talking a different language, bringing different expectations and interpretations to the project. The artist has taken on board the comments of the teacher to the detriment of the project.
South East gallery educator

Artists and teachers have benefited from working as part of a team. Artists have learned about the different perspectives of those working in galleries and in schools and have developed skills to meet the needs of schools.

An important element of the projects was the development of partnerships between artists and teachers as peer professionals. At the interim review meeting there was recognition that the role of the artist should be clearly differentiated from that of the teacher in order for the collaboration to gain maximum benefit. One artist felt that she had adopted the position of a second teacher during the sessions. This was seen to significantly reduce the impact on students' learning by maintaining the status quo of the lessons and limiting the experience of how a professional artist works and develops ideas.
London coordinator

The importance of the role of gallery educator as broker in the relationship between the artist, teacher, school and gallery was highlighted during the programme. This became particularly clear in two cases: one where the relationship between the artists and teacher broke down; and the other where the gallery educator had not established a relationship with the senior management at the school so releasing students from timetable etc. became problematic. These situations caused problems in the realisation of practical aspects of the projects and would have been more easily solved had there been earlier intervention from the gallery educators.
London coordinator

The key role of the gallery educator and the development of meaningful and sustainable partnerships are critical in enabling the gallery sector to respond to the aims of 'Every Child Matters' and delivering a cultural offer.

A deeper understanding of learning and the conditions for learning through engagement with contemporary art
The *enquire* research findings are giving the consortium members, artists and teachers a better understanding of the learning that they can facilitate and tested effective methodologies for engagement. However, the process of working on projects together has in itself also created a deeper understanding and an awareness of the factors that contribute to learning.

The presence of an individual who has allowed the pupils (with the authority and support of the teacher) to break rules of the establishment has generated a space for respect and consideration.
South East gallery educator

The effect of one particular activity (where pupils were able to rearrange furniture in the classroom to create a comfortable space) led to one of the teachers reorganising her classroom.
North East gallery educator

I was surprised by the way the whole of Year 9 listened … They seemed really interested … the (enquire) students came up immediately and took it in turns to speak standing at the podium holding up their work for all to see. The whole of Year 9 clapped them at the end. I said how extremely proud of them I was and that they were a credit to both Year 9 and the whole school.
London teacher

The most valuable result of this first phase of the project was the action research team realising that the students' learning pattern, when back in their classroom, was so entrenched that Anthony and Rachel were unable to get them to change. Because of this the project was truncated, and became more about the making of artwork than developing meaning in artwork.
London gallery educator

Artists benefited from paid time to evaluate their work – another element vital to continuing action research.
North East coordinator.

What I have learned overall is that students do generally engage with projects where they are not presented with a right or wrong answer – where they are encouraged to share their thoughts and insight into things – where they effectively get to celebrate who they are.
North East artist

Of all the teachers, the history teacher is the most enthusiastic, experimental and challenging. He encourages the artist to bend the rules and push the pupils in their creative thinking. He allows pupils to be individuals and expressive and to find their own understanding of the project.
South East gallery educator

We'd discussed what we felt had worked well, or less so, and decided that … we would be more experimental and really discover the possibilities of having an artist in the classroom for an extensive length of time.
London artist

Following the review of phase 1 and 2 the Chisenhale team took a bold step and changed the workshop structure. They abandoned the short school sessions and arranged a week-long intensive workshop to take place at the gallery. The teacher was so impressed by the radical shift in students' learning within the gallery environment that she arranged for Year 11 to be off timetable for an entire week – a remarkable feat.
London coordinator

Identifying and addressing training needs

Working on enquire has stretched everyone involved. The demands of the programme and the opportunity to see where other people have valuable skills and experience often revealed areas where participants would benefit from training. The training needs included IT skills, planning and running meetings effectively, video editing, budgeting and financial control, and greater knowledge and experience of different contemporary art practices.

The Towner and Fabrica supported a trip to London for teachers, artists and gallery educators. The aim of the day was to introduce the group to a mix of commercial and non-commercial galleries that would not otherwise be accessed, to see and talk about contemporary art together and to gain a greater understanding of the issues around approach.

In one day the group of 13 visited 13 galleries. The response to the day was incredibly positive, the pace and amount of galleries was ambitious but added to the atmosphere of the day generating excitement and discussion ... The focus on small galleries, that most of the group did not know existed, created discussion around the nature of commercial galleries vs. public funded spaces, the location of the gallery, the way the gallery presents itself, interpretation / presentation. This is something that should be offered to other teachers as a development trip, using a combination of consortium galleries and commercial spaces.
South East gallery educator

Section

04

The enquire programme:
communities of
critical enquirers

enquire: inspiring
learning in galleries

Artists have acquired skills and experience to take on work with children and young people and teachers have had their practice rejuvenated.

The experience of participating in *enquire* can be summed up on behalf of the whole consortium:

> Overall the *enquire* project provided the South East cluster with a unique experience to explore their own and each other's practice in a supportive environment. It also enabled a deeper exploration of gallery education practice with artists and teachers. The project will have a lasting impact on education strategies and delivery in all three galleries.
> South East gallery educator

Career development

The cluster is an interesting model for career development in gallery education, which is a relatively young profession, poorly paid and with very little career structure or progression. Individual gallery educators or small teams in galleries try to satisfy high expectations and to meet ambitious targets – to offer innovative practice, for high numbers of people, often from socially disadvantaged communities. *enquire* demonstrates a means of providing peer support and building capacity to enable gallery educators to develop and manage more effective partnerships and programmes of work or to take on more responsibility or management roles in galleries.

Similarly, artists have acquired skills and experience to take on work with children and young people and teachers have had their practice rejuvenated.

Working with the university provided the gallery educators with an understanding of the research culture and research methodology. This knowledge is now applied in the gallery environment to assess the impact of their work with young people. It also enabled them to gain access to a body of knowledge outside of their own field that they can now draw on to develop their practice.
South East coordinator

The experience of making presentations at the seminars contributed significantly to gallery educators' willingness to make presentations about their work beyond the gallery environment.
South East coordinator

The value of the *enquire* project is evidenced by the career development of Natalie Walton, the former Assistant Education Officer at Towner Art Gallery who, in spring 2006, was appointed Head of Education at Milton Keynes Gallery:

> As an early career gallery educator I have found working on the *enquire* programme a daunting, liberating and supportive experience. It has been a process of learning through doing and has succeeded in carrying teachers, artists and other galleries along with it.

> It has allowed the group of gallery educators within the cluster to work closely together to discuss their work and clarify their thinking. The support has come from the national network as well as the immediate cluster partners – which has been invaluable. It has also seen the growth of long-term relationships with schools through intense partnerships

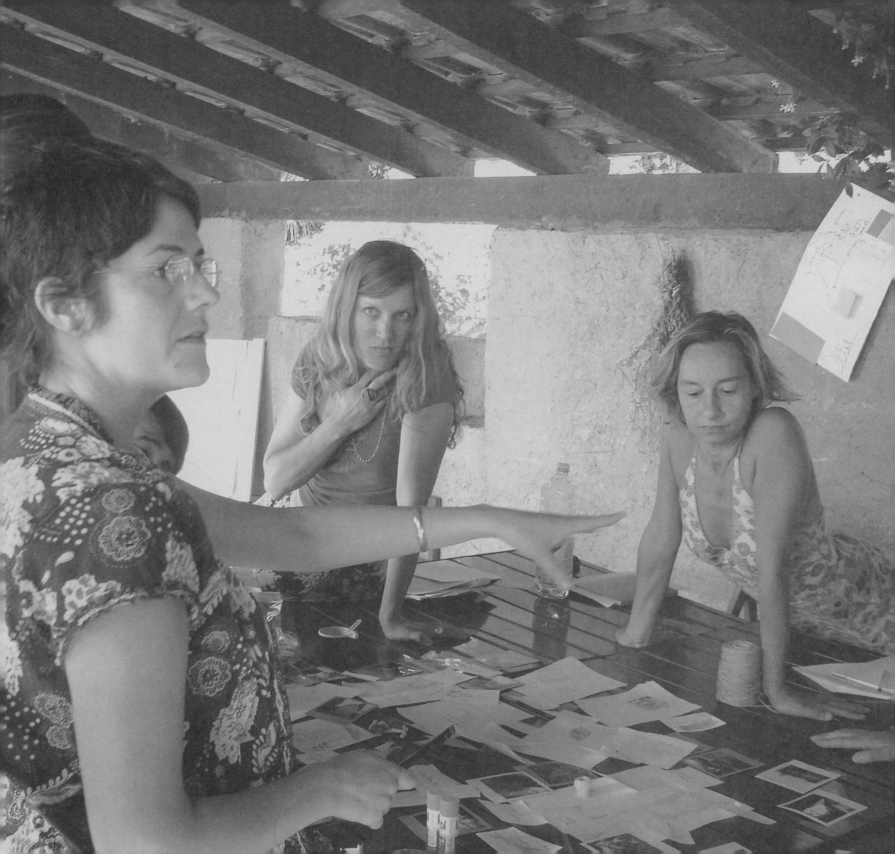

Section
04

The enquire programme:
communities of
critical enquirers

enquire: inspiring
learning in galleries

between artist, teacher and gallery educator. As a result of working in this way I have implemented learning sets of artist, teacher and gallery educator in other projects with positive outcomes.

enquire has been a growing experience – personally and professionally. Having benefited from working on enquire and moved to a new post, I have recommended that the budget at Towner include funds to bring in a critical friend for the education officer, to give an objective voice to planning and evaluation of projects.

The enquire programme is a core element in the work of engage, which is concerned about the career structure and opportunities for gallery educators. The enquire research and experience of formal and non-formal learning are being disseminated through engage nationally and regionally, through engage Cymru, engage Scotland and its international membership and events.

The professional development inherent to enquire conforms with Eraut's research, that through non-formal learning – at work and with colleagues – individuals and groups acquire considerable useful knowledge, expanded understanding and enhanced capability and capacity. Furthermore, that this useful learning can be facilitated by providing:

– a learning climate,

– management that understands and supports the benefits of non-formal learning,

– mediating strategies.

These enable and encourage a social context in which there is interchange, shared engagement with people learning from each other, participation and autonomy.

The work processes that involve learning as a bi-product correspond with the cluster model and involve:

– working alongside others,

– consultation,

– tackling challenging tasks and roles (some challenge but not too much, and with support from colleagues),

– problem solving,

– trying things out,

– consolidating, extending and refining skills,

– working with clients.

'Watch this Space', another strand of Strategic Commissioning and managed by engage, provides opportunities for teachers to undertake placements in galleries and gallery educators to work alongside teachers in schools. This programme also facilitates non-formal learning as defined by Eraut.

It is also possible that the cluster model has been so effective for learning because gallery educators, artists and teachers are all interested in creating learning opportunities and, in wanting to take part in enquire, are open to both taking risks and being critical about their own practice. In addition, the gallery educators work with constantly changing exhibitions, as well as with different learners, and are therefore used to taking on new ideas and adapting their thinking.

Eraut goes on to point out that non-formal learning is best undertaken and most effective in teams. This can be problematic in the contemporary workplace where there are high levels of mobility and increasingly short-term contracts. This is certainly a problem in gallery education where only large galleries have a team, contracts can be short and staff levels are reliant on project funding.

Timing and planning

Most of the problems encountered on the programme related to the short timescale available to plan and implement the projects and research.

It was most successful when the enquire research questions were at the core of a project rather than laid over a project which was already in the process of being developed. It also increased the chances of all the partners taking ownership of the project and participating fully.
South East coordinator

The cluster's criticisms arise from a lack of planning at the start of the programme: in the North East initial projects were rolled out very quickly due to time constraints. At this stage, the team would have benefited from more time to think creatively together.
North East coordinator

The earlier a member of the action research team was involved in the development of the project the more likely they were to create a successful working relationship between the partners. The earlier the idea of the research was introduced as being an integral part of the gallery project the more committed the teachers were to supporting and engaging with the research questions. Towner Art Gallery ran their research project in the autumn term and were able to learn from the experience of De La Warr and Fabrica and created a letter of contract with the schools they worked with, which set out the commitment required from teachers, artists and pupils engaged in the project. It set out a project agreement, which created an obligation for the school to participate.
South East coordinator

Whilst more time for planning would have been beneficial to the research programme, it is also fundamental to forming worthwhile partnerships and effective educational projects at any time.

Front-loading a project and spending time in meetings without an agenda and providing opportunities to build trust is critical to creating successful relationships.
South East coordinator

The chances of two artists, or an artist and teacher together, understanding one another instantly is unlikely. There must be time and inclination and finances to set up these relationships thoroughly.
London artist

Advocacy

enquire has also enabled more effective advocacy for gallery education, at a number of different levels, and the research findings will provide useful evidence to support gallery education. The research reports are being disseminated through the *engage* national and international membership, journals and website, through numerous partner agencies and at events nationally and internationally. Connections and partnerships have been furthered or developed with the Arts Council nationally and in the regions, with the MLA, the national museums and galleries, the National Society for Art and Design Education (NSEAD), Creative Partnerships, the regional Hubs and with universities.

Interim reports were presented at the INSEA and UNESCO conferences on art education in Portugal in March 2006 (6). The research findings will be presented at international conferences in St Petersburg in September 2006 and in Paris in January 2007.

The publication of this report coincides with a joint publication, between Creative Partnerships and *engage*, which looks at the contribution that the contemporary gallery sector makes to formal education, *Towards an inspired future: Creative Partnerships and gallery education*. (7)

Gallery educators have become more confident and acquired new ways of articulating the impact of their work, within their own organisations and to schools and other clients. Existing courses and training opportunities for artist educators have been strengthened by the experience of *enquire* and Sussex University is developing a new course informed by the programme.

Teachers have experienced the benefits of working with galleries and artists and have become advocates within their own schools and among local colleagues.

Through their work with the university and *enquire* the gallery educators have developed a language for articulating their ideas and strengthened their arguments about the benefits of gallery education. The research outcomes validate the gallery educators' beliefs in the value of gallery education and have given them a renewed confidence to make the case for funding gallery education and to promote their work to a wider audience than they would have previously considered addressing.
South East coordinator

I was able to sample two days of this (Live Art programme) at the Summer School last August which is a starter for the MA in Fine Art and Education. I have used the work of Tenching Hsieh as inspiration for projects at school since seeing some of his work on display at BALTIC and also attended some of the Live Art performances/seminars at BALTIC ... I will be doing a presentation about the project at the next Sunderland Art Teachers' network meeting.
North East teacher

We were lucky to get these opportunities. I believe that experiences we give to youngsters at a formative part of their lives can change the way they think forever – they are the cultural consumers of tomorrow.
North East teacher

After 18 months, *enquire* has provided the contemporary gallery sector with researched evidence about the learning benefits for children and young people of engaging with art and artists and about some of the conditions for learning. These can be drawn on and used by the profession in its work and in advocacy, and by researchers adding to the growing body of research into gallery education. They also indicate how gallery education addresses the ambitions for children and young people set out in 'Every Child Matters'. High expectations, innovative thinking, valuing individuals and ensuring that each child progresses as well as they possibly can are fundamental to enabling enjoyment and achievement in education, employment and personal lives.

The programme has tested the 'cluster' model as a relatively simple means of providing formal and non-formal professional development and support for gallery educators, artists and teachers that could be replicated with modest resources. The cluster is also an effective mechanism for brokerage and delivering a cultural offer. As *enquire* continues in 2006-08 the first consortium of three clusters will be expanded to include at least four more in other regions across the country, to deliver more projects with children and young people, carry out research and learn together.

References

1 A summary of Professor Michael Eraut's research and a bibliography have been compiled by Judith Furner which can be found at www.en-quire.org

2 Dr Carey Jewitt is co-editor of *Visual Communication* (published by Sage) and is currently writing a book *Technology, Literacy, Learning: A Multimodality Approach* (forthcoming, Routledge).

3 The North East cluster arranged a workshop about communities of practice: 'a group of people who share a concern or a passion for something they do, and learn how to do it better as they interact regularly.' Etienne Wenger's definition sums up the experiences of all the teachers, artists and gallery educators that have engaged with the *enquire* programme in the North East. www.ewenger.com

4 Centre d'entrainement aux methods d'education actives: www.cemea.asso.fr

5 *Learning in the Gallery: context, process, outcomes* by Emily Pringle was commissioned by the Arts Council and published by *enquire*. It can be downloaded from www.en-quire.org and is available from *engage*.

6 International InSEA Congress 2006, *Interdisciplinary Dialogues in Arts Education*, Viseu 1 – 5 March; http://insea2006.apecv. pt. UNESCO World Conference on Arts Education, *Building Creative Capacities in the 21st Century*, 6 – 9 March, Lisbon; http:/portal.unesco/culture/en/ev,php-URL_ID¬=26967&URL_DO¬¬=DO_TOPIC&URL_SECTION=201.html

7 Anson, L. and Sillis, J. (Eds) *Towards an inspired future: Creative Partnerships and gallery education.* London: *engage*, 2006. Available to download from the *engage* website, or contact *engage* to purchase a copy.

RESEARCH REPORT OVERVIEW

This overview of the research programme looks at the research context for *enquire*, the methodologies employed by the three clusters in partnership with each university and discusses the research findings in relation to the Contemporary Gallery Education framework.

Emily Pringle

Contents

Introduction

This text provides a review of the research to date by examining the context from which *enquire* has emerged and drawing together the findings from the three clusters. These findings will be explored in relation to the model of learning in the gallery termed the Contemporary Gallery Education (CGE) learning framework, which is discussed in *Learning in the Gallery: Context, Process, Outcomes*. (1) The text also interrogates the research model and methodologies adopted in order to inform future research into gallery education and best practice within the profession.

The background to the research

As outlined in the introduction to this report, the concept of a programme of research and professional development focusing on learning in contemporary art galleries came from a Visual Arts Learning task group that was convened by Arts Council England. Thus *enquire* is a research programme that emerged from, and subsequently focused attention on, the gallery education sector. The partnering of HEIs with practitioners is a model that the visual arts department within ACE has developed over a ten-year period in order to research aspects of visual arts and cultural education practice (2). With each of these visual arts research projects the aim was to marry the 'know-how' of art education professionals with the 'know-what' of the academic community to stimulate debate and to contribute to the overall knowledge base of the sector.

enquire is research that originated from the profession, rather than from within academia, although the partnerships forged between the galleries and HEIs are central to the success of *enquire*. The programme stemmed from a desire by the profession to investigate the nature of pedagogy in the gallery so as to understand and develop more effective practice. This history is significant for a number of reasons and will be returned to throughout this paper, not least because some productive tensions emerged during the research which arguably can be traced back to the origins and initial aims of the project.

The wider context – gallery education, knowledge development and research

The survey of relevant literature that culminated in the publication *Learning in the Gallery: Context, Process, Outcomes* (3) identified that gallery education is a dynamic area of activity that has been developing and expanding rapidly in the last ten years. Gallery education operates within, and negotiates between, the overlapping spheres of art practice, curatorial programming, and formal and informal education. It is affected by policy initiatives relating to the cultural and education sectors, whilst also responding to regeneration and social inclusion agendas. At the same time gallery education is informed by a wide range of discourses, including those surrounding community arts practice and more recently 'socially engaged' or 'negotiated' art practice. Ideas relating to engaged pedagogy and collaborative learning also underpin the practice, alongside concepts relating to the role of the gallery, the nature of the artwork and its reception by the viewer.

Galleries in the UK have been providing education activities for over 25 years and particular models of good practice have been developed. However, the character of gallery education has to some degree determined how these models are articulated and disseminated, especially to those beyond the sector itself. For instance, gallery education has historically been largely practitioner-led, particularly in contemporary art galleries. Artists, gallery educators (who can themselves be artists) and teachers have been at the forefront of developing learning and teaching strategies in the gallery and have in many cases built up considerable skills and knowledge. However, as Scott et al (2004) have noted, this form of knowledge develops through individual reflection on action and primarily enables the practitioner to develop his or her own, or possibly group practice (4). In other words, this knowledge is gained through direct experience of practice and is not necessarily acquired with a view to contributing to the growth and refinement of that practice more widely. Hence, gallery education is a profession where ideas have tended to be shared through more or less informal networks, rather than through academic publications and opportunities. This has impacted on the sector's relationship to policy makers. It is, therefore, significant that *enquire* is a research programme that has been supported by policy makers from the outset and will go on to inform future policy decisions.

However, as noted above, gallery education is changing rapidly. Government interest in increasing and widening access to museums and galleries is partly responsible for the increase in research into the sector (5). But, equally, there is recognition within gallery education itself of the need to professionalise the practice. This necessitates rigorous and systematic investigation of the processes and outcomes of the learning and teaching experience in the gallery in order to inform practice and to rationalise some of the claims being made for gallery education (6). More recently, practitioner-led research has been initiated and supported by galleries (7) and *enquire* needs to be considered alongside research conducted within the sector (8). Not only that but, as is discussed below, it is apparent that the HEIs working on *enquire* draw upon their own research in this area. *enquire* can thus be seen as part of the ongoing process of theorising and articulating the specific nature of pedagogy in the gallery, whilst contextualising it and making it more widely accessible.

This focus on interrogating creativity and learning is reflected across the cultural sector. Most notably, *enquire* can be seen to complement the work of the Museums, Libraries and Archives Council (MLA) which culminated in their 'Inspiring Learning for All' framework and the development of the Generic Learning Outcomes as a means to measure learning outcomes (9). The GLOs offered a starting point for the first stage of the clusters' research programme, however the findings from the first and subsequent stages of *enquire* indicate that learning in the gallery is complex and can be seen to differ in some ways from the nature of the learning experience in museums. The *enquire* research suggests that tools such as the GLOs offer a useful, but ultimately incomplete, tool for examining the conditions for, and process and outcomes of, gallery education practice.

Context within the research – HEIs and galleries
The research is constructed as a partnership between clusters of galleries and an HEI located in three areas of England. Each cluster came together independently and each exhibits different internal relations. In the South East, there was pre-existing contact and an ambition to develop a peer network between the three galleries who subsequently approached the University of Sussex to be their HEI partner. In the London cluster, the Institute of Education, University of London, had an existing relationship with the Whitechapel Gallery, which took on the role of lead gallery.

Similarly, in the North East, there was an existing relationship between BALTIC and the University of Newcastle, which formed the core of the NE cluster. The basis for these working relationships can be seen to have impacted on the research methodology adopted, the research questions explored, the progress of the research and the form and content of the final reports produced by the HEIs and the cluster coordinators.

Equally significant, and a particular strength of *enquire*, is the character of each HEI. The research partners, based in particular departments within their HEIs, brought individual and collective knowledge and expertise to *enquire*, which informed the theoretical context from which they approached learning in the gallery. For example, the researchers for the NE cluster are based in the International Centre for Cultural and Heritage studies, within the University of Newcastle and have expertise in museum, gallery and heritage studies. Individuals brought to the project experience in conducting research into museum and gallery visiting and participation in education activities. Their interest and previous research in the concept of capital (see page 124 for reference) as a means to understand how visitors engage with museums informed the research in the NE cluster. The researchers in London are based within the Art, Design and Museology department at the Institute of Education. Their particular expertise centres on the teaching of art and design within schools, as well as the role of contemporary art and artists, and critical studies in education. The London cluster's research explored learning in the gallery in relation to these concerns and the final report draws extensively on the researchers' knowledge to contextualise their findings.

The SE cluster presents a slightly different picture in that the galleries, the HEI and the schools prioritised the research interests of all the participants. Their research evolved through three phases wherein each phase was informed by activity in the previous phase. Throughout these stages the researchers could draw on the skills and knowledge of their partners at the Centre for Continuing Education at the University of Sussex and the methodological expertise of others at the University relating to learning theories and action research. This collaboration impacted on the process of the research as much as the outcomes. The expertise within the HEI helped to articulate the nature of the learning experience in the gallery, but also drew particular attention to the learning and professional development of the cluster partners and the value of action research as a method for further research in this area.

Each of the three research reports that are published here is consequently different and presented according to the methodology employed and normal practice of each institution.

Each of the three research reports that are published here is consequently different and presented according to the methodology employed and normal practice of each institution.

The character of the galleries involved also shaped the development of *enquire*. Each of the 12 galleries and visual arts organisations is distinct and varies in size, staffing, level and nature of funding and purpose. Some, such as the Laing and Towner Art Galleries, have permanent collections of historical and contemporary work, whereas BALTIC and the London galleries have no permanent collections. A few of the galleries had existing working relationships with each other, but the majority came together for the first time for *enquire*.

The variety is characteristic of the sector and in particular contemporary art accommodates a range of 'galleries'. Evidence of this is provided by the *engage* membership which includes over 500 arts centres, artists' studios, galleries and museums. Equally, a recent survey conducted by Burns Owen Partnership for ACE (10) found that approximately 1200 organisations in England regularly programme contemporary visual arts. The survey also identified that there is a strong commitment to education and outreach work in the sector. In the non-commercial sector, 71% of organisations in England provide dedicated education and outreach programmes.

The gallery sector's activities range from ongoing programmes in major national institutions to one-off projects in small contemporary spaces. Although galleries vary in scale and resources the sector as a whole is characterised by relatively low levels of funding (frequently on a piecemeal or project-by-project basis) but high levels of activity (11). Consequently, projects are typically of a short to medium term duration, involve intense involvement with a relatively small number of participants and are 'one-offs', often specifically associated with the temporary exhibitions. Working in this way tends to leave little opportunity for gallery education professionals to reflect on their practice, to share and build on tested models or to assess the longer-term impact of their work.

Learning in the Gallery identified that, although gallery education embraces a range of activities, the practice can be seen to aspire to the following four goals:

- enabling participants to engage with, and gain greater understanding of, original works of art and the exhibition context,

- developing participants' analytical and reflective skills,

- encouraging participants to engage with art and artistic practice in order to develop their own creativity and creative making skills,

- developing subject specific and cross-curricular learning (12).

These give some indication of the parameters of learning which gallery education recognises and with which *enquire* necessarily engages.

Research findings – what was learnt?

The first thing that can be said about the findings from *enquire* is that much has been learnt. The research structure allowed for considerable autonomy within the over-arching aim; 'to explore and identify the conditions for maximising the transformative potential of gallery education for young people'. Hence the clusters each developed their own more focused research question and, in the case of the SE, each gallery explored a further issue. Thus, although the overarching research question for *enquire* was 'What are the conditions for enabling learning in the gallery context?' a total of six additional questions have also been explored across the clusters. This has produced rich and detailed data regarding the learning experience for the young people involved in the projects. The structure of *enquire* and the focus on action research has also drawn attention to the learning and professional development of the cluster partners (the artists, gallery educators and teachers). Not only that, but the experience of *enquire* provides a model for potential further research in this sector, hence there are wider applications for the broad learning from the whole programme. Each of these three aspects of the findings will be examined now. (A detailed analysis of the learning and professional development within the clusters is explored in Section 4, from page 18).

The young people's learning

As each cluster developed their own research questions, the focus of the HEI reports varies. The NE concentrates on the findings relating to shifts in capital that took place among the young people who participated in the gallery education projects. London examines the conditions and strategies that can develop the young people's critical thinking in relation to contemporary art, but also draws attention to aspects of the experience of the action researchers. The SE examines the *enquire* research process, with a focus on the action researchers' experience, before addressing the findings based on the first stage of their research (which concentrated on gathering views on what is unique about gallery education and the extent to which the GLOs adequately measure the practice) and exploring the specific research questions developed by each gallery in the cluster. It is important not to oversimplify, but equally, whilst respecting the diversity and richness of the individual projects and the range of research foci, it is valuable to draw together common findings and identify divergences.

It is worth noting at this stage that each cluster identifies learning as a social and transformative process through which individuals make meaning from their experiences (see page 15). At the same time *enquire* recognises a broad conception of learning that includes changes in emotions, behaviour and engagement, as well as the acquisition of skills and knowledge. Thus the research emerges from a particular theoretical context which foregrounds collaborative meaning making between teachers and learners within a learning community. This conceptual framework is well established within educational research and is acknowledged within gallery education (13).

The review of literature and learning frameworks that constitute *Learning in the gallery: Context, Process, Outcomes* informed the development of the proposed Contemporary Gallery Education learning framework. This framework emerges from current thinking relating to learning in the gallery and seeks to highlight the complex, interrelated nature of the teaching and learning experience in the gallery, wherein context, process and outcomes are mutually dependent. The findings from the *enquire* research are grouped below according to these three categories.

enquire findings

Context (Where the learning happens)

Personal (The prior knowledge, experience and motivation of the learner):

All three clusters recognise that at the start of the projects students possessed notions of art and art making that were shaped by school pedagogy and which informed their attitudes to learning within the *enquire* projects:

- All three clusters find that skills-based learning was privileged by the young people.

- London finds that the majority of students identified making as the aspect of their art lessons they enjoyed the most and that students saw art and design primarily as an outlet for personal creativity.

- The NE and London identify that the young people considered that engaging in art activities was an opportunity to engage in relaxing and therapeutic activities.

- London finds that many of the students maintained that art and design was divorced from social and cultural practice and that

This framework emerges from current thinking relating to learning in the gallery and seeks to highlight the complex, interrelated nature of the teaching and learning experience in the gallery, wherein context, process and outcomes are mutually dependent.

students resisted discursive and written activities in their art classes at school.

- The NE finds that children's understanding of art practices were mostly related to traditional technologies and media and they had limited understanding of and engagement with conceptual or abstract approaches.

- The NE identifies that children found it difficult to think in terms of experimentation and risk-taking in relation to their own art making.

- The NE cluster identified that students have existing and complex levels of social, human and cultural capital which inform their relationship to art. They also noted that the *enquire* activities were part of a series in which the children had been involved therefore it was difficult to segregate research findings from these ongoing processes.

Socio-cultural (the nature of the community of learners (the group) and the facilitation by the educator).

The London and SE clusters identify that students in the *enquire* projects worked within communities of practice, which are described as sites of shared experience that enable members to develop as critical thinkers through mutual engagement in common activities (London cluster report).

- London and SE find that the artist represents someone 'new' who creates a fresh dynamic.

- London and SE identify that the artists had credibility as professionals in the field and that this influenced the young people's attitude towards art and participation in the art-making process.

- SE identifies that individuals had opportunities to experience role change that opened up new ways of seeing their own potential.

Site-specific (the nature of the learning environment).

SE and London find evidence that gallery education introduces differences in the young people's learning due to disruptions in their normal patterns. These include changes in environment, space and timetable.

- The SE notes that removing the structure of the school environment forced the young people to renegotiate their relationships with peers and adults.

- London identifies that using external sites for learning encouraged students and teachers to re-conceptualise the process of learning.

37

Process (how the learning develops)

Collaborating (by valuing individual responses within a group, sharing learning, dialogue).

All three clusters find that dialogue and collaborative modes of learning were central to the gallery education experience.

- All three clusters find that the *enquire* projects employed discursive and questioning strategies. The emphasis in the interaction between artists and students was on asking questions and listening, so as to develop the students' critical and reflective skills.

- All three clusters find that there was increased teamwork and co-operation amongst the students.

- All three clusters highlight that during the projects students appreciated the opportunity to work collaboratively, positively critique one another's work and draw on the ideas of their peers as a valuable resource for learning.

- All three clusters identify that learning is evolutionary and develops through partnerships between adults and young people. London and the SE highlight evidence of 'scaffolding' wherein learners work alongside more experienced peers/ teachers who adopt the role of supportive and knowledgeable experts and nurture the student's learning.

- The SE and London note that young people value and respond well to relating at an 'equal' level to the adults.

Experimenting (by engaging, revealing, risk-taking, maintaining open-endedness).

All three clusters find that risk-taking and experimentation take place during gallery education projects.

- The NE identifies a link between increased self-confidence and opportunities for students to experiment.

Analysing & Reflecting (by questioning, contextualising, reconsidering).

All three clusters identify that young people were given opportunities to develop their critical skills and engage in ongoing processes of reflection.

- London finds that students actively reappraised their work and their attitudes to contemporary art.

- The SE and London note that students adopted a process-led approach to working, through which they saw that 'getting things wrong' can aid reflection and lead to greater understanding and enhanced development.

Engaging holistically (by responding on emotional and physical, as well as cognitive, levels).

All three clusters identify that the young people became immersed in the projects.

- London identifies that certain students were absorbed in making to the point where activities became semi-automatic.

- London identifies that particular students preferred to work in haptic modes – engaging physically with plastic materials in combination with new technologies.

- The SE finds that the young people became 'lost' in ideas and were responsive to their creative impulses.

Outcomes (what the learning involves)

Reflection (increased analytical/ reflective thinking, articulation of learning)

All three clusters find the young people had increased understanding and appreciation of art as a body of practices and concepts.

- NE finds that the children reflected on their work with a sense of achievement.

- SE and London identify a development in the young people's critical skills.

Meaning (using shared knowledge and skills)

All three clusters find that students acquired knowledge, skills (conceptual and practical) and techniques relating to engaging with and making art.

- London identifies that students felt that two of the main skills they had developed were the ability to work with others and the ability to see from others' points of view.

- NE and SE identify in the young people an increased familiarity with, and ability to use, the experiences of making art, viewing art and visiting art galleries.

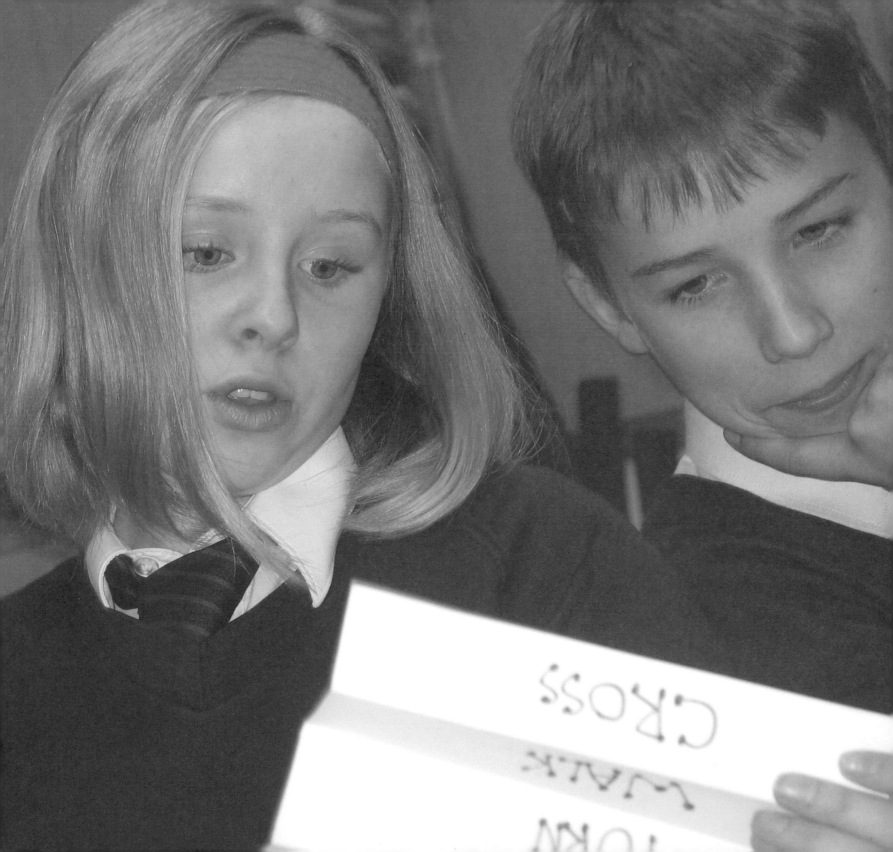

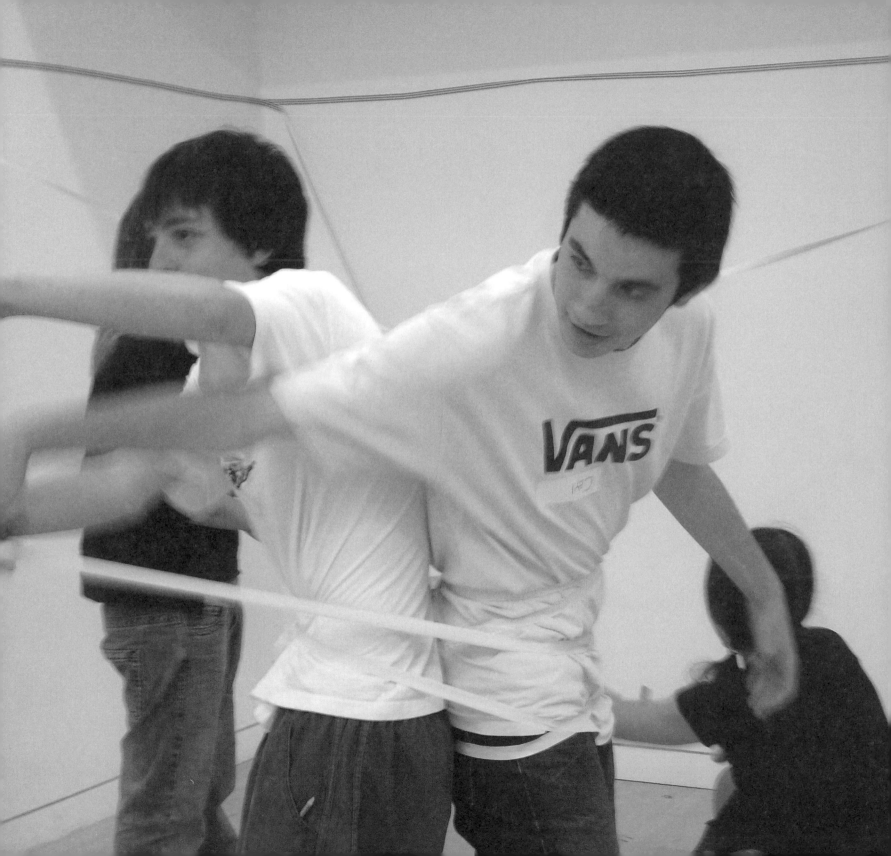

The research model, with its emphasis on partnerships between galleries and HEIs and on action research as the preferred methodology, has allowed for a range of issues to be explored within each cluster.

Engagement (increased involvement, commitment, passion/pleasure)

All three clusters find the students' engagement with and enthusiasm for their art-making work was increased and that there was evidence to suggest that this increased engagement extended to other areas of their lives and work.

- SE finds that students made connections with other parts of the curriculum such as dance and drama.

Responsibility (taking ownership of individual and collaborative learning development)

All three clusters find that within the *enquire* projects students were given considerable autonomy and encouraged to see themselves as agents of their own learning.

- SE identifies that students felt in control of their own work.

- London finds that students identify the process of learning in the gallery as 'liberating', which encouraged them to take ownership of the project.

- London and SE identify that students work most effectively and appreciate having freedom, but within a structured environment where they are supported by adults.

- London finds that the *enquire* projects afforded students an opportunity for self-expression.

- London and SE find that there were moments during the *enquire* projects when students took control of their own learning (self determination).

Empowerment (increased self and cultural awareness and confidence)

All three clusters identify that students' self-confidence had been enhanced.

- NE finds that students had increased understanding of the role of art in social, professional, economic and personal life, increased understanding of possible economic or employment benefits of engaging with art and increased self-interrogation about career plans in relation to engagement with art and the contemporary art gallery.

- NE finds that students demonstrated increased social interaction through engagement with art (i.e. making, critiquing, showing and displaying) with family members (bonding) peers (bonding and bridging), and others, including gallery staff and artists (linking).

The action researchers' learning
The second 'tier' of learning is that of the gallery educators, artists and teachers who participated as action researchers. *enquire* set out to enable participants to reflect on their practice and evidence emerges throughout that this occurred continuously through the programme. This learning is explored in section 4, p18.

enquire as a research model

enquire was set up in order to inform and develop the gallery education sector. The research model, with its emphasis on partnerships between galleries and HEIs and on action research as the preferred methodology, has allowed for a range of questions to be explored within each cluster.

Each of these individual questions contributes to the overarching research question ('What are the conditions for enabling learning in the gallery context?') and has provided a wealth of useful findings. At the same time a number of productive tensions have been identified which can valuably inform the future development of research into this area. These can be summarised as follows:

1. Each of the clusters had different perceptions of action research as a methodology for use in researching the practice. NE researchers acknowledge that they did not employ action research as a methodology and the Institute of Education researchers have described the model they employed as a 'hybrid'. The SE appears to be the cluster that engaged most with the principles of action research.

2. There is a difference between research as practice and researching the practice. (The London researchers, for example, position themselves as critical friends who are researching an action research project). Action research provides an insight into the process and conditions for learning, particularly for the researchers themselves, but there can be a need for additional qualitative data collection in order to capture evidence of the learning of all those involved and in order to explicate the practice more widely.

3. The different roles inhabited by the partners in each cluster were not always negotiated fully at the start. This can lead to some confusion especially between the galleries and the HEIs. The SE notes the need for all the cluster partners to be involved from the start in all aspects of the research programme, in order for action research to function effectively.

4. There were a number of issues relating to the timetable for the research programme:

 • HEIs and galleries work to longer timescales than this stage of enquire allowed for. Longer lead times would have allowed the partnerships to develop specific projects to address the research questions and the action research teams to develop shared communities of practice more effectively.

 • London and the NE note that the enquire projects were short-term interventions and therefore it is difficult to predict the longer-term impact or nature of the young people's learning.

Points for consideration

Each of the cluster reports draws conclusions and makes recommendations for further research. In addition to these and to the productive tensions identified above, a number of further considerations can be raised:

1. There is value in the complexity of this research model. The practice itself is dynamic and multi-dimensional and currently under-researched. By providing opportunities for the clusters to develop their own research foci, enquire has examined a range of issues and 'tested' the potential of different methodologies for exploring learning in the gallery.

2. The findings from the enquire programme appear to correspond broadly to the CGE learning framework, which itself emerged from current literature relating to pedagogy in the gallery. In particular the evidence that collaborative, dialogic learning within the specific and 'different' context of the gallery supports students' meaning making and critical and reflective skills, which in turn contributes to increased engagement and self-confidence amongst students, corresponds to the picture emerging from gallery education practice generally.

3. enquire demonstrates that a range of theoretical frameworks can be used to explore the practice. For example, concepts of capital provide one way of examining issues such as identity formation in relation to learning in the gallery.

4. Opportunities for further investigations are presented by the findings from this stage. For example the concepts of 'scaffolding' and 'communities of practice' suggest potentially fruitful avenues for research in the future.

Notes

1. Pringle, E. (2005) *Learning in the Gallery: Context, Process, Outcomes*. London: Arts Council England and *enquire*. See www.en-quire.org/research/index.htm and the publication is available from *engage*.

2. See *The International Journal of Art & Design Education*. (2003) Vol 22.2. Corsham. NSEAD.

3. Pringle, E. (2005).

4. Scott, D. Brown, A. Lunt, I. & Thorne, L. (2004) *Professional Doctorates: Integrating Professional and Academic Knowledge*. Maidenhead: Open University Press.

5. Since it came to power in 1997, the present Labour government has prioritised access and learning in relation to the arts. See, for example, Department for Culture, Media and Sport (2000) *Centres for Social Change: Museums, Galleries and Archives for all*. London: HMSO. The government has also made a specific commitment to creative and cultural education through the establishment of the Creative Partnerships initiative (see www.creative-partnerships.com).

6. Xanthoudaki, M., Tickle, L . & Sekules, V. (eds) (2003) *Researching Visual Arts Education in Museums and Galleries*. London: Kluwer Academic Publishers.

7. See, for example, Fuirer, M. (2005) *Jolt, Catalyst, Spark! Encounters with Artworks in the Schools Programme at Tate Modern*. www.tate.org.uk/research/tateresearch/tatepapers/05autumn/fuirer.htm. (accessed 10th November 2005)

8. Most notably *engage's envision* project. www.engage.org/projects/en-vision.aspx (accessed 23rd June 2006 and their international research work under the auspices of *Collect and Share*.www.collectandshare.eu.com (accessed 23rd June 2006)

9. The Generic Learning Outcomes model (GLOs) was developed and piloted through the Learning Impact Research Project (LIRP) carried out by the Research Centre for Museums and Galleries (University of Leicester) on behalf of Museums, Libraries and Archives Council (MLA) in 2003. They were primarily piloted in museums, archives and libraries. (www.mla.gov.uk, accessed, 19th June 2005)

10. Arts Council England *Review of the Presentation of Contemporary Visual Art Final Survey Report*, Burns Owen Partnership, August 2005 http://www.artscouncil.org.uk/downloads/BOP_061004-ACECVA-Final-Survey-Report_revised_April2.pdf

11. Ibid, 2004.

12. Pringle, E. (2005).

13. The London Cluster report, for example, notes that constructivist and co-constructivist learning have been the focus of educational research in schools, galleries and museums for many years.

LONDON CLUSTER RESEARCH REPORT

Report on research undertaken by the Whitechapel Art Gallery, Chisenhale Gallery, Bow Arts Trust and SPACE – the Triangle in collaboration with the Art, Design & Museology department, School of Arts & Humanities, Institute of Education, University of London, and partner artists and teachers.

Final report by Nicholas Addison and Lesley Burgess, Institute of Education, University of London (IoE) in collaboration with Tara Chittenden, Sophia Diamantopoulou, Jane Trowell (researchers), Henrietta Hine (Whitechapel Art Gallery), Annie Bicknell (Bow Arts Trust), Leanne Turvey (Chisenhale Gallery) and Tanya Skillen (SPACE – the Triangle).

Contents

Introduction

The Critical Minds project provides an opportunity for the London cluster to develop and investigate partnerships between schools, artists and contemporary art galleries. By focusing on learning within the context of these partnerships the research team aims to discover whether traditional pedagogies in art and design can be complemented and extended to develop a more critical and creative curriculum. In response to the generic research question proposed by *enquire*: 'What are the conditions for enabling learning in the gallery context?' our analysis counter-balances research from the Museums, Libraries and Archives Council (MLA 2004) which resulted in a set of Generic Learning Outcomes (GLOs), that is the products of, rather than the conditions for, learning.

Our particular interest in young people's access to contemporary art demonstrates a concern to identify the critical thinking students use when engaging with unfamiliar and potentially challenging practices. This way of thinking, and the process of reflection closely allied to it, is one that has the potential to transform attitudes, practices and, ultimately, values. These processes are central to the reflexive, dialogical and socially engaged practices of many contemporary artists whose work can be seen to challenge normative practices and naturalised beliefs. Such works are often overlooked in the mass media where contemporary practice is represented by only those works that have the potential to shock. With this exposure contemporary art comes to appear absurd, deficient or pornographic.

The art gallery and its educational programmes are therefore a vehicle through which these characterisations of contemporary art can be questioned and a fruitful dialogue developed with schools in which the needs and interests of students can be related to the concerns of artists, critics, curators and educators. Additionally, through this research, we hope to provide insights into the ways gallery education enables students to question both assumptions about their habituated ways of learning and the institutional systems that label them as specific kinds of learners.

The London cluster defines learning as a social and transformative process. This understanding posits learning as something that is constructed by individuals in interaction with others and their environment; put simply, learning is a social process through which people make meaning from experience (Vygotsky 1978). This understanding contrasts with traditional definitions of learning where it is theorised as a process of the acquisition, assimilation and application of knowledge. In this latter definition knowledge is something objective, something that experts (teachers) can pass on to novices (students) through a process that Paulo Freire terms the 'banking system', one that he believes is counter-productive (1990). In contrast, when learning is theorised as a constructive process the learner is recognised as the maker of meaning and the teacher as the person who constructs learning situations to make this process possible. This is not just a facilitative role but a creative and collaborative one.

The geography of our research, across different and institutionally distinct pedagogical sites, and its focus, contemporary art, makes the art gallery an appropriate locus for collaboration. This is a place where professionals from different disciplines (artists, gallery educators and teachers) come together to form partnerships to develop creative, critical and inclusive learning experiences. In this respect the Critical Minds research is informed by the government's drive to develop educational practices through partnerships (www.creative-partnerships.com; *engage* projects: *envision*, www.en-vision.org.uk and *Collect and Share*, www.collectandshare.eu.com) and to understand the conditions under which people best learn (www.inspiringlearningforall.gov.uk; 'About Learning' www.demos.co.uk). Most of these partnerships are concerned to encourage people, including school students, to make good use of the resources provided by public institutions. The MLA's GLOs are a significant contribution to this quest and they are being widely disseminated and applied to learning across the cultural sector. We believe that findings from the Critical Minds research can complement the GLOs and offer alternative understandings of the ways young people learn in the gallery context.

Methodology

Research questions

Generic (*enquire*):

> What are the conditions for enabling learning in the gallery context?

Specific (London):

> In what ways does action research as a form of pedagogic collaboration enable learning in gallery education?

> What conditions and strategies can develop young people's critical thinking in relation to contemporary art?

Action research

Action research refers to a way of researching in which participants in some field, here art education, identify a problem or area for development and collectively investigate how change can be effected. Through collaborative action they implement and review change in a cyclical process that ensures participants cannot distance themselves from the conditions that they intend to change. In this way, transformation is not imposed by some external body in the form of legislation or abstract theory but is instead grounded in the working lives of the participants. It is therefore the participants who explore the relationship between theory and practice and thus take responsibility for its theoretical validity, its application and its practicability.

In the model devised by the London cluster, action research teams were allocated to each of the four galleries: Whitechapel (lead gallery), Bow Arts Trust, Chisenhale, SPACE – the Triangle. These teams comprised art teachers, artists and gallery educators who met to plan, implement and review the pedagogical programme; Critical Minds was specifically designed in relation to the learning of secondary school art and design students. This process of 'reflection-in-action' required not only discursive review but diaristic habits and a regime of recording events and outcomes to contribute to data.

The Higher Education partner, Institute of Education, University of London (IoE) adopted the role of 'critical friend', engaging in observation and participant observation in order to gather data for analysis. In this sense, our report is not typical of action research in that the action researchers are not themselves responsible for the findings and recommendations. Rather they have been responsible for the construction of a specific pedagogic discourse that has formed the object (pedagogic conditions and relations) for analysis and that has in turn informed the findings. We have therefore devised this in-between, hybrid model in order to analyse the perceptions of the action research teams and those of the students. This allows us to identify and examine the various voices at play within the pedagogic discourse, a process that requires some critical distance and therefore places the HEI team in a parallel, if complementary, position. Nonetheless, the collaborative and qualitative orientation of our report is sympathetic to the aims of action research and although the report does not aim to describe the full richness of the experience, both for action researchers and for students, we believe it highlights those elements of the programme that help to answer the research question.

Discourse analysis

The way in which we analyse data throughout this report draws on a type of discourse analysis. We define discourse as a particular way of relating to a phenomenon (here, art in education) that both conditions how it is talked about and how it is produced as a set of practices. As Stuart Hall explains: 'all understanding occurs and all meaning and knowledge are constructed through discourse, discourses both create knowledge and define a way a thing can be understood and spoken about' (in Barker and Galasinski 2001: 31). We therefore look at the ways participants experienced the Critical Minds project as expressed through reflective conversations and interviews. These reflections tell us what artists, gallery educators, teachers and students felt about their experiences at a specific moment after the pedagogic events had taken place, either as a part of the action research process or as staged conversations between students and researchers in the form of interviews.

Although the data collected through this process is in the form of language we also recognise that the events referred to are multimodal, combining, for example, linguistic, visual, haptic and kinaesthetic forms of communication in specific social situations. This multimodal experience is the vehicle through which the institutional discourses of artists, gallery and art education are

communicated to participants. This means that discourse, in our understanding, includes modes of communication other than language; as Kress and Leeuwen stress: 'Three things are designed simultaneously: (1) a formulation of a discourse or combination of discourses, (2) a particular (inter)action, in which the discourse is embedded, and (3) a particular way of combining semiotic modes' (2001: 21). Although this research prioritises linguistic forms of data as indicative of the discourses at play in Critical Minds, we recognise that the project was a complex combination of interactions and productions, many of which prioritised modes other than language (for example, visual objects, gestures represented on film) and that these modes are equally productive of the discourses embedded in the project.

Data

The data that we have selected for our analysis is in the form of transcribed speech and written texts and is drawn from:

• student entry and exit questionnaires,
• in-depth interviews with 12 students (three from each school chosen by the action research teams in relation to the categories: 'good' at art, 'resistant' to art, 'wild-card' [in the findings the 'wild card' students are given individual 'labels': hyperactive, live-wire, unfathomable, enthusiastic]),
• action researchers' reviews.

Research ethics

The IoE team followed the British Educational Research Association's (BERA) ethical guidelines (2004) in which respect for participants, democratic values and the principle of academic freedom is considered in relation to responsibilities towards participants, sponsors and the research community.

In order to ensure the confidentiality and anonymity of participants no individual or school is named, although, with agreement, the IoE research team and participating galleries are identified. All participants provided voluntary, informed consent to allow the research team to use statements, uttered or written, as data within the research and for the reproduction of photographic records. Permissions were sought from the Head of each school to undertake in-depth interviews with students. These interviews were conducted to encourage students 'to express their views freely in all matters affecting them, commensurate with their age and maturity' (BERA 2004:6). Before the report was completed the action research teams

were provided with drafts and invited to comment on matters of fact and interpretation; their feedback informed the final version.

Background (Contexts)

The Critical Minds programme is conceived as a collaboration between artists, gallery educators and teachers who represent three forms of educational practice: artists' placements, gallery education, secondary school art and design. Each of these practices manifests itself as a type of discourse. We recognise that Critical Minds cannot be divorced from the discourses in which it is embedded. It is therefore necessary to establish how institutional discourses frame the developing project and condition the way students relate to it. It is also important to acknowledge the ways in which students themselves are positioned within specific social situations and cultural contexts and how these constitute significant, demotic discourses that parallel the institutional ones and likewise inform the conditions for learning in gallery education. In this way, our research looks at the relationships between these discourses as they meet, complement, contradict or resist one another and, in turn, form new, pedagogic discourses.

In this introductory section we categorise the schools involved in Critical Minds in relation to their students' socio/economic status, taking into account the catchment area and government criteria such as free school meals. We also provide details about the artists', gallery educators' and teachers' backgrounds and other contextual information to indicate the partnership resources. The curriculum subject art and design is the vehicle through which many young people first have access to galleries and artists and we therefore provide an overview of this curriculum (its policy and procedures) to suggest how students' experience is framed by normative classroom practices. We cite students' perceptions of their experiences of the curriculum subject art and design to demonstrate the extent to which they confirm or provide alternatives to these norms.

We define the aims of the galleries' educational programmes by citing a document (the Whitechapel's evaluation of 'Creative Connections' [Carrington and Hope 2004]) indicative of the institutional discourse that facilitates and regulates practices in the field (Creative Connections is an ongoing project organised by Whitechapel Art Gallery, the lead gallery in the East London cluster). These aims are analysed to identify the institutional

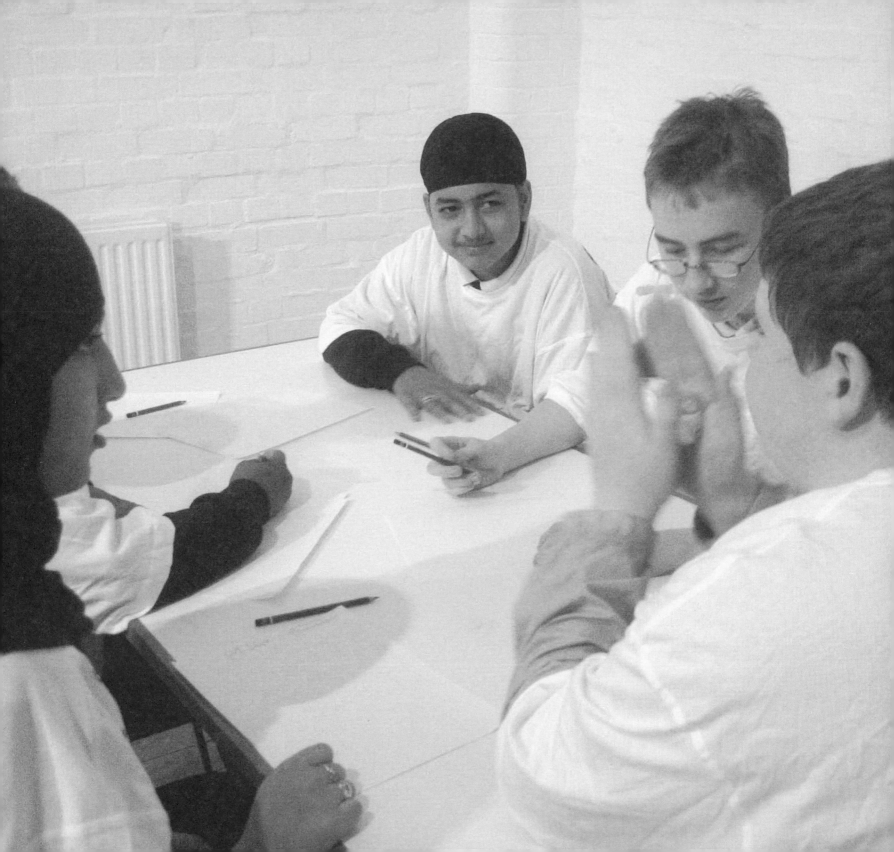

discourse framing Critical Minds and we cite the views of the action research teams (artists, art teachers and gallery educators) from each of the four galleries to establish points of convergence and difference. We end this section by examining whether artists, as interventionists within the institutional discourses of galleries and schools, encourage participants to think differently about their learning.

Schools

School 1:

School	Co-educational comprehensive, 1,154 students, over 17 languages are spoken, media arts college, new block, lots of IT, drama, theatre, 33% eligible for free school meals
Students	Year 10 and Year 9
Department	Successful; orthodox: good resources (including technology)
Teacher	Ten years, painter, perception that students are becoming difficult, two involved in the project have behaviour monitors
Artist	Video artist
Gallery educator	Fine art, new to project, community arts-based, little work with schools
Project	Two visits to Francis Alys (video artist) exhibition
(Phase 2)	
Department	Fine art, good results/reputation, 'school art', pastiche-led
Time/space	Five x 1 3/4 hour sessions plus two-day block, one gallery visit (Phase 1)

School 2:

School	Girls' comprehensive, 1,415 students, largely of Asian origin (mostly third generation) (mostly Muslim) (aspirational re. the professions), 75% eligible for free school meals
Students	Year 10 and Year 11
Department	Teacher independence within liberal ethos: wide resources (including technology)
Teacher	Newly Qualified Teacher (NQT) crafts (textiles)
Artist 1	Installation: working in schools for ten years
Artist 2	12 years in UK: musician, writer, performance central, extensive educational work with creative writing
Gallery educator	Former primary teacher (art and design specialism)
The project	One visit to Whitechapel, Nunnery outside, two days
Time/space	Broken by long stretches, end of project two-day block

School 3:

School	Co-educational comprehensive, 1,080 students, ethnically diverse (no dominant culture) money for new arts block (art and design excluded). Coming out of special measures, social economic disadvantages: above 21% SEN, 63 languages, 48% EAL, high student mobility, attainment on entry low compared to average, Local Education Action Zone, technology college, 55% eligible for free school meals
Students	Year 9
Department	Diverse practice, informed by teacher interests/specialism, fairly well resourced, best ever grades for art and design last year (2005)
Teacher	Three years, fine art (mixed media), experience working with gallery and artist
Artist	Mixed-media/conceptual (inc. video) everyday life as practice
Gallery educator	Artist, arts project management and training, former Steiner school teacher

Project	Phase 1: Whitechapel three visits to 'Faces in the Crowd' Phase 2: Museum of Childhood, (Paul McCarthy exhibition deemed unsuitable for under-16s) Chisenhale Gallery
Time/space	Once a week, two-hour sessions each morning for 12 weeks

School 4:

School	Co-educational comprehensive, 1,350 students, challenging, inner-city, deprived area, EAL 75%, many ethnic communities, Bangladeshi, Pakistani (Muslim) (girls wear the hijab) Hindu (cultural memory differences, religion interwoven), strict. Contemporary art deemed offensive (nudes) attainment on entry low, pressure on teacher to perform, 33% SEN, sports and arts mark status (drama), over half are eligible for free school meals
Students	Year 10
Department	Feels neglected, budget cuts year-on-year, limited resources
Teacher	Head of Department, prior experience of working with same team
Artist	Photographer, ('not in the normal sense') already worked on research projects
Gallery educator	Painter (landscape), PGCE in art and design, secondary and primary experience
Project	Chisenhale Gallery exhibitions
Time/space	1. Once a week, one hour, some sessions missed, two whole day sessions at the Gallery, four in the classroom 2. Block of five whole days in the gallery space with field-work, use of new technologies (galleries)

Art and design

Art and design is a National Curriculum foundation subject at Key Stage 3 which ensures that all students participate in art education for the first three years of their secondary education. At GCSE it is a popular option, 209,647 students elected to follow the subject in 2005, and rising numbers are following art and design at 'AS' (58,182) and 'A2' levels (40,454). In addition there are a number of full time vocational courses such as AVCEs increasing the student population engaging with visual education as a potential route into employment and thereby highlighting the need for art educationalists to engage with contemporary practices.

Art education has a long and distinguished history in this country and at times has been a vehicle for progressive education positioning art and design within both creative and affirmative discourses (Ruskin 1840-; Morris 1883; Fry 1909; Read 1943; Richardson 1948; Thubron & Hamilton in Lynton 1992). The effect of these discourses in schools has been somewhat intermittent, and it was not until the arrival of the National Curriculum (DFE 1991) that an attempt was made to legislate for progressive principles within the general aims of the subject so that creative and self-expressive practice rather than skills-based training became an entitlement for all (five to 14 years).

In the current version (DfEE 1999) the opening lines echo these sentiments: 'Art and design stimulates creativity and imagination. It provides visual, tactile and sensory experiences and a unique way of understanding and responding to the world' (p.166). However, for some years before its publication there had been calls to ensure that the subject also acknowledged the visual arts as a critical practice (Field 1970; Eisner 1972; Allison 1972; Thistlewood 1989; Hughes 1998; Steers 2003). It was recognised that the subject should not only encourage young people to make works of art but that it should enable them to engage critically with visual culture; just as in English language and literature, art and design should be concerned with the reception as well as the production of cultural forms. However, despite revision the critical dimension is still seen as a fragile and limited aspect of the curriculum (Hughes 1989; Davies 1995; QCA 1998; Addison et al 2003; Downing and Watson 2004).

The two most common ways in which art teachers confidently address critical studies is by directing students to analyse canonic works of western art with reference to the formal elements and by recourse to transcription and pastiche, an acritical orthodoxy where students 'copy' and/or emulate the work of a favoured artist by using photographic reproductions.

4/enthusiastic: Normally it will either be analysing a piece of work that we are working on, say an artist, or we'd be copying one of the works and making it into our own.

It is possible, however, for transcription and pastiche to lead to critical forms of practice if students are encouraged to move away from the imitation of surface to a consideration of process:

2/artist 1: There's nothing wrong with engaging in an exercise that is derivative, so that you can understand how that style works, understand the pros and cons in reference to what you like. It helps to inform, especially when you are young and in a formative stage, your interests and your passions and your likes and dislikes, and there's nothing wrong with copying as an approach to understanding art. (13.12.05)

Critical studies as an investigative process is perceived as alien to the making-led practices which characterise discourses in the subject and which are believed to be an outlet for self-expression and the 'accurate' representation of the visible world

(Atkinson 2002). When questioned about the type of art that they liked, students were most likely to interpret this question in reference to practical activities undertaken in their art lessons. Over one half (57.1%) of students referenced making or skills, whilst just over one third (33.8%) produced the names of artists/styles.

The prominence of making and practical activities within students' perceptions of 'art' was further demonstrated when students reported what they enjoyed about their art and design lessons. Table 2 indicates that for over one half of students (50.6%) making, and the satisfaction gained in making, was the aspect of their art lessons that brought them the most enjoyment; this was by far the most common response to this question. The social aspect of the art lesson, and the acquisition of new techniques/skills were both given as factors contributing to enjoyment by 13.9% students in each instance. Although only 13.9% saw the social dimension of the art lesson as a reason for their enjoyment, findings from the exit questionnaire show that working with others was the skill that most students agreed they had developed as a result of this project (73.4% 'strongly agreed' or 'agreed' with this; see Chart 9, page 79). It is notable that learning about artists was only considered an enjoyable part of the art lesson by 1.3% students.

Table 1: What sort of art did students like?

	No. of students	%
Practical: referenced making/skills	44	57.1
Theoretical: referenced artist name or art movement	26	33.8
Other	7	9.1
Total	77	100.0
Left blank	2	-

Table 2: What did students enjoy about their art lessons?

	No. of students	As % of all students in cluster
Making/satisfaction	40	50.6
Social	11	13.9
Creativity/expression	7	8.9
Techniques/skills	11	13.9
Learning about artists	1	1.3
Other	6	7.6
Left blank	3	3.8

Chart 1 illustrates the findings from Table 2, reinforcing the notion that for the vast majority of students making/satisfaction and the ability to develop new techniques/skills feature strongly in what they enjoy about their art lessons. This was true across all four of the schools taking part in Critical Minds.

Chart 2 disaggregates the findings by school, showing that beyond making, there were some distinct differences between what students enjoyed. Students at school 2 strongly enjoyed the creative/expressive dimension of their art lessons, whilst this aspect was not mentioned by any students at school 4, who were more likely to enjoy learning techniques/skills. Students at school 3 were the only respondents who claimed to enjoy learning about artists, this part of the art lesson was not reported as an enjoyable aspect by students from any of the other schools.

Making takes on this privileged position because it is seen to answer the primary aim of developing practical skills for the purposes of expression. This emphasis on making also militates against contextual approaches not only because of time restrictions but because the discussion of traditions and imposition of conventions is seen as potentially contaminating, a dilution of the personal expression which is supposedly the ultimate goal of the subject. This is very peculiar to art and design as one of the artist's notes:

2/artist 1: Thinking back to my learning art at school and learning science, it would be just like practical science everyday and you would never just do practical science everyday because there's the context to put it on and you are making sense of why did someone do that and the other things they had been looking at. (16.3.05)

However, those students who enjoy the way the subject is currently taught reaffirm their preference from traditional making practices:

4/enthusiastic: I like painting a lot and just using my imagination or copying a piece of artwork and creating it into my own work...

(When you think of contemporary art what springs to mind?)

I do not know... I haven't got a clue.

With the aim to develop discursive, critical practices this making-led climate was perceived by the artists as an obstacle:

3/artist: 'Dialogue' was our issue, so we were thinking 'how can we get discussion going' and this superseded activity. (14.2.06)

Despite the move towards more discursive and collaborative practices many of the students maintain a sense that art and design is somehow divorced from social and cultural practice and is rather an outlet for personal creativity:

1/resistant: ... it helps you to be creative. You can do anything, just like using your imagination.

Chart 1: What students liked about their art lessons

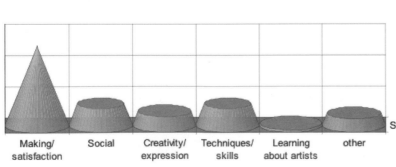

Chart 2: What students liked about their art lessons

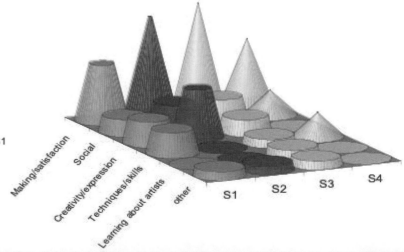

3/resistant: Art is really creative and I really get into it and want to do more. Sometimes I even spend time like during my break doing my work, cos I really look forward to it.

3/good: Yeah, I like it cos it shows our creative side and we can be as messy or do whatever we want and it still is art. I think it's really good.

Additionally the time out from the logocentric curriculum afforded by art and design is seen as an opportunity to relax, to engage in expressive, therapeutic activity.

2/good: I think art is more relaxing. If you're having like a bad day you can show that through your art, like. If you're feeling upset like, and you're asked to do a shading thing, you can shade it dark, and if you're happy then you can reflect that in your drawing, or whatever you do.

1/hyperactive: ... some time you come from playtime happy or sad and by using art you can express your feeling in a more visual way.

3/unfathomable: Art makes you relax more because it's not like, it's stuff that you know that you can do, that in other lessons you have to learn about and stuff like. So Maths, you have to, it's more complicated than art.

In the same way that some students identify with the subject and see it as an escape from the disciplinary structures imposed by the logocentric curriculum, many parents/carers and other subject teachers (often including the senior management team) relegate the subject to one in which recreational and remedial functions are foregrounded.

2/live-wire: I think a lot of people in my class chose art because they thought it would be easy.

3/good: In art you can just be as wacky as you want and then like you really enjoy yourself but in other lessons you have to really study about what you're doing. But in art you can just know what you are doing and just get on with and just be as messy or as wacky as you want.

2/good: I mean, you can give them instructions, but I think it's best to just let them have their way and just let them interpret what they're going to do and what they feel like doing. Art is not right or wrong, it's what you think something should look like. So I don't think somebody should be telling you what to do, you should just come up with it. That's why it's all different.

These perceptions constitute a notion of art that is peculiar to schools, one that bears little relationship to contemporary practices (Dawe-Lane 1995; Dawtrey et al 1996; Hughes 1998; Burgess and Addison 2004) but one that has developed from the discourses of expressivism that fuelled aspects of early modernism (Kandinsky 1911; Croce 1901; Dubuffet 1948). In expressivism at its most extreme, all cultural conventions are seen as an obstacle to the expression of pure feeling. Within this tradition, language, especially in its reflective and analytical rather than poetic modes, is seen as an inadequate vehicle for communicating the immediacy, complexity and sublimity of human experience, experience that can be embodied through the arts (Witkin 1974; Abbs 1987; Hargreaves 1983; Ross 1984). The discourse of expressivism tends not to be so extreme in schools (Taylor 1986) but traces of it remain sedimented within populist notions of art as a 'mirror of the soul'.

1/hyperactive: Art means so much stuff, believe it or not, it means body and soul... If you're doing a project about anger and, for instance, you decide you're going to have a baby, there's no way in hell or heaven that you can sit down and do something really deep and dark about art. You'd probably just chuck it in the bin and start doing this totally miraculous thing about love and other stuff and next thing you know you might draw this pregnant woman with a baby. There are load of pictures like that, I seen. I don't think you should have all this long debating and talk in the classroom about what art means. You should make art... if you want to talk you should act or be in English, right? If I talk in art I like to have a laugh and talk with people, but then I don't concentrate and my art is not so good, you have to have your mind in art. So I think it's about body and soul and other matters. I don't really think, like, anyone is with me, but I don't care what anyone else thinks.

Despite the necessity for instruction and explanation and a fondness by students for social chatter, an antipathy for language has developed in the art room, especially in relation to discursive and written activities. Within this pedagogic discourse word and image are conceived as opposites designating text as 'matter out of place'.

2/good: I like writing because I like English and I like being creative in the pen. I like being imaginative... Not in art. I'd jot stuff down, but not like the way we did it because I just think in art you should just use your hands, but like not in writing.

Other students recognise that the regimes of assessment within schooling ensure that writing is an inevitable albeit a necessary evil.

2/live-wire: Anyway, you have to write in art because otherwise you can't show that you've understood it.

This antipathy is at odds with the uses of text/image in the wider field of material and visual culture. Students often come across works of art not in galleries and museums but through the mass media. Students were asked to indicate sites where they had seen contemporary art outside of the classroom. The findings in Table 3 show that for 60.8% students the Internet was their primary source for viewing or encountering contemporary art. Students were not asked to elaborate on the types of works they had seen which they felt were 'contemporary art'. However, the top three responses – the Internet, magazines (given by 44.3% students) and newspapers (by 30.4% students) are all sites where image and text coexist, within a multimodal totality sometimes including sound. This suggests, if not confirms, that

students are more familiar with the intersection of text/image through their actions outside of school, an experience of visual and material culture that is not continued into their practice in the art classroom.

Chart 3 illustrates other points of encounter with contemporary art given by students. Public spaces were cited by 27.9 % and art centres by 26.6%. A range of answers given by just one or two individuals, and therefore not included in the composite data here, although still worthy of mention were: buses, books, posters, cartoons and bands.

In modern and contemporary practice, artists, craftspeople and designers frequently deploy language in the form of speech and writing to complement or even displace the image (it should be remembered that writing is a visual mode). When artists use multi-media, the boundaries between different modes of expression and communication are blurred and the reception of the work is dependent on multimodal readings (Kress and Leeuwen 2001). Many students are familiar with and adept at using multimedia technologies so that the division between word and image is largely restricted to school art and design. This understanding of visual culture is quite distinct from the culture of school art where the dominant values are presented in the form of a binary opposition, that between accuracy and

Table 3: Where had students seen contemporary art outside of the classroom?

	No. of respondants giving this as an answer	As % of all students in cluster
Internet	48	60.8
Magazines	35	44.3
Newspapers	24	30.4
Public spaces	22	27.9
Art centres	21	26.6
Studios	14	17.7
Community centres	12	15.2
Total no. of instances	176	-

Chart 3: Where had students seen contemporary art

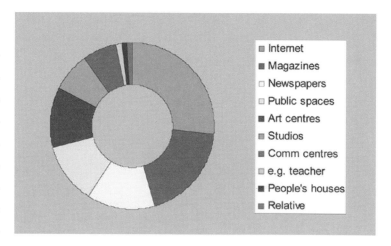

expression, with their implications of objective and subjective practices (Atkinson 2002).

Despite the promised panacea of new technology and examples of exceptional practice in some art departments (iJADE) traditional drawing and painting remain the dominant practices. Although these practices are still vital and potent to artists working within the contemporary field, school art continues to privilege optical and mimetic procedures rooted in a nostalgic pictorialism that limits understanding. Most of the artists' projects within Critical Minds explicitly challenge these understandings employing discursive, questioning strategies and moving between and across semiotic modes.

In these ways, 'School Art' is often characterised as insular and retrospective (Hughes 1998; Steers 2003; Downing and Watson 2004). However, it must be reaffirmed that this model of art and design does provide an important and popular alternative to the logo-centric curriculum, a counter-weight to information-led pedagogies that can all too easily alienate students whose social background denies them access to the social and cultural capital necessary to achieve within an academic environment.

2/live-wire: I like them a lot [art lessons] They're practically the only lesson I enjoy in school ... You don't get bored to death. Everything else is really, to pass it you have to learn a certain something. There's no, like you have to know it for definite. You have to know the rules of it, you have to know everything about it. But with art you don't need to, there's all sorts of answers. There's not just one answer like 2+2 is 4, there's lots of different answers.

Gallery partnerships: artists, art teachers, gallery educators
The questionnaires indicate that east London students' introduction to galleries tends to be facilitated through school visits to the large national institutions. Of the students taking part in Critical Minds, 87.3% had visited a gallery prior to the project. Of these, school trips accounted for 77.2% whilst only 6.3% had made visits on their own.

Bearing in mind that school visits were providing gallery exposure for the majority of students, they were asked to list the names of any of the galleries they could remember visiting. The aggregated findings are shown in Table 5 below. Tate Modern was the most commonly recalled gallery, being listed by just under one third of all students (33.0%). Behind this was Tate Britain, recalled by 19% students and then the National Gallery, London – by 5.1%. 21.5% of students claimed they could not remember the name of the galleries they had visited.

Table 4: Who had students visited a gallery with?

	No. of students giving this answer	As % of all students in cluster
School	61	77.2
Family	19	24.0
Friends	10	12.7
On own	5	6.3

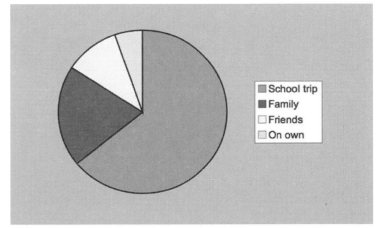

Chart 5 shows the spread of gallery visits by each school. This indicates that Tate Britain was the only gallery recalled by students at school 4, whereas students at school 1 listed the names of seven different galleries they had visited, either as a school trip or external visit. Students at school 1 also reported greater diversity in the spaces visited than students at the other schools, claiming visits to sites from the Dali Museum and Henry Moore Institute to Tate Modern and Tate Britain. Tate Modern accounted for the gallery listed by most students at school 2, whereas Tate Britain was the only gallery recalled by students at all schools. The chart indicates the prominence of national institutions within students' experiences of gallery visits.

This dependence on the Nationals is not surprising given that they house many of the canonic exemplars students are encouraged to reference in their work. They also offer practicable, published frameworks for accessing works of art. Both the collections and the pedagogic apparatus therefore take on the status of legitimate knowledge. Additionally, their popularity may be partly due to the relatively anonymous environment they provide for both teachers and students. This places less responsibility on the dialogue required to sustain the partnerships necessary for working with smaller, local galleries as in the Critical Minds project.

Institutional discourse

We have begun to map students' perceptions in relation to discourses in the field of art and art education in order to understand their experience of art and design in schools. Similarly, here we investigate the educational discourse within the Whitechapel Art Gallery to exemplify the language and rhetoric that forms around contemporary art when it is exhibited and promoted within local communities. We interweave statements by gallery educators with an analysis of an official document to establish the aims of educational partnerships and how they impacton learning.

The Whitechapel Art Gallery has been a pioneer in the development of outreach programmes enabling artists to collaborate with local schools and communities, including the recent 'Creative Connections' (beginning 2002). It should be remembered that Critical Minds draws on the action research undertaken by participating artists, gallery educators and teachers and therefore includes evaluations of existing and ongoing practice, including Creative Connections). For the purposes of this report, the aims of Creative Connections have been selected as indicative of gallery education. The aims are stated as follows:

With a focus on improving students' visual literacy, creative skills, understanding and enjoyment of modern and contemporary art, Creative Connections aims to increase students' motivation to achieve, particularly at exam level, while encouraging an

Table 5: Which galleries did students remember visiting?

	School 1	School 2	School 3	School 4	No. of students listing this gallery	As % of all students in cluster
Tate Modern	7	19	0	0	26	33.0
Tate Britain	5	6	3	1	15	19.0
National Gallery	2	2	-	-	4	5.1
Don't remember	6	-	9	2	17	21.5

Chart 5: Visits prior to project

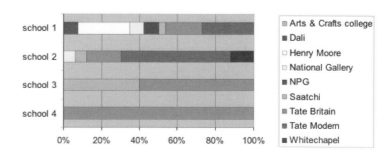

increased awareness of the role of contemporary artists within society, through interaction with living artists.

Placing artists in schools, Creative Connections aims to foster creative collaboration between artists and teachers, giving teachers the opportunity to extend their engagement with modern and contemporary art, and through regular forums and inset sessions, Creative Connections aims to support the professional development of both teachers and artists.

(www.whitechapel.org/content.php?page_id=1905 retrieved 23.3.06)

In these aims gallery educators are positioned as mediators who connect the rapidly changing field of contemporary practice to the mainstream curriculum, a role that presupposes art teachers are unsupported in developing a critical and creative curriculum that makes reference to contemporary art. In effect, such support implies a deficit model (Dawe-Lane 1995; Burgess 2003):

> 3/gallery educator: The vast majority of teaching in art is skills-based [cites evidence from report *School Art, What's in it?*, Downing 2004] Most artists and galleries can bring an expansion of that, and risk-taking. (14.2.06)

Gallery educators believe that they can ameliorate this situation through their brokerage:

> 2/gallery educator: I think, having worked with lots of teachers and lots of artists... there is a big difference between them, and the whole sort of brokerage issue in this project has been easy because you've made things quite easy. (21.02.05)

The actions which gallery educators deploy within Creative Connections are characterised in two ways, one: a nurturing role, 'encouraging', 'foster'[ing], and 'support'[ing], a role replicated in Critical Minds, albeit with more egalitarian intentions:

> 2/gallery educator: Everyone is sort of on an equal platform and understands that at the beginning, and the teacher feels valued as a maker and a practitioner themselves. (21.02.05)

And two: by actions that pertain to measurable outcomes of progression: 'improving', 'extend'[ing], 'increase'[ing]. Gallery educators participating in Critical Minds notably assess the project in such terms:

> 2/gallery educator: It was definitely a progressive process. I mean, I don't actually think it started really, really properly until we were actually concentrated working in the gallery and at that time that was that point where I thought the [students] were having really serious transformation. (13.12.05)

Gallery educators are in a position to mediate between schools and artists because they have access to the resources (curators, critics and contemporary artists) that teachers supposedly lack. These resources provide them with intellectual and cultural capital, a capital that can be redistributed through the agency of the artist. In Critical Minds most artists differentiated their role from the other roles in the partnership:

> 2/artist 1: I'm not hired as an educator, I'm hired as an artist and it's really important that when you're hiring someone like me, or someone like X, you're not hiring an educator, you're hiring essentially an adjunct to an educator. (22/02/05)

Through school placements gallery educators are able to introduce artists as agents of change. Indeed Creative Connections claims that over a sustained period, gallery educators can facilitate 'interactions' and 'collaborations' between artists and teachers that will enable students to gain pleasure from modern and contemporary art, develop an awareness of art as a social practice and improve their school performance.

This process also makes possible collaborations between artists and teachers that encourage mutually informing, reflective partnerships.

> 3/teacher: I felt supported. I wasn't on my own. It's a very solitary experience, teaching. In the classroom with loads of lads coming in and out. You don't talk to adults unless you seek them out! It's lonely! Sometimes a whole week of only speaking to children. Sometimes talking to adults is a most scary proposition because your vocabulary has been reduced to the level of 14-year olds. You lose social skills. (14.2.06)

The rhetoric of the aims of Creative Connections closely mirrors government policy documents (NACCCE 1999; DCMS 2000; DCMS 2001) in which museums, galleries and libraries are seen as central to the development of a multi-skilled population in support of social inclusion. Its aims also relate to the five generic learning outcomes (GLOs) of the MLA (2004) particularly the activities and cognitive and cultural competencies as outlined in the expanded descriptions which can be found at (www. inspiringlearningforall.gov.uk):

GLOs	Creative Connections
1. Knowledge and Understanding 'deepening understanding'	• understanding; extend [teachers'] engagement
2. Skills 'intellectual skills' 'knowing how to do something'	• visual literacy; creative skills
3. Attitudes and Values 'opinions about [self]/other people' 'positive attitudes'	• awareness; motivation to achieve
4. Enjoyment, inspiration, creativity	• enjoyment; creative collaboration
5. Activity, behaviour, progression	• interaction; collaboration; inset; regular forums; achieve... at exam level

However, Creative Connections stresses learning as a social process whereas the GLOs are more concerned to understand the effect of learning on individuals.

Charts 6 and 7 explore students' perceptions of the difference between gallery and classroom education.

Students were asked to provide in writing what they saw as differences between learning in the gallery and learning in the classroom. Although these comments were collected following the students' participation in the Critical Minds project, they made no reference to the specific context of the gallery/artist partnership with whom they had worked, nor did they make any reference at all to the 'artist' specific to their project or as a generic title. Responses were coded by commonality and the most pervading themes charted below. Chart 6 illustrates commonalities of response across all four schools, whereas Chart 7 breaks down responses by school.

In all of the schools apart from school 4, students expressed the idea that being in the gallery enabled them to see 'the real thing' as opposed to working from reproductions. Students also commonly made reference to the different environment, which in many instances they linked to new stimuli and inspiration. The talked of a gallery being a 'more fun' place to learn and individual students made reference to being enabled to see or think in different ways within the spatial configurations of the gallery environment.

Chart 6: Difference learning in gallery

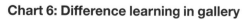

☐ School 4
☐ School 3
■ School 2
▨ School 1

Chart 7: Difference learning in gallery

▨ school 1

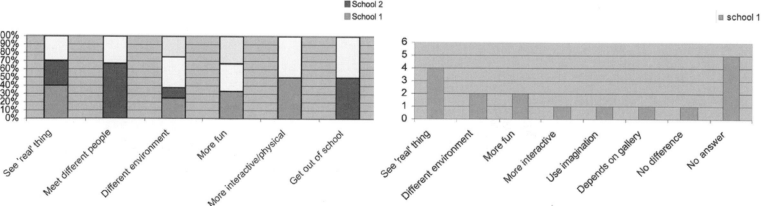

Artists as agents of change

At the beginning of the project, when the action research teams were introduced to the MLA Generic Learning Outcomes, many of the gallery educators found them acceptable as a pragmatic framework within which to investigate learning. Teachers too were familiar with conceiving learning in relation to given aims, objectives and learning outcomes which they have continuously to articulate and record as evidence of the efficacy of their teaching. However, there was a noticeable resistance by the majority of the artists who perceived them as a set of limiting criteria, a mechanistic and reductive set of abstractions that in no way represent the complexity and richness of learning within artistic practice. This sense of different values and ways of working remained throughout the project and informed the developing dynamic of the action research teams.

> 1/teacher: I was getting quite cross and I felt I was seen as the one that was nagging all the time and I hate that. I was the one who was saying 'quiet!' and actually blowing my whistle and it was awful. (14.12.05)

> 2/artist 1: You know we're hired for our skills and as you said, one of the great skills is this unspoken skill, this unspoken understanding, that we're not educators and we're not disciplinarians. I think one of the greatest compliments that you can get... is the teacher coming up to you afterwards and saying 'I had forgotten how to teach that sort of way' – to get kids to think in a different sort of way. (22.02.05)

> 1/teacher: The kids as well take it in on board better than if it was coming from me, you know, having somebody else actually explaining it [a painting in a gallery] to them is also good. Actually, just having somebody else there putting it across, it's just a different technique, a different way of seeing. (21.2.05)

> 1/artist: as not a trained teacher, I can come up with the creative exercises... I really am trying to think: 'will that work as a group?' No, that should be broken down and stuff. But I don't know how to do it. (14.12.05)

> 3/gallery educator: It wouldn't be right for teachers to impose artists' roles onto themselves. It informs what I do; but it wouldn't be right.

In the following section we discuss how students perceive this dynamic. It is evident that many of them do see the experience as different.

> 2/good: The fact that we had two artists that we could go to and I think it's improved my ability to do art more because we've got feedback from actual artists and to work with them is a really nice thing,

> 1/resistant: There was a difference because with [the artist] it was more like fun and you get to walk around and express your ideas, but, like, when you're in the art room the vibe isn't really here.

(7) Difference learning in gallery

School 2

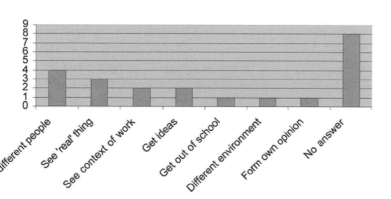

(7) Difference learning in gallery

School 3

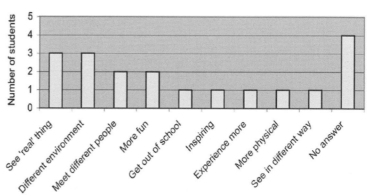

4/good: Cause it's just great to do something arty, but not really, concerning that much art ... Like, in the art class we wouldn't do this basically. We just draw.

1/good: It's very different because we didn't really do any drawing or making of any sort. It was all like about filming, which was just a different thing.

4/enthusiastic: I liked the fact that it wasn't all in the room all the time. It was out in the park doing the work, as well as getting ideas and things like that... It just means that I can be free and use my imagination as much as I want.

Of particular interest is the way that many students characterised the experience as not only pleasurable but as liberating, a freeing process that appears to have encouraged them to take ownership of the project.

1/resistant: It was like, it gave us like more freedom to like use our own ideas, and, yeah, like to be out of lessons and be doing something more interesting, and stuff like that, yeah.

4/good: Yeah. Freedom... in our art lessons we have to do like a certain thing for our course work. With this... it's like a topic and you just pick what you wanna do and you just do it in your own way with more freedom.

Writing, which students see as antithetical to the subject, was introduced in ways where its normative function was replaced by exploratory and metaphoric uses.

2/artist 1: I was wondering... whether it would be accepted or not, because it's not necessarily viewed as what one does in art class, to actually pick up a pen and write. But they seemed to be perfectly willing to do it and a lot of the stuff I was seeing around the table was great; it was poetic, it was stretched and surreal and comfortable with being like that. (16.3.05)

The artists noted that teachers are liable to become institutionalised, establishing routines and formulaic procedures that are antithetical to creative and critical practice.

2/artist 2: Quite often when I have been to secondary schools, I find the challenge is sometimes not the isolation of the students but the teacher, and how being involved in that system has actually affected them from having a relationship with a gallery or contemporary artist and they have been a teacher first and an artist second, rather than an artist first and maintaining that level. (21.02.05)

3/teacher: I put one of my drawings on the table and they couldn't believe I could draw! 'Oh miss you mean you can draw as well?' 'As well as what?' 'Teach!' And that's my sad

(7) Difference learning in gallery

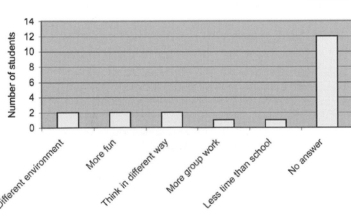

□ School 4

Many students characterised the experience as not only pleasurable but as liberating.

point, me personally wishing they didn't think they needed an artist in the room to feel they had an artist in the room.

3/artist: It's the problem of having an artist in school. They then see the art teacher as just a teacher. But then there's the contradiction of the art teacher showing their art. There's no reason why the project we did couldn't happen without me. Why couldn't a more experimental project happen in the classroom?

Findings

The institutional discourses of gallery education, school art and artists' interventions frame the way in which Critical Minds has been designed and implemented as an educational programme. Students' reflections on their experience of these discourses, as a discourse itself, demonstrate that they often recognise the conditions that best support their learning (understandings that the action research teams are not always able to discover because they do not have the opportunity to engage in one-to-one, in-depth conversations with students). To this end, the terms we employ to categorise the findings have emerged from an analysis of transcripts of interviews between IoE researchers and students.

These emergent terms were reformulated from the conversational language of the students into terms that relate to specific learning theories (an additional conditioning discourse) as well as the terminology of the research questions. Thus 'conditions for learning', 'critical thinking' and 'transformations' become the main categories within which the emergent terms are framed. As Wood and Kroger (2000) point out: 'The task of discourse analysis is not to apply categories to participants' talk but rather to identify the ways in which participants themselves actively employ and construct categories in their talk' (pp. 29-30). However, Fairclough and Wodak (1997) recognise that: 'Discourse is not produced without context and cannot be understood without taking context into consideration... discourses are always connected to other discourses which were produced earlier as well as those which are produced synchronically and subsequently' (p. 277). We intersperse the voices of the students with those of the action researchers to discover how the pedagogic discourse produced by the partnership is experienced and understood differently by the various participants. In addition, these understandings are correlated with the findings drawn from the entry and exit questionnaires.

Conditions for learning

The way we are structuring these findings acknowledges how students experience pedagogic relationships in school settings, the site where they were introduced to the Critical Minds project. As we have demonstrated, the majority of students receive the art and design curriculum as a given, a type of knowledge which is manifested as a set of practices in which certain values are embedded, specifically the objective/subjective oscillation between accuracy and expression. It is within the regime of accuracy that many students see themselves as excluded ('I can't draw') and thus as failures; whereas within the discourse of expressivism many see themselves as included ('I can be myself') and thus as contributors, although this contribution is not always valued ('a child of five could do it'). We therefore begin the analysis by looking at the pedagogic relationships between teachers and students, artists and students and within students' peer groups, before moving to a consideration of the ways students do, or do not, take ownership of the project and their own learning. This is followed by an examination of motivational factors that can be deployed strategically by adults to encourage engagement with and ownership of learning.

Adult expertise/support

The rhetoric of art and design promotes freedom as the ideal condition within which students can develop as unique individuals: 'Art and Design is the freedom of the individual, the freedom of expression and the freedom to fail without retort' (Waterfall in DfEE 1999: 116). However, as we have demonstrated, although students experience their art and design lessons as different to dominant logocentric pedagogies, they nonetheless note its constraints. The comments below indicate that despite the emphasis on self-expression students appreciate a structured environment in which they are supported by adults. The discourse on accuracy and the wider experience of schooling possibly condition these responses.

2/live-wire: Well, obviously there are wrong answers, you can't just, well I mean, I know people do it, just like draw a line on a piece of paper and say 'that's art' but I think the right way to teach art, I think we're being taught art really well because we've all got our own little projects, but we all still get the teacher's attention, yeah.

What the student is articulating here, beyond the discourse on accuracy, corresponds to theories of pedagogy in which learning, as a cognitive process, develops in the first instance through interaction with others, not as an isolated, independent act: 'Every function of a child's cultural development appears twice: first, on the social level, and later, on the individual level; first, between people (interpsychological) and then inside the child (intrapsychological). This applies equally to voluntary attention, to logical memory, and to the formation of concepts. All the higher functions originate as actual relationships between individuals' (Vygotsky 1978: 57).

2/good: ... we can interact with people who do this for a living and that helps us to express it in class and we produce more good work.

Further to this social conception of learning Vygotsky theorised a fundamental condition for learning which he referred to as *The Zone of Proximal Development* (ZPD). This term denotes: 'the distance between the actual development level as determined by independent problem solving and the level of potential development as determined through problem solving under adult guidance or in collaboration with more capable peers' (Vygotsky 1978: 56).

2/live-wire: But we managed to still create an original piece because there was a lot of people who didn't think we could do it, but we proved them wrong and we did it by asking for help, I think.

(Do you think a gallery is a good context for learning?)

1/resistant: Yeah... it's usually if you're with somebody that can explain it; it's better for learning than just walking around. You can walk around and like admire work and things, but to understand what they were like, what the meaning was to their work, you'd need somebody to be with you, I think.

2/good: ... when we first started with Miss A we got the idea of 'habitat' and I didn't know what she was talking about. As the lessons went on she was gradually explaining, she was a good explainer. When you needed help she would come to you, because there's like so many people in the class so, like, it was hard for her to get around. But she did come and I think I produced really good work, like, with her help as well. But she wants you to, with your own mind, think of the ideas. She doesn't always give you the answer, which is good.

There is a recognition here of the way teachers have to structure the learning experience to account for an oscillation between individual and group needs, to translate new concepts into accessible terms (an incremental process) and, in time, slowly withdraw support to encourage students to work independently and take ownership of their learning.

4/good: They did help providing the cameras. Instead of telling us what to do, they told us like a topic. Not really that 'you have to do this!' Just a way of doing something. We had to figure it out and do it in our own ways.

These comments echo the notion of 'scaffolding', a metaphor used by Wood, Bruner and Ross (1976) to define aspects of Vygotsky's ZPD process. Here a teacher or peer provides students with assistance in those tasks or concepts that they are unable to tackle on their own, providing positive reinforcement and praise even when 'errors' occur. Once students have developed the skills to understand this process the teacher or peer slowly dismantles the scaffolding leaving students to continue their work independently. As Benson (1997) claims: 'Scaffolding is actually a bridge used to build upon what students already know to arrive at something they do not know. If scaffolding is properly administered, it will act as an enabler, not as a disabler.' (Accessed 8 May 2006 from http://www.galileo.peachnet.edu/).

1/resistant: I think you need to be quite positive a lot of the time and use constructive criticism instead of just pointing out negative aspects.

Mutuality
While most students recognise that supportive structures are important in making learning possible, they are keen to point out that they prefer pedagogic relationships in which there is mutual respect. As Bell Hooks claims in her argument for engaged pedagogy: 'respect... is essential if we are to provide the necessary conditions where learning can most deeply and intimately begin' (1994: 13). Both the most positive and the most negative comments by students relate to these relationships.

1/good: She [the artist] talked to us much more as if we were adults, that's not compared to my teacher... I liked that she talked to us as adults, and even when some people were messing about and not listening she like tried to explain why

they should listen, not just shouting at them and telling them what to do. She seemed very different to our teacher, I guess she seemed like I would be if I went into a class, she seemed almost like one of us, yet she was still quite, I don't know, in charge and wouldn't let us mess around too much. [pause] But then like we always knew our teacher was in the room as well.

2/live-wire: … was babying us and we found [it] really irritating. I'm not going to name names… That's just my own personal opinion. And Z was babying us and then this person that had supported all of our work before, suddenly turned around and agreed… I know they probably had their reasons, we still felt hurt that we weren't trusted, to be trusted to do our own piece of work.

2/good: They were friendly and they did interact with us like how we would interact as teenagers, but you have to remember they are grown-ups so you can't exactly be, you know, teenager-like with them. But if they got angry they didn't lose their cool; they like made us understand stuff. But I don't think they did get angry.

2/artist 2: I think, like most young people, the students enjoyed being treated like adults and being given responsibility for their own work/exhibition. It's sometimes easy for me to forget how important encouragement and unconditional support can be – especially when it comes from someone who does have to give it – both X and I were always aware that we weren't teachers. (14.12.05)

Another alternative to the prescriptive, teacher-directed models can be found in heuristic education where teachers and students work together to discover solutions for themselves through a process of trial and error, a way of problem-solving that provides a certain mutuality in pedagogic relations (Schon 1992). Some artist-led initiatives have moved beyond this mutuality by developing a more engaged approach where students are invited to instigate projects based on their own interests and lived experiences rather than on problems provided by others (see Lacy 1995; Paley 1994; Harding 2005). Freire calls this approach 'problem posing' as distinct from 'problem-solving' education (1990). None of the projects in Critical Minds took on this form exactly, indeed the evidence suggests that most of the

adult teams doubted students' capacity to generate projects from their own experience because schooling discourages and disempowers such approaches.

2/artist 2: Going into schools rather than gallery education I've become aware that there isn't the chance for people to develop their own ideas. Projects are set, and what's nice about going in as an artist is that you don't necessarily have to follow that model. (16.3.05)

However, adult teams recognise that it is important for students to ask questions and listen to others as a pre-condition for developing critical skills, skills that will enable self-esteem, self-determination and, ultimately, well-being.

3/artist: You should be able to walk into any space, in any context and be able to ask questions, have a really good discussion… You don't have to have art history knowledge because that's what's so scary… you feel inadequate. The questioning thing is the only way to approach art.

2/artist 1: It's nice that they are able to express their opinions too and be able to defend their position and ask questions. We, as a society, tend to try to dampen a lot of that down because if you ask too many questions then you're a troublemaker! (13.12.05)

2/artist 1: As Walt Whitman said 'to make a better society you need to make better people' and part of making better people is making people who question, who want to know and who have opinions and are willing to get into arguments. (13.12.05)

Student ownership
Lack
The comments by students indicate that they accept aspects of the given power relations within schooling, albeit reluctantly in some instances. This acceptance can be seen to be generational in its formation, simulating familial relationships where guidance, support and boundary setting characterise interactions. However, it is evident that students want their voices to be taken seriously, appreciating a space for equitable if not equal relations. As a consequence, within formal pedagogic situations, students are unlikely to make personal meaning unless adults recognise them as both subject to and agents of learning.

2/live-wire: We were going there [gallery exhibition of students' work] expecting like to be able to do our own thing and then we were given photos and told to arrange them and I was just like 'well this isn't what I was expecting'... I wouldn't want my mum to come to a gallery and see how I had arranged some photos. I'd want my mum to see how we'd done some work.

Here, expectations about what constitutes student production and what counts as art combine with a sense of disempowerment and alienation. This lack of ownership was felt by a number of students toward the end of the project.

2/live-wire: I did like doing this project a lot and I liked the artists we were working with, but I don't think the final gallery is a fair representation of the work we've done. It's like [pause] it's [long pause] I can understand why it is the way it is because it is a school thing, it is funded by the government, although it's an outside project it's not, it's a school thing.

The exhibition marked a stage when adults intervened in the student production both because of pressures of time and also a perceived need for a representative and coherent presentation that they assume students are unlikely to realise.

2/gallery educator: [choosing images for the exhibition powerpoint]

I thought this photograph kind of suggested conceptual, critical thinking more than some of the other images which were just workshop shots. And I guess it will come out more professionally than the other things, which I think is important to the girls, that it feels like a proper exhibition. (02.11.05)

2/gallery educator: What are we going to do about these labels? Because the girls seem to want them just put up like that, but they've done this sort of bubble writing, you know, um...I thought I could print them out on the computer or we should use a uniform font or something? (08.11.05)

Self-expression

In secondary art and design, despite the rhetoric of self-expression, the curriculum is largely determined by educationalists. It is true that at GCSE students are expected to make choices and plan the trajectory of their work; nonetheless, autonomy is encouraged within a framework which is circumscribed by learning criteria that inhibit students' agency. In contradistinction, students' experience of the Critical Minds project provided a certain freedom from constraints, an opportunity for self-expression.

3/good: Yeah, I mean when I say wacky like, when we done our film art... it was just like a side of us that we wanted to express to other people, like the way we was.

The 'wacky' and 'weird' descriptors that figure in some of the responses indicate that students recognise the difference of these projects to the prescriptive regimes under which they usually work. But this difference does not always revolve around issues of ownership.

4/good: It was just weird. It's been like a daily routine and then it just changes.

Congruence

Despite the fact that the art and design curriculum is often critiqued as insular and removed from the everyday experiences and needs of young people, some students are able to identify with school practices from a number of subject positions. For example, it is notable that 50% of the students (2) identified as resistant to art for the purposes of the research typology of Critical Minds contradict such labelling.

2/disengaged: I do like my art lessons... that's the lesson that I actually concentrate in once I get into the work and I actually do enjoy art a lot. It's like your own, you're expressing your own, yeah, you're expressing your own working through, not just writing, like through something else... And basically it's included to our environment as well, so it shows where we live and everything, as well.

The art and design curriculum is often perceived as reproducing bourgeois values; visiting galleries is a primary means by which the middle classes enable their children to adopt those markers of distinction that provide them with the taste and authority to take up professional and leadership positions (Bourdieu 1984). Gallery visits within the official curriculum are in this sense a form of distribution, in this instance of social capital. While for many inner-city students there is a clear disjuncture between their usual leisure activities and visits to galleries, some have the social (and cultural) capital that results in a cultural competence when using such venues. The student below has an awareness of the different systems of perception and interpretation acquired

through informal as well as formal processes of socialisation. This enables her to be quite dismissive of what Critical Minds has provided because, for her, cultural capital is already a possession.

2/good: I have been to a lot of galleries because my uncle is an artist... Yeah, I mean, I go to galleries anyway, so nothing's really changed about that, but I go to them more now because it's kind of nice after this project and having different ideas.

Although Critical Minds aims to introduce students to critical practices in the field, some students were able to bypass this aim and identify with the 'cool' status that has accrued to high-profile, contemporary art (Stallabrass 1999). This provides a form of cultural capital that is linked to an international, street-wise, global culture.

4/good: I like the scary art... There's this artwork, David Shrigley: I think he's just funny. He is like a cartoonist, if that's the word. It's just so crazy and so random and I like being crazy and random. It's just cool; it's cool artwork. Yeah.

Most members of the adult team thought very highly of this student and yet her interview suggests less critical thinking than others. She identifies here with 'cool' as an attribute of both artists who are provocative and humorous and of herself (an academic student who is also a leader and a 'funky' role model).

Making sense of activities in relation to personal preferences
For some students there is, however, no such congruence and they have to work at making sense of the art and design practices by relating them to habituated modes of making, for example those that exist in the home (Mason 2005). The student cited below identifies himself as an imaginative person, despite the opinion of some of the adults involved in the project:

4/artist: He is confident playing football maybe; he is not confident thinking about art. So I don't have any strong opinions about him except for he needed a lot of pushing, he needed a lot of direction. He needed a lot of attention.

The student recognises that his Critical Minds homework provides an outlet for therapeutic, expressive, almost cathartic, responses. He suggests that he usually finds it difficult to work this way in a public forum, possibly because of the emphasis in this part of the project on emotional disclosure, a practice in which boys are often reluctant to participate.

4/resistant: The one that they gave us a sketchbook to take back home, we did pictures of how we felt. First I thought it was a bit strange. When I went home, I found it kind of easy, cause I just draw a few pictures, cause I am a very imaginative person... so a few crazy images of how I felt. Mostly it was easy and fun to do; a kind of like release or stress or whatever's in it. Eventually I got the idea. So I wanted to do like a cartoon book, where you kind of lift the pages and things that move. We did it with a video camera and play dough.

He evidently prefers to work in haptic modes, engaging physically with plastic materials in combination with new technologies; preferences that correspond to the findings of Ofsted (2004) who claim that 'the interests and achievements of boys, in particular, can be secured by starting with direct exploration of materials or the use of ICT' (p. 3). At a later stage in his interview he comments on the acoustic potential of the gallery space, 'Surroundings... kind of, we just shout and echo'. In this different space he revels in the materiality of 'noise' recognising that certain spaces can be used as an acoustic field, a place to foreground sound. This recognition reinforces his preferences for non-logocentric, physical experiences, preferences that could be valued as multimodal resources as practised within contemporary art.

Strategies to encourage ownership
In traditional pedagogy, 'ownership' is the term often used to refer to the way students gradually take control of, rather than instigate, the learning process, one where they take possession of learning through a combination of teachers' guidance and their own efforts. This is in contradistinction to the transmission model termed 'spoon-feeding' which can produce a culture of dependency blocking any possibility of autonomy while ensuring 'good' results. In the former, ownership may take place at the moment in a pedagogic situation where the learner's interest in the object of study appears self-generated, an interest that potentially leads to student initiative and resourcefulness, whether individual or collaborative.

4/resistant: They were kind of giving me ideas of their own as well to help me come up with ideas... So I made one idea, which I saw when I went further through the park, next to the palm tree thing, that says 'freezing' while it is supposed to be in the sun. I put a little sign that it says 'freezing'... like a postcard.

In this particular project students are taken out of the gallery and school context into the local environment where they are invited to make textual interventions in an attempt to encourage viewers to see the familiar in unexpected ways. One strategy provided by the artist is to deploy inversion, an accessible procedure in which an expected characteristic is replaced by its opposite. Although the resistant student acknowledges that the artist and teacher initially give him ideas, on reflection he claims ownership of the inversion for himself. By providing strategies to encourage ownership, educators enable students to find some sense of congruence between the curriculum and their interests; in effect they generate an interest that might not occur without their intervention.

Motivation
Interest
Interest is a primary motivational factor and is particularly important for school age students. As Kyriacou's research findings (2001) indicate although young people are highly motivated and many elements of the environment pose challenges for them, after a number of years in education this intrinsic motivation is undermined and dampened. The most ubiquitous reason given by students to account for disaffection with schooling is boredom and the way that much of the school curriculum appears to have little relevance to their lives and possible futures. This disjunction suggests a need to explain the educational rationale for specific types of knowledge and to make connections explicit. Below we provide testament by students who developed an interest in the project and seek to identify which factors they found motivational.

4/resistant: I think it was very fun, very good... It was very interesting as well, it engaged you in what they [the artists] were doing and you know, lots of communication, it made you come across the kind of people that you don't normally speak to.

This student is aware that he does not usually have the opportunity to work with artists and that this is potentially a lack. Additionally, by identifying an increase in communication he suggests that the give and take of conversation, discussion or debate does not characterise normal interactions in his art and design lessons. His key words: 'fun', 'interesting' and 'communication', in combination with 'inspiration' from the student below, correspond directly to some of the outcomes highlighted in the GLOs (MLA 2004).

1/resistant: They [the artists] also like helped us think of ideas for our video and inspired us.

Disrupting expected patterns
Critical Minds activities were located in both schools and galleries but also in in-between spaces: journeys to and from the official locations, field-work in parks and playgrounds. The rhythm of the project disrupted the usual pattern of the school day and this was experienced as motivational, even liberating as was working in groups and producing artwork on a much larger scale (these communal and spatial factors are discussed at more length in the next section).

4/resistant: ... we go outside, which we don't go often, and we do a lot of big art stuff than you know in the classroom. Like the big canvas, or the one all of us did with one video camera, standing in our group and talking about our group like that. We don't do that often.

Connecting to youth culture
As many teachers come to understand, and as Willis (1990), McRobbie (2000), Buckingham (2005) and others have demonstrated, it is also motivational to make connections between the objects of study and current taxonomies within youth culture. This is a strategic deployment of demotic discourses that may be, as with the case of celebrity cited here, acritical. We have already noted the 'cool' cachet that one student attached to specific forms of contemporary art; below other students recognise that the persona of the artist equates with fame and celebrity and this is a hook with which teachers can draw students into an engagement with practices they might otherwise dismiss.

3/resistant: Yeah, cos an artist, I think, they draw things and they're quite famous and they know the things that they do.

1/hyperactive: (the project was film-based) Film is much easier [than drawing]. Film is more fun because it makes, it feels like someone like 50 cent and guys that you would normally see on television, that's how it makes you feel. You know, like many people are going to watch you on that particular film so you think, 'ah if loads of people are going to see me I better make a good impression.' I find I really liked it, it was very fun.

On one level, students' participation in a project that had a high profile within each school provided them with a sense they were involved in something worthwhile. Prior to the final exhibition, opened by a government minister, the gallery educators had stressed to students the potential significance of the project for informing government policy and thus providing it with a missionary status.

3/unfathomable: It was interesting because it got a lot of people involved like the government and artists and stuff like that.

Public voice/exposure
Indeed, the opportunity to show their work in a public space other than school was in itself motivational for a large number of students.

3/resistant: ... some man was looking at it and he was presenting it to other classes, I think other schools came as well, and other schools really liked it a lot. And it was really nice and my work was the best one.

2/disengaged: Basically I want to say it was really good because we got a chance of showing our art to other people as well and things like that... I think others should get the chance to do it as well, the same.

3/unfathomable: Because normal work is just when work is not going anywhere and if you're doing the project it's like, it's going to go somewhere you want it to be at its best...

3/unfathomable: Yeah, because you don't want people thinking it's a rubbish piece of work.

2/good: To have a private viewing at this age is really nice because it's something you can put down that you've done and something you can be proud of, which is good. I got to work with my friends and stuff, that's nice.

However, if these motivational factors are isolated from critical discourses and deployed merely as strategies to gain attention, then they are not enough, indeed they may even be counterproductive.

Levels of Criticality	Domains		
	Knowledge	Self	World
4. Transformatory critique	Knowledge critique	Reconstruction of self	Critique-in-action (collective reconstruction of world)
3. Refashioning of traditions	Critical thought (malleable traditions of thought)	Development of self within traditions	Mutual understanding and development of traditions
2. Reflexivity	Critical thinking (reflection on one's understanding)	Self-reflection (reflection on one's own projects)	Reflective practice ('metacompetence', 'adaptability', flexibility)
1. Critical skills	Discipline-specific critical thinking skills	Self-monitoring to given standards and norms	Problem-solving (means-end instrumentalism)
Forms of criticality	Critical reason	Critical self-reflection	Critical action

('Levels, domains and forms of critical being' in Barnett 1997: 103)

Critical thinking

The Critical Minds project confirms much existing research (Davies 1995; Addison et al 2003; Downing and Watson 2004) that claims art and design is a making-led, expressive and non-discursive subject in secondary schools. This was confirmed by a number of students in the interviews who were at pains to show how they value the potential of the subject to offer an affective alternative to the logocentric curriculum with its language and number-based systems and procedures. However, Critical Minds was designed to discover whether access to contemporary art and artists would encourage students to develop a more discursive, enquiring approach to art and, in doing so, support critical thinking.

It is the logocentric curriculum that is traditionally given credit for enabling critical thinking, a term that describes an analytical and reflexive approach rather than a reactive or habituated one. Problem solving has already been cited as a process that requires critical thought, an approach familiar to design-based activities in which pragmatic solutions are realised in response to practical difficulties. Already here it can be seen that language is not necessarily fundamental to this way of thinking, that it might be possible to offer solutions in the first instance through drawing and modelling. The processes employed in fine art practice whether affective, conceptual, metaphoric, perceptual, further intensify the types of critical thought that people can deploy in art and design and complicate those definitions of critical thinking that focus on reasoning, argument and judgement conceived of solely in terms of language. In this way, the production of artworks by students participating in Critical Minds (including drawings, films, 3D constructions, performances, text-pieces) could be seen as holding or embodying critical thought. However, the following analysis is primarily based on data taken from the student interviews and therefore focuses on discursive and reflective thought rather than making. In this respect it must be admitted that this research is partial and does not pretend to do justice to the full experience of both the students and the action researchers.

In order to provide a holding form for the diverse ways in which critical thinking can be manifest we make reference to a useful model devised by Ron Barnett (1997) in which levels of knowledge are related to the domains of self and the world.

We understand the 'world' here to refer to social, cultural and natural experiences suggesting that critical thinking enables a person (self) to deploy critical skills in order to interact with others and their environment and thus contribute to critical thought, a phrase that Barnett uses to describe the collective and collaborative endeavour that results in forms of knowledge (p.17). This thought thus enables individuals to work together to inform and potentially transform experiences; in other words it provides them with a degree of agency. Critical thinking, defined purely as a set of cognitive skills divorced from the contexts in which they are formed and applied, results in a series of competencies that fail to acknowledge how they are socially and culturally produced and therefore how they embody specific power relations. We therefore acknowledge these power relations in the way we analyse how students navigate and deploy the various discourses, demotic and institutional, at play in Critical Minds.

The following analysis tends to gravitate to levels 1 (critical skills) and 2 (reflexivity) although in some instances student statements can be interpreted as indicative of 3 (refashioning of traditions). In the exit questionnaire students were asked to rate the extent to which participating in Critical Minds had enabled them to develop skills in areas that pertain strongly to level 1. Charts 12-15 show the findings, broken down by each school. Aggregated data can be found in Chart 16. In the interviews and action research reviews the rhetoric and hyperbole of some statements might appear to correlate with level 4 (transformatory critique) but as they are not accompanied by critical explanation we have saved them for the final section 'Transformations' where participants make claims about profound changes in attitudes and values.

Critical skills
The two skills which students most commonly agreed ('strongly agreed' and 'fairly agreed') they had developed as a result of the project were 'working with others' (of all students 32.9% 'strongly agreed' and 40.5% 'agreed') and 'seeing things from others' points of view' (of all students 20.3% 'strongly agreed' and 50.6% 'agreed'). The significance of the former is addressed in the later section on communities, collaboration, mutuality. The ability to see things from others' points of view is possibly a pre-requisite for such communities because it enables dialogue and potentially the mutuality that students so

prize. Given the aims of *enquire* it is particularly gratifying to find students identifying these two skills as the most significant. As can be seen from Chart 16, p.73, very few students claimed to have developed no skills in any of the areas. The two skills which drew negative or more neutral responses were 'using new technologies' and 'researching ideas'. Of these two skills, both drew some level of disagreement from 15.2% students, whilst researching ideas drew the highest neutral response, given by 30.4% of all students.

If the above charts indicate student responses to skills identified by the research team, the following sections categorise examples of critical thinking as identified or used by students during the interviews. It is therefore not a comprehensive list of critical thinking skills or the ways Critical Minds fostered such thought, rather it is a demonstration of the use of critical skills deployed by students while reflecting on their experience of the project and can be said to indicate their perceptions of their own learning.

Awareness of the need for critical thinking
The first section demonstrates that some students recognise the need for critical thinking within art and design, perceiving the Critical Minds project as something beneficial to both an understanding of art and to its making (although one student notes that its associated activities can be irritating).

> 3/unfathomable: Usually teacher says what to do; you do it. But in like these projects you get your mind into it because it's more interesting so, like, learn to listen more and get into it more and stuff like that.

2/good: I didn't think there was going to be that much writing in the project because art, you don't do much writing, but it helps writing stuff down because you can go back to it and you can produce more better art. With everything, you have to write stuff down because you won't remember everything, which is good, but it was annoying sometimes.

Recognition (and aesthetic appreciation) (level 1)
One of the skills, or possibly dispositions, that is traditionally prized in art education is aesthetic appreciation, the ability to find pleasure in both natural and cultural experiences. In relation to works of art two categories are privileged, the 'beautiful' and the 'sublime', whereas with design this duo is supplemented by 'fittingness'. Students are said to participate in aesthetic appreciation if they recognise (the critical part) and enjoy that which is beautiful (pleasing), sublime (awe inspiring), or fitting (appropriate for purpose). Although we would suggest that these categories are not universal but culturally and historically specific, students tend to be taught how to appreciate them with reference to 'neutral' formal properties, ones that can supposedly be applied to all visual practices. These properties include visual and spatial elements such as line, tone, colour, shape and volume. On one level this list enables students to access traditional art but does little to provide a vocabulary to help them address its symbolic forms or the social contexts in which it was produced. Neither does it support students to investigate dominant contemporary forms such as installation, performance or dialogical practice. It is therefore not surprising that the student cited below gravitates to a contemporary example that can be analysed through formal means.

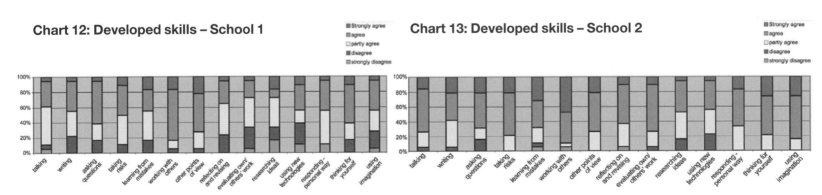

Chart 12: Developed skills – School 1

Strongly agree
agree
partly agree
disagree
strongly disagree

Chart 13: Developed skills – School 2

Strongly agree
agree
partly agree
disagree
strongly disagree

1/good: I like Michael Craig-Martin because it's kind of, I don't know, I just like it. ...

(Can you say what you like about his work?)

Um [pause] just because of the bold colours, I suppose. In a way it's quite bland because it's just flat, but I don't know. It's, you know, I haven't had to think like this before. [pause] um I think [pause] I like the fan on the big building, I think it's really nice. Now why do I think it's nice? I guess I like the shape, the way it curves around. I like the bold colours because it's bright and happy and especially if it's colours that I like anyway.

Categorisation (level 1)
The ability to distinguish between different phenomenon so as to create patterns of difference and similarity by which to come to know the world and navigate experience is seen as quite primary to critical thinking. Such patterning also enables students to set up the structures required for analysis, that is the ordering of experience into constituent parts as a means to understand the relationships that make up some whole. (It is worth noting that sometimes analysis is seen as alien to artistic thinking where 'poetic' and/or syncretistic thinking, in which the world is perceived as a whole, overrides analytical methods; Ehrenzweig 1967). The formal elements described above are a typical analytical structure and in this instance students are given the categories to enable them to use a privileged discourse in

art education. For example, the degree to which students are able to apply a formalist terminology when they annotate their sketchbooks, both in relation to their own and others' work, largely determines how they are assessed in relation to the GCSE objective 'AO2: analyse and evaluate images, objects and artefacts showing understanding of context' (Edexcel 2003). In the statements below it is evident that students are trying to define their understanding of contemporary art in relation to the official discourses provided by Critical Minds but also in relation to their phenomenological experience of works of art.

(What kind of art did you do at the gallery?)

4/resistant: I'd call it expressive.

(What is contemporary art for you?)

I think it's like simplicity in the work and originality and a lot of imagination in the work. So contemporary art is, you know, let's say maybe something new, or something that makes you feel a different way or something like that. Something that you find speechless when you look at it with no expression or you don't know what you think. Something that questions what you thought already or what you didn't... That makes you think; wonder. People would say it's a shed (referring to Simon Starling's 'Shed boat' exhibited in the Turner Prize exhibition 2005) and you know they normally don't think of anything else. It's stuff that makes you think and wonder.

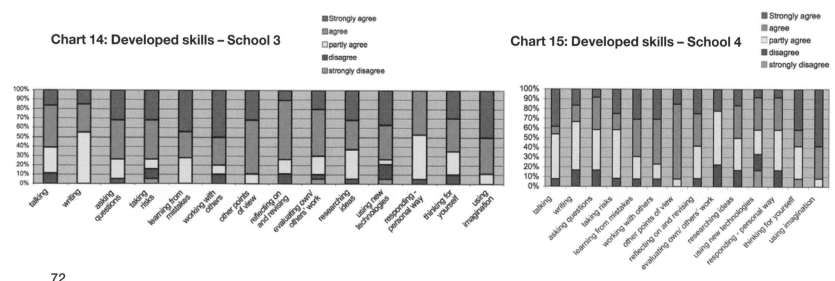

Chart 14: Developed skills – School 3

Chart 15: Developed skills – School 4

■ Strongly agree
■ agree
☐ partly agree
■ disagree
■ strongly disagree

This student has understood that contemporary art often questions expectations and assumptions in an attempt to change perceptions. Additionally he recognises the way artists may deploy ambiguity as a means to engage audiences actively in meaning making. Later in the interview he noted:

> 4/resistant: I think that anything can be contemporary art. If you rearrange this table and take a picture it can be art. You know do shapes and stuff.

Here he realises that within the discourses of contemporary art any material can be transformed and reframed as art, that even mundane objects of everyday use are an available resource. However, he has recourse to a formalist language in his final explanation.

Comparison (level 1)
The process of categorisation produces the structures through which the world is named, a process of differentiation that marks out the interests of a particular individual, social group or culture. Often phenomenon are paired to form what are termed binary oppositions: these are either/or structures in which the one term is dependent on the other for its meaning, e.g. male/ female; good/ evil; word/image; success/failure and which help to simplify the complexity of experience. However, they also serve to inculcate dominant social and cultural values (one term is always privileged over the other) so as to inform behaviours and attitudes. This emphasis on extreme difference encourages students to make comparative judgements, a process that is particularly common in school, whether those judgements are being made by teachers or students and whether they are about student in relation to student or between student and some normative criteria. The following statement is a response to a question about the difference between working in the gallery context and the art room where the researcher notes the 'whiteness' of the former space:

> 4/resistant: The classroom, it's not that it's not good or anything if you look at it at an artistic way; the different colours, the stuff here. It's like a mixture. I mean even the dirt. Some bits like this, playing with different colours and stuff.

The student differentiates these spaces and the implied cleanliness and austerity of the gallery by evoking the art room's material qualities. He diplomatically frames his description by qualifying the status of the 'dirt' and 'stuff' (usually pejorative terms), as necessary for 'artistic' action, 'playing'. Previously he noted that the gallery space afforded an echo so that he was able to play with his voice differently to the way the classroom allowed, a place, in contradistinction, that is full of 'stuff', absorbent, saturated. Despite an evocation of the art room that might indicate a space of some interest for him he nonetheless continues by explaining that it is place of routine, where his imaginative potential (as far as he is concerned) goes unrecognised. Post-project on returning to the classroom he opines:

> 4/resistant: I was sad at first, but eventually I got used to it again. When we got back we continued again. So I would have said I was sad but got on with it basically.

Contextualisation (level 2)
A number of students demonstrate that they understand how practices and the meanings and values attached to them are contingent and context specific. They can say, for example, how the reception of art requires skills in which interpretation is made possible through contextual information or how student production may be conditioned by adult expectations and thus limit their potential.

> 1/resistant: I think it's quite important to understand what they [artists] meant when they made the art and how they were inspired... Because that's why they did the work, so if you're looking at the work you'd need to know that, why they did it and what meaning it has to it, otherwise you wouldn't understand it.

One of the skills, or possibly dispositions, that is traditionally prized in art education is aesthetic appreciation.

2/live-wire: Well, it's a school thing... Even though the work we did was good... the final thing that people are going to see needs to be like simplified and just made easier and like [pause] all that people are going to expect from a Year 11 art show is like what they're getting.

In relation to the Critical Minds project one 'resistant' student claimed:

4/resistant: I am not saying it was bad or anything. It reminded me these things that you do to get young people off the streets. To do something productive, or you know, something worth the time to take them away from what they are doing.

Through his participation in Critical Minds and its congruence with community projects aimed at engaging alienated youth, he realises that the project is different to school work, possibly a vehicle through which to encourage the active participation of resistant or reluctant learners. However, he implies that such activities are not necessarily aimed at learning but rather for the purpose of containment, demonstrating an almost cynical mistrust of the motivations of the project instigators. Notice too how he disassociates himself from this resistant group (he uses the third person 'them').

The following student notes that certain practices in school art, different genres, require different conceptual frameworks and methods: life drawing is a vehicle for developing mimetic skills of representation, whereas imaginative briefs require both personal and inventive responses and do not depend on perceptual criteria for assessment.

(What do you think are the critical, the main skills to know in art lessons?)

1/good: [long pause] I think that's a difficult question because [pause] it's really just to draw exactly what you see normally, if you're doing life drawing. If you're making something up then you do exactly what you think. I don't know. Like I said, there are all these different types of art now, so you can just kind of do anything and say it is 'art', so it doesn't matter anyway.

However, in her closing remarks she acknowledges that the contemporary art that she has been introduced to in the project puts into question these very same criteria, that such practice is potentially devoid of skill.

Making sense of something new through existing frames of knowledge

The process of contextualisation and the intertextuality of the references students deploy make it evident that they often achieve this skill by comparing the new phenomenon to existing frames of knowledge. In the example below, the student relates the animation he was intent on producing (and the absurd incongruities and juxtaposition of scale that he had been advised to use) to a genre of film exemplified by a recent remake of a classic movie.

4/resistant: Mostly, kind of what you see in old movies like King Kong, or something where you have those little buildings and this giant thing. In these days when you look at it you know it's not real, cause then people used to think it's like a big giant; so it's kind of recreating something like that. You just put an animal that you don't really see it. You see an elephant in the middle of London.

The foregrounding of multimodal processes employed by contemporary artists, as well as their preference for conceptual practices, can be a barrier to people who expect visual forms of semiosis to be privileged in art, particularly the genre of mimetic pictorialism exemplified by traditional painting and photography. In the statement below the student makes reference to gesture as a semiotic process, one that s/he is already adept at reading through the medium of film. Thus the performative element that she not only witnessed but participated in through Critical Minds, is acceptable to her because she recognises this type of communicative act as a valid form of popular expression.

> 2/live-wire: Well, like, if you look at a piece of art or whatever, it's 'oh yeah, yeah, that's art', then someone says to you 'why is it art?' or 'what do you like about it?' And if you just said: 'this is a piece of art', they wouldn't understand why you liked it and, if you liked it or you didn't like it, what you thought of it. Because... the use of words... you know in a film... is like the use of body language, how that shows, represents something. So you have to describe it and use language to show you understand what's going on.

Reflection/Evaluation (Level 2)

Throughout schooling students are subjected to a regime of assessment through which their 'progress' or 'development' is measured against normative criteria enshrined as 'standards'. As has been suggested, the whole premise of Critical Minds, like any action research, is that something needs to change. The discursive and collaborative programmes of the Critical Minds projects were designed to demonstrate how engaging with contemporary practices might question and challenge orthodoxies in school, where making and insularity characterise practice. On numerous occasions students were invited to discuss artwork, their own and others, and in some instances to consider their own learning. This officially sanctioned reflection took the form more of an evaluation (seeking the value of some phenomenon) rather than an assessment (measuring some phenomenon in relation to agreed criteria). As is evident from the comments below many students were surprised by what they perceived as the openness of contemporary art, the lack of right or wrong answers, or indeed the inversion of normal standards.

> 1/resistant: Well it's like [pause] you know, like some people, [pause] they don't do very much but they say it is art. Like, I've seen just a line or just an object, they haven't even done it themselves, but they say it is art. So, like, in this project walking is art because you say it is, or film, or anything. You don't have to be good at art; it doesn't matter.

Three of the 12 student interviewees remained sceptical about aspects of contemporary art, particularly the perceived lack of skill in the way conceptual art is produced. Because the curriculum valorises skill, expressivity and verisimilitude, they found it difficult to understand how the processes of appropriation, re-contextualisation and performance, alluded to in the above statement, could be recognised as forms of expressive, representational action. However, a later statement indicates that the same student was moving towards an understanding of contemporary art, highlighting the importance of sustaining engagement with such practices.

The artists' presence, their credibility as professionals in the field and willingness to engage students in dialogue, was, in some instances, a means to persuade students of the validity of different ways of working. This is evidenced in the way that some students began to use and take ownership of the artists' language:

> 2/resistant: ... before, everything I had to do really, really neat. I used to rub it out and do it neat again, but they [the artists] say in every mistake there's something new or something, yeah? So it looks better with the mistakes. Without the mistakes it's too neat and then it's a bit dead. Like, you know, when you sketch, those lines make it look nice. Those lines that come out, yeah, they make it look lively, without the lines it looks a bit dead, you see?

This taking on of new ideas and practices embedded in the artists' discourse displays the growing respect many of the students developed for the artists and the way they challenged school orthodoxy.

> 4/resistant: The challenging thing about it was that I was trying hard to come up with something very funny. Then I just relaxed and I thought I'd come up with anything. It ended up stifling the flow, stopping me from coming up with something. And then eventually I just relaxed and that's come up (pointing to artwork).

Here the student takes on board metaphors used by the artist to describe the creative process and locates them within his own practice demonstrating a growing awareness of the conditions under which he is able to work and a sense of himself as a learner. However, other students are more circumspect:

> 4/resistant: I am not sure the thing changed how I thought or did anything like that. I think, I don't know actually. Maybe it hadn't changed me at all. It was me then, and it's still me now; subdued or not subdued. I am not quite sure; a bit confusing.

Elsewhere this student suggested that the project had enabled him to work to his own strengths. However, he anticipated that the normalising regime of the classroom would mean that the difference the project had promised would not be maintained and he sensed that he might not have the power himself to sustain it. This leaves him here feeling somewhat disappointed and highlights the need for follow up.

Both the students cited below reflect on the degree to which they felt they had ownership of the project. Both are concerned with the authenticity of their experience: the first in relation to the way the experience is communicated to others through exhibition and the second in relation to the potential of a pedagogic situation to enable a sort of raptness.

> 2/live-wire: I think the only way they're [audience to exhibition] going to see it [students' investigations/making] is through the photos, they won't actually be able to experience it, which is why we wanted to take control of our art, arranging our photos, and make it into a piece so that people might be able to actually experience what we learnt through the project.

> 1/resistant: Every time I do art I've been thinking if the circle is perfect or stuff like that. But when I stop thinking about that and when I'm drawing, I let like my mind and my body become like a tool in my art, right? Okay, this is as basic and plain as it is. When I'm drawing I concentrate on only what I'm supposed to be doing. My mind is focused on it and you just, you just don't think about making mistakes. If you do make mistakes gradually and gradually the next time you draw, you'll change that mistakes.

This student realises that making can be a totally absorbing, mental and somatic process in which the regulating function of the ego is suppressed in favour of semi-automatic, unconscious processes. She notes that a concern for correctness gives way to a holistic, syncretistic approach (Ehrenzweig 1967). However, in the final sentence she also indicates that she understands how learning can be incremental, that in reflecting on her work she is able to learn from 'mistakes' and effect change, an activity that occurs after or perhaps during her making and that corresponds to Donald Schon's notion of 'reflection in action' (1987), an idea that characterises how analytical processes can be reconciled with intuitive and creative ones (Prentice 2000).

Meaning making as a social process (level 3)

The individualistic, expressive paradigm of school art, complementing the perceptual/mimetic model, limits the extent to which students conceive collaboration as either feasible or ethical and also encourages them to neglect the idea of audience. This inward, solipsistic orientation negates any consideration of the ways in which art is viewed, interpreted and disseminated as a discourse, so that students' expressive work is presented as a closed declaration rather than a communicative statement or open question. Because most of the artists working on Critical Minds value socially engaged practices, audience participation and collaboration figured prominently in their discussions. It is particularly notable how some students began to engage with these ideas and take into consideration the ways in which audiences might be encouraged to interact with their work. In this first statement, the interaction is not an afterthought but an integral part of the conception of the work. In this respect students can be said to be re-fashioning the tradition of school art to accommodate the socially engaged practices of participation and 'undecidability' (here, troubling the public/private dichotomy).

> 4/enthusiastic: We wanted people to think what could be inside a house. Because our idea was to be, a thinking house... would be private... We could stick on the walls things we liked and no one else could see this. We knew it was our private little area. But we wanted people to think 'what was inside there?' What could there be? What are their private thoughts? ... We were gonna get a little post box and people could put in the post box what they thought was in the house.

In the following statement a resistant student articulates an understanding of the work of Francis Alys (a contemporary artist whose video installations they had visited) in terms of process rather than outcome, a way of working in interaction with a local environment that she recognises as a resource to be adapted and used for meaning making.

> 1/resistant: He [Francis Alys] does like lots of walks and videos them, but he uses like rules and things that tell him how to go and where to walk...He maps out like walks that he takes and he uses either string, or a map and he marks out and he walks, like he has a certain pattern to his walk, so like he'll stay on the left side of the road, or like he'll walk and when he reaches a bridge he'll cross the bridge and keep walking, things like that... That's what we did. We all like had our own routes and ways to walk and then it was videoed, but we linked up as well, like when we met other people walking, so they changed our walk.

She also recognises here, that although the film she made with her peers in collaboration with the Critical Minds artist is somewhat imitative of Alys, it is, nonetheless, an appropriation of a way of thinking and mode of practice (establishing rules etc.) that affords them the opportunity to express something about their subject positions within the school environment. The work they saw by Alys suggested how everyday street paraphernalia can be utilised to construct an alternative soundscape, a sign of resistance to regulated behaviours (he taps objects as he passes them). In response, the students developed rules to condition the trajectory of their walk which took them to peripheral parts of the school grounds, territory about which they feel some ownership. At this significant moment they signal this sense of ownership by setting up a barrier between themselves and viewers who are positioned on the other side of the school railings. This marks a hiatus in an otherwise regimented performance before they eventually return to the predictable constraints of the school corridors.

Transformations

In this section students describe transformations in their attitudes and practices as a result of Critical Minds, sometimes providing an explanation about the source or trigger for change. The categories are not comprehensive but signal the most frequently mentioned changes. They relate strongly to the earlier sections but are included here because of the strength of the assertions; as such we leave them to speak for themselves.

Attitudes/values

> 2/disengaged: It's actually made me enjoy art more... I wasn't interested in art before at all and now I'm actually starting to do my work, and even in the art gallery, I started to do my work and Miss was actually shocked! It is quite good.

> 2/live-wire: I learnt to, like, just to make things without always being too concerned with the final thing, like having the freedom to try out things or to change your mind, like, as you do stuff.

Behaviour
2/good: ...when I used to work under pressure I used to get all like 'agggh this is going to fall apart!' I used to get so angry, but now I've learned to control myself because I know that if I have a clear mind whilst I'm under pressure something good will come out of it, which is good.

Confidence
4/resistant: I wouldn't say I'm better. It's only up here it's changed (pointing at his head)...

(Do you think you're more confident now in your art practice?)

Yeah... I don't ask for help that much. I have improved

(What do you think helped you be more confident?)

I think because of the boldness of this idea and everything that happened... The big imaginative things that we did and ideas and stuff.

3/good: I think what was new for me, is that I discovered a side of me, like in art, I thought like cos I'm not a good drawer and when it comes to doing art I thought 'oh no I just have to draw' but it was just a new thing like you get to do whatever you want like with paint and you like get to help other people but usually I'm just sitting there drawing and I just get a little bit confused and a bit agitated.

Information/skills acquisition
2/good: Also, I can speak about art more, like with the presentation. I like English so, yeah, I could write something to describe it. But more like [the artists] helped us to see other stuff in a work, so now I can say what things mean.

1/good: I gained a lot more information about what type of art she does [the artist] and about how you make a film...

Re-definitions
1/resistant: I think I learnt that art doesn't just have to be like drawing and painting, it can be lots of other things... Well, video and just everyday things. Walking can be art and just pointing a video camera, anything you film can be called 'art.'

3/unfathomable: I liked it because I realised that art is more than just a piece of like pictures and stuff that there is more to it, there can be videos, mail artists, loads of stuff.

4/good: Art is everything around us. Everything and anything is art. This is art, if you photograph it and put it on the video. Yeah.

4/enthusiastic: When a little group of us was looking through these books. We actually see things that art can be about. We actually discussed: it can be about the human body, a sticker on the table... anything.

Thinking other
2/disengaged: They [the artists] really make you think of other, just like beyond the painting, just not like it's a normal painting, but it's actually more than just a painting... They just tell you to think further, that's all they do, not much. Then you do actually do it and then realise what it is about.

4/good: It gives you another, like, way of looking at art. Or even if you haven't thought about art, it enhances your vision of art. So yeah...cool.

Conclusion: Partnerships and Collaboration

Critical Minds has demonstrated that conditions for enabling learning in the gallery context can be enhanced by collaborative partnerships between professionals from different institutions and fields. In particular, our research identifies that students have used critical skills throughout the project and that these were developed and extended due to changes in practice: interventions by artists, relocating sites for learning, collaborative activities, reflective practice. We argue that what is distinctive about Critical Minds revolves around the combination of intervention and collaboration, principles that are recognised as central to the idea of communities of practice (Lave and Wenger 1991). These communities are sites of shared experience that enable members to develop as critical thinkers through mutual engagement in common activities. In this section we draw on comments from all participants to highlight the way these principles are embedded within the project, albeit that both 'engaged pedagogy' and 'communities of practice' were not explicitly articulated as a theoretical framework for practice.

Communities, collaboration, mutuality
The social organisation of pedagogy is of particular significance to the ways in which learning can be developed within specific communities of practice. Through collaboration, Critical Minds set up a new possibility for a pedagogy situated somewhere between and across the school and the art gallery, an

in-between space extending both the role of gallery education and its sphere of influence. This role was first established in the 1970s and has continued to change in response to educational research and the new critical approaches demanded by developments in contemporary art practice. As we have noted, the Whitechapel Gallery, lead gallery in Critical Minds, was one of the first art galleries to employ an education officer, promoting the importance of a critical practice that is both socially engaged and located in contemporary practice. Social engagement relates to Bell Hooks' theory of 'engaged pedagogy' in which experiential and reflexive practice is fundamental to the development of a mutually supportive learning community, one that 'recognises each classroom as different, that strategies must constantly be changed, invented, re-conceptualised to address each new teaching experience' (Hooks 1994: 10). Her approach to pedagogy avoids authoritarian teacher-student models whilst recognising that the teacher/educator still has a responsibility to 'orchestrate' the learning; an approach based upon a commitment to continual shared investigation. Therefore, in communities of learning, relations are about 'we' and 'us' rather than 'me', 'you', 'them'.

2/gallery educator: [The] philosophy of everybody buying into something because they're interested in it and because they're interested in the people working in it, and they're feeling like they're getting something from it and that we learn from each other, has been really fundamental in keeping the momentum going throughout the eighteen months, which is a long project.

2/artist: ...the whole thing was so collaborative. I mean, a lot of it, I guess you could say, was the two artists and the art teacher working together... we all developed the lesson plans and we all developed where the day is going to go and we all worked on problem resolution together, and battled time restrictions.

3/good: I think it is all good now because everyone is trying to blend in with everyone else, trying to help you and that.

Participants from each of the constituencies in Critical Minds recognised this mutuality as beneficial to learning and for teachers and students in particular that mutuality signals relations that are different to the norm. With respect to teachers, classrooms can be demanding, densely populated, complex social environments and, although under constant scrutiny, they remain psychologically 'alone'. Watkins (2005) points out, 'If you examine images, prints, paintings and photographs of classrooms over the centuries, you will readily list observable similarities – classroom walls, rows of pupils, status, gender and power... a social distance between pupils and teachers'(p.8). Over recent years this distance has been exacerbated by distant policy makers who prescribe strategies for improvement in ways which do not always afford with teachers' professional vision, reducing their agency as well as their morale (Ball 2001).

Chart 8: Importance of skill ■ working with others

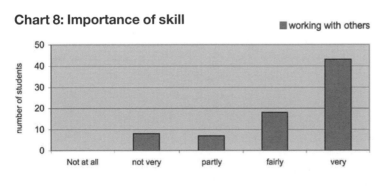

Chart 9: Developed skill ■ working with others

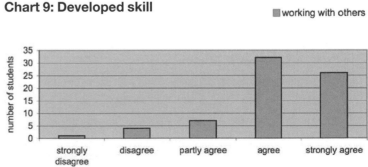

For students, the opportunity to work together was greatly appreciated. In their exit questionnaires they were asked to rate various skills in terms of how important they pereceived them to be within art and design. Chart 8, previous page, illustrates that the students reported working with others to be an important skill (43 students, or 54.4% of all students, felt it was a 'very important' skill, whilst 18, 22.8% of all students, thought it was 'fairly important').

Students were also asked to rate the extent to which the project had enabled them to develop skills in a range of areas. In consideration of working with others, the majority of students 'agreed' that they had been enabled to develop skills in this area (32 students, or 40.5% of all students). An additional 26 students 'strongly agreed' with this statement (32.9% of all students). The ability to work with others was one of the main skills that students felt they had developed as a result of taking part in this project.

Classrooms are not islands but are influenced by the ethos and culture of the school – two out of four schools participating are designated community schools.

Recognising learning as a dialogic, social process
Notions of constructivist and co-constructivist learning have been the focus of educational research in schools, galleries and museums for many years (Bruner 1977; Goodman 1984; Gergen 1985; Dierking 1996; Hein 2001; Watkins 2005). In Constructivist theory, the learner is recognised as a knowledgeable resource, a person who brings to every learning situation her or his understandings of the world. In this way, learning is conceived as a process of adaptation in which the learner's view of the world is constantly modified by new information and experience.

3/good: But then I just learned that instead of doing paintings all by yourself, you can just like express yourself with different people like working together.

(Do you think that you've learned anything from this project that you'll use in your art lessons?)

1/resistant: Um, yeah, I'd say working as a group to form art, and yeah, taking in other people's ideas, as well, to use.

Building on constructivist theory, co-constructivism emphasises that such learning is necessarily a social process in which language and dialogue are primary (Watkins 2005). These dialogues take place between individuals who are socially situated within historically and culturally specific learning environments.

2/disengaged: Say we're doing us and everything in our project, yeah, it's basically about what's in London and what's connected to us and everything.

In both formal and informal pedagogic situations the values accruing to these environments enact particular power relations, and for co-constructivists they have to be acknowledged before any mutuality can be developed.

2/artist: One of the things I like about these groups is that they were groups. They were really not led by one girl and everyone sort of kowtowing to the dowager queen. They worked together and they argued the points and they talked about the materials to be used and not used and why, and worked as groups

Chart 10: Importance of skill

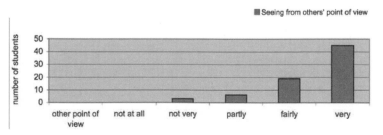

Chart 11: Developed skill

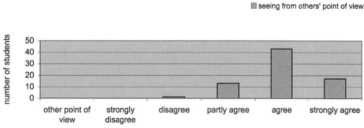

2/gallery educator: ... people get the opportunity to actually speak to different people and have different perspectives, and actually talk through their ideas, talk aloud... It wasn't there at the start. It was definitely a progressive process. I mean, I don't actually think it started really, really properly until we were actually concentrated working in the gallery and at that time that was that point where I thought the girls were having really serious transformation, and that was the point where they were working in their groups, they were very definitely learning from each other, they were really talking about what they were doing and if you walked around the room and listened to them I was absolutely amazed that none of them was off task at all. They were so focused on actually talking about why they were doing things and what they were using.

Dialogue and collaborative work are rarely seen in art and design, for, as we have suggested, pedagogic aims in the subject tend to valorise individual expression. Ironically, teachers realise these aims by directing students to reproduce stock signs of difference. In secondary schools, research has repeatedly shown that pedagogic power relations are predicated on the reproductive role of schooling (Bourdieu and Passerson 1970; Bernstein 2000) and in this scenario the teacher's task is to reinforce and perpetuate dominant cultural and social values so that they come to appear natural and inevitable (mutuality does not figure as an important principle in traditional pedagogies). In modernism, artists represent the antithesis of these normative values and it might be supposed that their interventions would disrupt and possibly contest the status quo (Taylor 1989). However, in the Critical Minds action research teams, although distinctive roles were retained, oppositional positions were rejected in favour of negotiated ones.

2/artist 1: You have to be willing to not only collaborate but to compromise and to give up on every great idea being included. That's just not going to happen, but you subjugate to the greater good so you can create a seamless whole. That definitely could not have happened with the groups if they were not working together, working on problem resolution, being willing to say 'alright I think this is a great idea but the group as a whole want to go in a different direction, then I'll deal with that.' It's very mature... and it shows they did learn a number of the really salient lessons we were trying to get across.

This move towards negotiated decision-making led to increasing student collaboration and a realisation that the ideas of others are a valuable resource for learning. By engaging with different points of view students recognised that their own learning can be enriched and expanded, a process that builds an empathetic learning environment.

Empathy

Students were asked to rate how important they thought it was to display empathy, or 'be able to see things from others' point of view' within art and design. Only 3 students felt this skill was 'not very' important. More commonly, students felt it was 'very important' (given by 45 students, or 57% of all students) or 'fairly important' (given by 19 students, or 24% of all students).

On completion of the project, students were asked to rate the extent to which the project had enabled them to develop empathetic skills. Chart 11 shows that only one student felt they did not develop skills that enabled them to see from others' point of view. 17 students (21.5% of all students) 'strongly agreed' that they had developed empathetic skills, while a further 43 students (54.4% of all students)'agreed' they had also developed skills in this area.

Time

2/good: You have to attend every lesson because if you miss one lesson you're like behind and you need full hours to do all the stuff. You have to be determined and you have to be dedicated to your work. You have to have a clear mind and be able to work under pressure because we did have to in a matter of two days. But afterwards it's something to be proud of, what you've done in that short matter of time.

The fragmented nature of the school curriculum (on average art teachers only see KS3 pupils for 55 minutes each week) is often cited as the reason why teachers find it difficult to establish continuity and build constructive relations with students.

2/disengaged: It was a bit hard because you sort of forget what you did last lesson.

Such conditions are exacerbated in interventionist projects where 'strangers' enter an environment in which time is restricted and has to be necessarily condensed.

2/artist 1: I think it worked really quite well. My only frustration was not having enough time with the girls and that was one of our big issues, certainly, both for me and for [artist 2]... One of the things we did a lot of wrestling with in our group to actually resolve, [was] we came up with taking the four sessions combined into the two days... which was really, really productive.

In those projects where sessions were organised in blocks of time, the action researchers noted their ability to develop constructive relations with students and colleagues. In this sustained environment the action research teams were able to plan a series of sequenced activities moving between discursive, investigative, creative and collaborative practices. This afforded students the opportunity to come to know one another through common endeavours.

Through their research into practices that have been part of the tradition of informal education, Lave and Wenger (1991) have developed an understanding of how communities of practice are developed and sustained. They explain that for a community of practice to function it needs to generate and engender a shared repertoire of ideas, commitments and memories and that it takes time for a shared sense of joint enterprise and identity to develop. As Hein (2001) insists, co-constructive pedagogy cannot be expected to take place on a three-hour visit to the gallery.

There is a danger that projects such as Critical Minds serve to reinforce normative relations because they act as a one-off bubble where they are perceived as limited outsider interventions. Alan Kaprow (in Lacy 1995) warns of this effect when he claims:

'Almost anyone will seem to flower if unusual attention is paid to them. It's what happens over the long term that matters. Rephrasing the question to What happened to the kids after they left us?" probably must be answered: "They returned to the way they were." And so, if sustained instruction and growth are necessary for lasting value, as I believe they are, the whole thing was an educational diversion. At best, they were entertained.' (p. 156)

3/artist: One problem is that we didn't get a chance to contexualise the project within the school. I was chatting at break and I asked one of the really able students 'are you going to take art next year?' She said 'No'. I said 'Why not?

That's a shame'. She said 'Because I don't like drawing and painting.' And I said 'But, but, but, but what have you been doing !!!!' She said 'Ohhhh'. Is the workshop a bubble? Could this be art in school?

There is then a need not only to sustain partnerships, but to ensure that the wider school community are aware of the project, that management gives its support and that what is learned from the project is revisited, developed and embedded in the curriculum.

3/gallery educator: What was evident was that I needed to have a relationship with the rest of the staff and Head because I was unable to do anything about it... I hadn't met the Head of Art, hadn't spoken to him... I should have insisted from the start, I should have met with the Head and Head of Art. (14.2.06)

1/teacher: I am going to have to then take it to the rest of the department in some sort of format where they can actually start putting some of this stuff into their classrooms because if they don't, for our school, then we've actually not developed at all. It needs to be developed for the rest of the team. There are four other art teachers who need to know what I've learned. (21.2.05)

Space

Spatial metaphors are often used to define pedagogic relations: 'open', 'situated', 'zone', 'scaffolding', 'border-crossing'. Despite this, the physical spaces in which teaching takes place in schools are rarely considered as a significant aspect of learning. This often results in the replication of hierarchised spaces predicated on power relations which are not conducive to collaborative or socially engaged practices. Outside the logocentric curriculum pedagogic spaces do differ, from the drama studio to the sports field, but these spaces are also predicated on ancient disciplinary structures that locate the body in regimented and predictable ways. This sense of routine and entrapment is well expressed in the following statements:

1/resistant: For future teachers, all I want to say for future teachers is that whenever you first have a child come up to you and say that they're bored about the art, right? ...Don't coop them up in the classroom with long debating about what you're going to do. Take them somewhere like the theatre, give them cameras, let them go around and take

pictures of like basically, if you're going to do something about wildlife, then wildlife pictures. If you're going to do something about the school, then school pictures.

2/good: No, I just think that doing this it's nice to get feedback from other people and to go out of school and explore, because being cooped up in a classroom you don't really learn that much but if you get to use different stuff and meet different people it will help you improve your abilities more.

2/live-wire: I don't like art galleries because I don't like being closed in, in small spaces for a long time.

Critical Minds set up the possibility of an in-between space where students were encouraged to acknowledge their journey to and from the institutional sites of the project. Additionally, fieldwork within community spaces was utilised for a number of sessions.

What was also noticeable was the way the institutional spaces themselves could be reconfigured to alter perceptions and possible ways of working.

4/good: We did... put ideas on paper on how we wanted to change the room. And I thought that's kind of... cause we get our own views and see how they come out on paper. But we didn't actually do it. It was fun just to think about it.

Although the potential of the exercise was not realised in this instance, it was evident in this session that students were able to reflect on the ways different spaces condition their learning and that through processes of mapping and reconfiguration they can inform adults about what works for them. This exercise also demonstrates how visual practices can be propositional and predictive, attributes normally associated with language.

Recommendations

For artist/gallery/school partnerships

Conditions for learning

1. Deploy socially engaged artists as interventionists to challenge limiting and normative pedagogic patterns and encourage participants to think differently.

2. Use external spaces as sites for learning (e.g. the contemporary art gallery, its communities and environs) to encourage students and teachers to reconsider and re-conceptualise the process of learning.

3. Develop communities of learning to:
 a. break away from the notion of the artist as an isolated creator,
 b. encourage dialogical practices to enable collaboration and mutuality,
 c. within the collaborative/facilitative paradigm, sustain the role of adults as experts within and across disciplines (students appreciate the knowledgeable support of adults as a means to develop peer-cooperation and autonomy).

4. Collaborative projects require time to enable:
 a. planning,
 b. implementation: those projects that were taught in blocks of time, i.e. two – four consecutive days, enabled both more sustained participation and deeper learning (student immersion, absorption, reflexivity),
 c. reflection and revision,
 d. dissemination.

5. Sustain partnerships to ensure continuity and to embed benefits structurally within the curriculum.

6. Maintain equitable communications between all participants – recognising the importance of the gallery educator as broker: facilitator, mediator, negotiator, administrator/manager.

7. Target KS3 students as a way to intervene within and potentially change limiting orthodoxies.

8. Provide opportunities for student motivation and ownership through:
 a. acknowledging and valuing student 'voices',
 b. differentiating activities in recognition of students' preferred ways of learning and lived experience,
 c. allowing students to participate in public exhibitions of their work, e.g. as curators: selecting, organising and displaying work.

9. Value collaborative projects as a productive form of CPD: acknowledge that participation by NQTs within experienced teams can contribute positively to their Induction Programme.

Developing critical thinking

Provide opportunities for students to:

1. work discursively, enabling them to:
 • be alert, attentive and listen to others,
 • consider different points of view,
 • analyse and debate opinions,
 • participate in collective meaning making,
 • acknowledge consensus and diversity.

2. evaluate their own learning discursively and in writing (Students' learning and understanding of learning is not dependent on their ability to explicate that learning. However, the interview process demonstrated that students who had been labelled as resistant etc. were, given an opportunity, adept at articulating such understandings).

3. use writing not only as an evaluative and explanatory tool (as in the annotation of sketchbooks) but as an investigative and creative tool (analysis and metaphor).

4. pose problems as well as solve them.

5. view and engage with contemporary art in galleries (many note how their learning is enabled and enhanced through first-hand experience of works of art rather than reproductions) and interpret artworks with artists and in relation to contexts.

6. participate in socially engaged artists' interventions as an alternative to normative and orthodox school/gallery practices so as to encourage students to questions expectations, assumptions and prejudices.

On research methods

a) Action research

1. Ensure participation by all researchers (i.e. at least participant observation) so that planning and research design are mutually informing, collective and negotiated processes.

2. All participants (art teachers, artists, gallery educators, researchers) should be given the opportunity to attend continuing professional development.

3. Participation provides:
 a) teachers with the opportunity to reflect on practice; develop alternative perspectives on learning; break the cycle of isolation they often experience in the classroom,
 b) artists with the opportunity to work within, around and beyond the constraints of school curricula and regimes,
 c) gallery educators the opportunity to build networks of educators from different sectors; to share and develop educational provision and strategies with each other to form local, regional and national partnerships.

b) For future research

In the context of working with gallery education and contemporary art/artists:

1. understand how critical thinking can be evidenced in making practices (as multimodal processes),

2. identify how particular spaces condition certain forms of pedagogic practice,

3. examine how collaborative and dialogical practices provide students with ownership and agency.

Bibliography

Abbs, P. (ed.) (1987) *Living Powers: the arts and education.* London: Falmer Press.

Addison, N.; Asbury, M.; Chittenden, T.; De Souza, P.; Georgaki, M.; Hulks, D.; Papazafiriou, G.; Perret, C.; Trowell, J. (2003) *Art Critics and Art Historians in Schools: A Synoptic Report of an Interdisciplinary Research Project.* London: Institute of Education.

Allison, B. (1972) *Art Education and Teaching about Arts of Africa, Asia and Latin America.* The Voluntary Committee for Overseas Aid and Development.

Atkinson, D. (2002) *Art in Education: Identity and Practice.* Dordrecht, Boston, London: Kluwer Academic Publishers.

Ball, S. (2001) 'Better read: theorizing the teacher'. In: J. Dillon and M. Maguire (eds) *Becoming a teacher in Secondary School.* OU Press.

Barker, C. and Galasinski, D. (2001) *Cultural Studies and Discourse Analysis: a dialogue on language and identity.* London: Sage.

Barnett, R. (1997) *Higher Education: A Critical Business.* Buckingham: SRHE and Open University Press.

Benson, B. (1997) *Scaffolding.* (http://www.galileo.peachnet. edu/ accessed on 8 May 2006).

BERA (2004) *Revised Ethical Guidelines for Educational Research* Southwell: BERA

Bernstein, B. (2000) *Pedagogy, Symbolic Control and Identity.* Oxford: Rowan and Littlefield.

Bourdieu, P. (1984) *Distinction: A Social Critique of the Judgement of Taste.* London: Routledge and Kegan Paul Ltd.

Bourdieu, P. and Passeron, J-C. (1970) *Reproduction in Education, Society and Culture.* Trans R. Nice, London: Sage.

Bruner, J. (1960) (1977 edition) *The Process of Education.* Cambridge, MA and London: Harvard University Press.

Buckingham, D. (2005) *Schooling the Digital Generation: popular culture, the new media and the future of education.* London: Institute of Education, University of London.

Burgess, L. (2003) 'Monsters in the Playground'. In: N. Addison and L. Burgess (eds) *Issues in Art and Design Teaching.* London: Routledge, Falmer.

Burgess, L. and Addison, N. (2004) 'Contemporary Art: Why Bother?'. In: R. Hickman (ed.) *Meanings, Purpose and Directions.* London: Cassell.

Carrington, S. and Hope, S. (2004) *A report on the Whitechapel Art Gallery's artist-in-school residency project, 2002-04.* London: Whitechapel Art Gallery.

Croce, B. (1901) *The aesthetic as the science of expression and of the linguistic in general.* Trans. C. Lyas. Cambridge; New York: Cambridge University Press.

Davies, T. (1995) *Playing the System.* Birmingham: UCE.

Dawe-Lane, L. (1995) 'Using Contemporary Art'. In: R. Prentice (ed.) *Teaching art and design: addressing issues and identifying directions.* London: Cassell.

Dawtrey, L., Jackson, T., Masterson, M., Meecham, P. (eds) (1996) *Critical Studies and Modern Art.* Milton Keynes: Open University Press.

DCMS, (2000) *Centres for Social change: Museums, Galleries and Archives for all.* London: DCMS.

DCMS, (2001) *Culture and Creativity: The next ten years.* London: DCMS.

DFE (1991) *National Curriculum Art Order.* London: HMSO.

DfEE (1999) *The National Curriculum: Handbook for Secondary Teachers in England KS3 and KS4.* London: HMSO.

Dierking, L. (1996) 'Contemporary theories of learning', Group for Education in Museums. *Developing Museum Exhibitions for Lifelong Learning.* London: The Stationery Office.

Downing, D. and Watson, R. (2004) *School Art: what's in it?: exploring visual arts in secondary schools.* Slough: NFER.

Dubuffet, J. (1948) In: C. Harrison and P. Wood (eds) (1992) *Art in Theory 1900-1990.* Oxford: Blackwell.

Edexcel (2003) 'Specification for GCSE Art & Design', accessed 8 May 2006 www.edexcel.org.uk/quals/gcse/art/gcse/1027/

Eisner, E. (1972) *Educating Artistic Vision.* New York: Macmillan.

Ehrenzweig, A. (1967) *The Hidden Order of Art.* 1993 edition London: Weidenfeld and Nicolson.

Fairclough, N. and Wodak, R. (1997) 'Critical Discourse Analysis'. In: Teun Van Dijk (ed.) *Dis-course as Social Interaction. A Multidisciplinary Introduction Vol 2.* London, 258-284

Field, D. (1970) *Change in Art Education.* New York: Routledge and Kegan Paul and Humanities Press.

Freire, P. (1990) *Pedagogy of the Oppressed.* New York: Continuum.

Fry, R. (1909) 'An Essay in Aesthetics'. In: F. Frascina and C. Harrison (eds) (1982) *Art and Modernism.* London: Paul Chapman in association with Open University Press.

Gergen, K. (1985) 'The Social Constructivist Movement in Social Psychology', *American Psychology* 40: 266-275.

Goodman, N. (1984) *Of Mind and Other Matters.* Cambridge, Mass.; London: Harvard University Press.

Harding, A. (ed.) (2005) *Magic Moments: collaboration between artists and young people.* London: Black Dog Publishing.

Hargreaves, D. H. (1983) 'The Teaching of Art and the Art of Teaching: towards an alternative view of aesthetic learning'. In: M. Hammersley and A. Hargreaves (eds) *Curriculum Practice.* London: Falmer.

Hein, G. (2001) '*The Museum and How People Learn*' paper given at CECA (International committee of museum educators) Jerusalem 15 Oct.

hooks, b. (1994) *Teaching to Transgress.* London: Routledge.

Hughes, A. (1989) 'The Copy, the Parody and the Pastiche: Observations on Practical Approaches to Critical Studies'. In: D. Thistlewood (ed.) *Critical Studies in Art and Design Education.* Burnt Mill, Harlow: Longman.

Hughes, A. (1998) 'Reconceptualising the art curriculum', *International Journal of Art & Design Education,* 17 (1). Oxford: Blackwell Publishing.

Kandinsky, W. (1911) (edition 1977) *Concerning the Spiritual in Art.* New York: Dover Publications; London: Constable.

Kress, G. and Leeuwen, T. (2001) *Multimodal Discourses.* London: Arnold.

Kyriacou, C. (2001) *Effective Teaching in Schools.* Nelson Thornes.

Lave, J. and Wenger, E. (1991) *Situated Learning: legitimate peripheral participation.* Cambridge: Cambridge University Press.

Lacy, S. (ed.) (1995) *Mapping the Terrain: New Genre Public Art.* Seattle: Bay Press.

Lynton, N. (1992) 'Harry Thubron: Teacher and Artist' In: D. Thistlewood (ed.) *Histories of Art and Design Education.* Burnt Mill, Harlow: Longman.

Mason, R. (2005) 'The meaning and value of home-based craft', *International Journal of Art & Design Education,* 24 (3). Oxford: Blackwell Publishing.

McRobbie, A. (2000) (2nd Edition) *Feminism and Youth Culture.* Basingstoke: Macmillan.

MLA (2004) *Inspiring Learning for All.* www.inspiringlearningforall. gov.uk

Morris, W. (1883) 'Art under Plutocracy'. In: G. Zabel (ed.) (1993) *Art and Society: Lectures and Essays by William Morris.* Boston: Georgeís Hill.

NACCCE (1999) *All Our Futures: Creativity, Culture and Education.* The report from the National Advisory Committee on Creative and Cultural Education. London: DfEE.

Ofsted, HMI 1986 (2004) *Ofsted Subject Reports 2002/3:* Art and design in Secondary Schools. London: Ofsted.

Paley, N. (1994) *Finding Art's Place.* London and New York: Routledge.

Prentice, R. (2000) 'Making connections between subject knowledge and pedagogy: the role of workshops'. In: N. Addison and L. Burgess (eds) *Learning to Teach Art and Design in the Secondary School.* London; New York: Routledge.

QCA (1998) 'A Survey of Artists, Craftspeople and Designers Used in Teaching Art Research.' In: *Analysis of Educational Resources in 1997/98, research coordinated by Clements, R.* (1996-97) CENSAPE: University of Plymouth.

Read, H. (1943) *Education Through Art.* London: Faber and Faber.

Richardson, M. (1948) *Art and the Child.* London: London University Press.

Ross, M. (1984) *The Aesthetic Impulse.* London: Pergamon Press.

Ruskin, J. (1840-) *The Lamp of Beauty: writings on art by John Ruskin.* This collection (1959). Oxford: Phaidon Press Ltd.

Schon, D. (1987) *Educating the Reflective Practitioner: Towards a New Design for Teaching and Learning in the Professions.* San Francisco: Jossey-Bass.

Schon, D. (1992) 'The Theory of Inquiry: Dewey's Legacy to Education', *Curriculum Inquiry,* 22 (2): 119-139.

Stallabrass, J. (1999) *High Art Lite.* London: Verso.

Steers, J. (2003) 'Art and design in the UK: The theory gap'. In: N. Addison and L. Burgess (eds) *Issues in Art and Design Teaching.* London: Routledge/Falmer.

Taylor, B. (1989) 'Art History in the Classroom: a Plea for Caution'. In: D. Thistlewood *Critical Studies in Art and Design Education.* Burnt Mill, Harlow: Longman.

Taylor, R. (1986) *Educating for Art.* Burnt Mill: Longman.

Thistlewood, D. (1989) *Critical Studies in Art and Design Education.* Burnt Mill, Harlow: Longman.

Trend, D. (1997) 'The Fine Art of Teaching'. In: H. Giroux and P. Shannon (eds) *Education and Cultural Studies: Toward a Performative Practice.* New York; London: Routledge.

Vygotsky, L. S. (1978) *Mind in Society.* Cambridge MA: Harvard University Press.

Watkins, C. (2005) *Classrooms as Learning Communities: What's in it for schools?* London: Routledge.

Willis, P. (1990) *Moving Culture.* London: Calouste Gulbenkian Foundation.

Witkin, R. (1974) *The Intelligence of Feeling.* London: Heinemann.

Wood, L.A. and Kroger, R.O. (2000) *Doing Discourse Analysis: methods for studying action in talk and text.* Thousand Oaks, Calf.; London: Sage.

Wood, D., Bruner, J.S., & Ross, G. (1976) 'The role of tutoring in problem solving', *Journal of Psychology and Psychiatry,* 17.

Websites

About Learning www.demos.co.uk

Benson, B. (1997) Scaffolding. (http://www.galileo.peachnet.edu/ accessed on 8 May 2006).

www.creative-partnerships.com

engage projects: *envision*, www.engage.org/projects/en-vision.aspx and *Collect and Share*, www.collectandshare.eu.com/

MLA (2004) www.inspiringlearningforall.gov.uk

(www.whitechapel.org/content.php?page_id=1905 n.d. retrieved 23.3.06)

SOUTH EAST CLUSTER RESEARCH REPORT

Report on research undertaken by Fabrica, the Towner Art Gallery and the De La Warr Pavilion in collaboration with the Centre for Continuing Education at the Sussex Institute, University of Sussex, and partner artists and teachers.

Final report by Nannette Aldred and Maeve O'Brien, CCE, University of Sussex drawing on work by Maeve O'Brien, Judith Furner, Janet Summerton, Sara Bragg and Mary Stuart (all University of Sussex) in collaboration with Deborah Barker (coordinator), Richard Beales (Towner Museum and Art Gallery), Sajida Fareed (Fabrica), Polly Gifford (De La Warr Pavilion), Natalie Walton (Towner Museum and Art Gallery), Liz Whitehead (Fabrica).

Contents

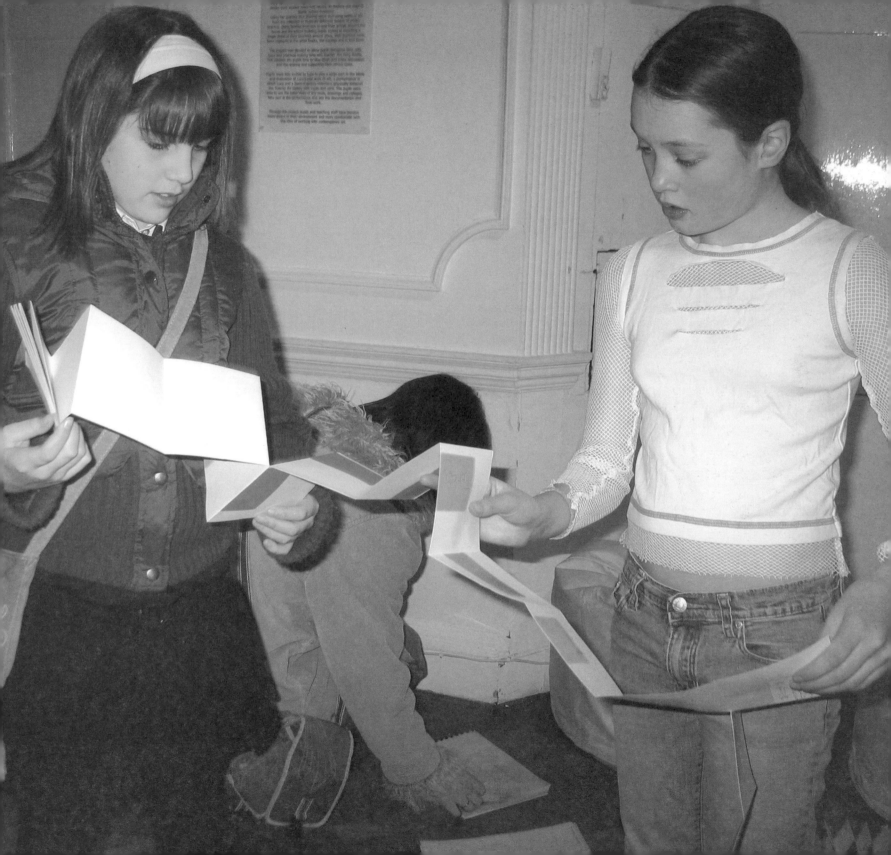

Preface

The organisations in the South East cluster that undertook educational activities funded by the *enquire* programme were:

- De La Warr Pavilion, Bexhill: a centre for contemporary arts with a range of activities that provided an opportunity to explore the relations between art forms;

- Fabrica, Brighton: a commissioning gallery promoting access to contemporary practice;

- Towner Museum and Art Gallery, Eastbourne: run by the local authority, the Towner is the only gallery in the cluster with a permanent collection.

The three galleries in the South East worked with researchers at the University of Sussex and representatives of *enquire* to devise an action research programme. All the galleries made use of their previous collaboration with local schools and artists and made further contacts where appropriate. Young people worked on projects with artists both in the school and at the gallery.

Theoretical framework for the South East cluster

The key theoretical question for the cluster asks, 'What is the nature of the learning experience that gallery education provides for young people as a result of the collaboration of a gallery educator and an artist?' This question articulated the enquiry that the South East cluster formulated in response to the call for interest in the *enquire* project. Early on, the cluster decided that they needed to engage in useful research about their region, its arts education and its gallery activities in meaningful ways. The relationship with the HEI would enable them to question their work critically and gain evidence of its impact using suitable methodologies; the *enquire* project allowed them to do this. It was also to be a dialogic partnership and the research would be developed between all the interested groups rather than led by the HEI.

enquire brought together educational theorists, cultural and museum studies researchers, art and cultural historians and gallery educators with the aim of developing a common language to devise and evaluate a means of measuring the benefits of gallery education to young people. A major part of the exercise had to reside in the formation of a shared language and common tools of analysis. In the south east we worked through this in round table discussions so that we could have a sense of shared

ownership of the project. Projects were designed by the individual galleries to address the common and specific questions.

Specific research questions

Each gallery devised an additional question arising out of the work they had done whilst establishing research interests during the questioning phase of *enquire* activity (see methodology on page 95 for detailed phasing). This question focused on something that they particularly wanted to address in their activities. The questions would enable each gallery to test out their education policy and activities in terms of their individual projects and young people's groups, whilst providing data for *enquire*.

The three questions were:

- De La Warr Pavilion: How does risk-taking/experimentation contribute to the learning experience through the exchange between artist, teacher and young person?

- Fabrica: Does working with artists in a contemporary art gallery offer a context for young people to find a voice and explore their identity?

- Towner Art Gallery: At which moment does a young person take on the responsibility for his or her own ideas and move the process of development on independently? As well as acknowledging the autonomy of individuals we will also encourage self-determination within teams and the group as a whole.

We consider that underlying all of these are questions of identity and partnership. The first can be addressed by considering the role of culture in the formation of identity and the second can be considered through the management of partnerships but first we will consider current gallery education practice.

Gallery education

At the opening national *enquire* seminar in January 2005, the first time that all the participants came together, it was apparent that a literature review of work on gallery education would be useful for all the participants. This has now been completed but unfortunately not in time for all clusters to agree on a single methodology for collecting and analysing the data during this phase of the project. Emily Pringle's research (1) will be very useful for any continuation of work in this area but it did not inform the original project. Her identification of 'Contemporary

Gallery Education' (CGE) and her account of co-constructivism, active learning and learning communities provide useful models for future work.

Identity

Paul Willis in his work on *Common Culture* (2) (1990) used the notion of 'symbolic creativity' which he argues is crucial to the formation of a self, and argues the significance of culture in forming identities. He was critical of 'high art' and its institutions, whilst arguing fervently for the importance of creativity and what he calls 'grounded aesthetics' in everyday life, especially in the everyday life of young people.

'The institutions and practices, genres and terms of high art are currently categories of exclusion more than inclusion. They have no real connection with most young people or their lives. They may encourage some artistic specialisations but they certainly discourage much wider and more general symbolic creativity... Young people are all the time expressing or attempting to express something about their actual or potential cultural significance.' (p. 206)

He sees some of the problem lying in the emphasis on objects. "Official' art equates aesthetics with artefacts,' (p. 214) whereas for him the significance is in process. This is born out by our findings on the *enquire* project and it is a process that gallery educators and artists bring to signification in their engagement with the ideas of artists and objects in the gallery (see below). He insists that 'imagination is not extra to daily life, something to be supplied from disembodied 'art'. It is part of the necessariness of everyday symbolic and communicative work,' (p. 208). He states that symbolic work, by which he means, 'the application of human capacities to and through, on and with, symbolic resources and raw materials ...to produce meanings,' (p. 207) is 'another kind of humanly necessary work – often unrecognised but equally necessary... to ensure the daily production and reproduction of human existence.'

He is concerned that where public funding and civic responsibilities fail, or when galleries seem exclusive to certain sorts of people with adequate cultural and economic capital, the market always steps in to provide something, but that substitute does not lead to 'cultural emancipation' (p. 214).

'Being human ... means to be creative in the sense of remaking the world for ourselves as we make and find our own place and identity ... Identities do not stand alone above history, beyond history... Memberships of race, class, gender, age and region are not only learned, they're lived and experimented with. ... Symbolic work and especially creativity develop and affirm our active senses of our own vital capacities, the powers of the self and how they might be applied to the cultural world. This is what makes... identity transitive and specifically human.' (p. 209)

Emily Pringle has usefully charted the changes in attitude to gallery use and gallery education practice since Willis's (1990) account of the relationship between young people and galleries. However, Willis's analysis is still useful in considering the formation of identity and its relation with symbolic creativity and forms part of the learning process in the Generic Learning Outcomes (see pages 95, 99 and 104).

Looking at the responses from teachers and students, it is also clear that they both have a working investment in their identities being articulated in relation to the other. The artists were able to carve out an identity that was positioned between the student and the teacher; many of the risks that the young people took in relation to their own sense of themselves involved being able to try out new and separate identities (rather than being captured by their school 'labels').

The formal questionnaires also went against the grain of the artists' self-identity; they raised anxieties about including formal activities into their hard-won informal 'spaces' which seemed to raise questions about their identities in relation to those of teachers.

There was some evidence of teachers' anxieties about themselves as art teachers and not being as well informed – especially in current concepts of art – although there is also some evidence of this changing during the project. (See page 99.)

These topics would be appropriate for further analysis.

Collaboration and communities of practice

'Everything you put into it meant more because it was coming from you.' De La Warr Pavilion, 'Utopias' project, November 2005

Interest in the *enquire* programme emerged from pre-existing contact between three galleries based in the south east and was later expanded to include an HEI partner to provide research expertise. This evolution is important because of the tone it set for the research programme as a whole. Action research, the methodology chosen for this research, requires participants to be fully active in all phases of the research programme. This includes devising research instruments, employing these instruments to gather data and collectively analysing these findings to invoke change or produce evidence of activity on which to devise future activity.

For participation at this level to be effective, a project using action research needs to develop relationships amongst the team that recognise each individual's orientation with the project aims as well as individual skills and expertise. The establishment of trust amongst the research partners is largely based upon this initial act of inclusion if one is to avoid participation by command (Kanter 1983). Day and Hadfield (2004) point to the literature review on empirical research on trust by Tschannen-Moran and Hoy (2000) which highlights trust as:

• a means of reducing uncertainty in situations of independence;

• necessary for effective cooperation and communication;

• the foundations for cohesive and productive relationships;

• a lubricant greasing the way for efficient operations when people have confidence in other people's work and deeds (p. 549);

• a means of reducing the complexities of transactions and exchanges more quickly and economically than other means of managing organisational life.

The South East cluster placed an emphasis on respecting the diversity of backgrounds found in the cluster participants and their varying research interests and experience. This variance was present in the matrix of project participants (artists, teachers, gallery educators, young people) and also in the research focus of the University of Sussex researchers (Culture Studies, Arts Management, Education).

Throughout the research process the cluster sought to develop a community of practice that actively devised research techniques through three key phases of questioning, activity and analysis, each phase of activity being informed and guided by the work of the previous phase. This approach is indicative of what Freire (cited in Hein 1998) identifies as critical consciousness, wherein the learning process is active and circumstantial. Research in the cluster captures evidence of learning across the partnership as well as evidence of the unique conditions that gallery education creates for young learners.

Context

The research was undertaken by the Sussex Institute at the University of Sussex. The Sussex Institute comprises the Sussex School of Education, School of Social Work and Social Care and the Centre for Continuing Education (CCE). Sussex Institute claims '[Its research] is united by a common aim to enable positive change in individuals and their societies ... The Sussex Institute is uniquely placed to make a major contribution to the future through the opportunities it provides for interdisciplinary collaboration in both research and teaching relating to issues in the UK and internationally. There is an extensive programme of research across the Institute funded largely through external grants and contributions from the Higher Education Funding Council (HEFCE). There are also a number of regular research activities and events in Sussex Institute, such as the Sussex School of Education Research Seminar Series, the Sussex Institute Research (3) and Research Ethics Workshops (4). Within the Institute, the departments try where possible and appropriate to collaborate on interdisciplinary research (5).

The *enquire* proposal formed just such a topic when it was first mooted and, although there was no one who had undertaken exactly the same sort of work, there was methodological expertise. This took the form of Professor Michael Eraut's work on learning theories including action research; Dr. Janet Summerton's on action research and CPD in the arts and cultural sectors; Pro Vice Chancellor Mary Stuart's paper on *'Participation, Voice and Research: participatory research methods and the arts; developing the voice of participants to develop the research'*; (6) and in Professor Judy Sebba's work in evidence based policy (7). There was also interest from a number of individuals (in education, social work and arts management) and wide support from the Institute and the then Pro Vice Chancellor of the University. Unfortunately, the timescale of the project has meant that we have not been able to draw on those resources as well as we might. In presenting the findings of this research within the Sussex Institute, we intend to develop this

area of research. Within the Institute we also aim to combine theory and practice and will develop gallery education CPD courses drawing on the findings of enquire.

Nannette Aldred teaches visual culture studies in CCE and is particularly interested in education and culture (8) and the relation between art and society, especially as expressed through cultural policy. She has been a trustee of Fabrica since its inception and so, through her roles within both gallery and HEI, operates in the space between cultural theory and practice. She has identified and brought together the various researchers and experts on the project. Maeve O'Brien (9) designed, wrote and evaluated research in the questioning phase of the project, contributed to the design of research tools and their subsequent application in the activity phase and provided analysis on arts management issues for the cluster. Sara Bragg brought her experience in designing questionnaires for young people (10) and Janet Summerton (11) was influential through her work on action learning sets, all of which underpinned the work carried out in the activity phase of the project. The questioning phase aimed to evaluate the appropriateness for the enquire project of the Generic Learning Outcomes as outlined by the Re:source (now Museums, Libraries and Archives Council) paper (12). For part two, Michael Eraut's work with Alderton, J. Cole, G. and Senker, P. on 'The Development of Knowledge and Skills at work' (13) proved useful, as did his talk on learning styles delivered to the enquire joint national seminar in Newcastle. (14)

The South East projects
The descriptions below summarise the activities coordinated by each gallery.

De La Warr Pavilion – Utopia and the Public Space
Through a careful consideration of what Utopia has meant and might mean to us now, the De La Warr chose to examine ideas about the relationship between art and society, explore individual hopes for social change and think critically about the way we are influenced by our built environment. It also aimed to allow participants to try on different identities and imagine what it might be like to be a town planner, an engineer or politician. What would they do if they had the power to make real changes?

The De La Warr Pavilion, in partnership with the Hastings and St Leonard's Excellence Cluster, worked with young people in secondary schools to explore these ideas. The project presented students with opportunities to work beyond the specifics of different curriculum areas. Students worked with a range of artists/creative professionals to develop ideas on the theme of 'Utopia and the Public Space'. A resource box was provided for each project with images, texts and objects to support and stimulate discussion. The project paired six artists with six schools in Bexhill and Hastings. Key aspects of the project were that artists spent three days in their partner school, working closely with their link teacher. Prior to this they had all attended a joint planning day. The project culminated in a joint exhibition of the students' work at the De La Warr Pavilion along with visits by other students to see and respond to the exhibition.

Fabrica
At Fabrica, the enquire research focused on seven 'one-off' gallery education activities with schools and an after-school club around three planned exhibitions, plus an outreach project at a local youth club. Workshops were generally artist-led (i.e. delivered by five artist educators, one gallery educator and one education volunteer) with sessions co-led, where possible, by two artists of different disciplines. Workshop design and planning incorporated aspects of Fabrica's recent work with CEMEA (http://www.cemea.asso.fr/). Although the school pupils only experienced one workshop in the gallery there was a strong emphasis on front-loading the projects with up to two meetings between artists, gallery educators and teachers to create trust and understanding between the professionals involved. These meetings were also used to explore ways in which the work in the gallery could be further developed back in school.

Whilst each exhibition was visually and conceptually distinct, overlapping and recurrent themes could be observed, namely: drawing and photography as a means of expression, a record of an event and as an autonomous language; ideas of process versus object, risk and change. Workshop seven took place outside of Fabrica's nine-month exhibition programme. Based on the contemporary art collection at Brighton Museum & Art Gallery, it loosely focused on Pop Art, but also addressed what we mean when we talk about contemporary art, and young people's perceptions of the gallery.

These themes, together with the stage 2 research questions, provided the basis for the activity planning between the researcher, Fabrica staff, freelance artist-educators, teachers and youth workers. The half-day school and after-school activities and youth club project built on existing relationships with city schools and youth services. Workshops with schools were designed either as a catalyst for new school projects or made a direct link with current coursework.

Towner Art Gallery – 3x3=1

Through the *enquire* programme, the Towner Art Gallery was able to reflect on its own education activities and develop, in close collaboration with artists and teachers, a programme of activity that truly pushed the boundaries of the art curriculum for Key Stages 3 and 4. 3x3 =1 was delivered by three artists in three schools in Eastbourne.

The Towner particularly focused on self-determination within learning. Some time was given to establishing a common understanding of that term when used in this context. The gallery education officer, the university researcher and the artists were all interested in the moment at which a young person takes on the responsibility for his or her own ideas and moves the process of development on independently. As well as acknowledging the autonomy of individuals it is felt by the group that self-determination can be present within teams and the group as a whole.

The projects were devised to support pupils to develop their own work over a sustained period of time. Each school had a structure of eight facilitated sessions with an artist, spread over eight to 16 weeks. The aim of this structure was to allow the artist, teacher and pupil to develop a relationship in which self-determination could be encouraged and monitored. Artist-facilitated lessons took place in the gallery space, the classroom and around the school building with an interest in observing and understanding space and place, both physical and intellectual. Artists worked together to identify the processes they go through as artists which they then took with them to the teachers and pupils to work in a similar way, making them more aware of their own learning and artistic processes. The project was strengthened and its processes supported by introducing works of art from the Towner's contemporary collection of fine art. Works were taken out to the school environment and also experienced in the gallery.

The three schools exhibited their work within their own school with special event days where the other schools were invited to attend a private view. All came together with the project workers for a meal in the closed gallery which allowed informal discussions and sharing of information. To explore the artistic process and to lay it open for the pupils to experience and question, the three artists were invited to create a work of art within the gallery. The artists were given one room in which to work together to produce a growing piece of work. Over four weeks the artists responded to the work that was taking place within the schools; the work developed as did the schools' project and was on view for pupils to see as part of their gallery visits and during independent visits to the gallery.

Research ethics

The University has set up a Research Governance Committee to oversee research governance arising from research and experiments, projects and demonstrations. It has produced a Code of Conduct for research governance (http://www.sussex.ac.uk/rrdd/) for ensuring that Schools within the University have proper procedures in place. These have been informed by national legal requirements (e.g. Data Protection Act) and the guidelines produced by many of the professional associations (e.g. Social Research Association, 2002). The University committee describes research governance as including ethical review, research integrity, quality assurance and risk assessment. It has set out the responsibilities for itself and for the Schools' research governance committees. In requiring Schools to set up research governance committees, the University is acknowledging the need to protect the rights and interests of others who might be involved in the funding, conduct and implications of research.

The Sussex Institute works in four broad areas of applied social research – law, social work and social care, adult learning and child learning – in which high standards of research ethics are essential and challenging. The Sussex Institute governance committee has produced standards and guidelines so that staff and research students can take responsibility for checking their own research activities and considering further implications of their work. They also apply to people involved in research under the auspices of the University including collaborators and volunteers.

The key standards identified are as follows:

- safeguard the interests and rights of those involved or affected by the research;

- ensure legislative requirements on human rights and data protection have been met;

- establish informed consent, even where this is difficult

- develop the highest possible standards of research practices, including: research design, data collection, storage, analysis, interpretation and reporting;

- consider the consequences of the work or its misuse for those involved in the study and other interested parties;

- ensure appropriate external professional ethical committee approval is granted where relevant.

These standards are applicable wherever the research is undertaken. The standards and guidelines are being supported through staff development activities; some aspects of the guidelines are general across all research in Sussex Institute e.g. establishing informed consent, other aspects are relevant to some research across all parts of Sussex Institute e.g. involving children in research, and others may only apply to one study e.g. interviewing vulnerable people.

Methodology

Action research
The *enquire* programme in the South East was developed on a foundation of action research principles. Action research is characterised by a desire to use authentic practice as the site for research activity that focuses as much on evaluating the processes in which communities of learners engage, as it does on measurable outcomes (Summerton 2005). An emphasis was placed on respecting the diversity of backgrounds found in the cluster participants and their varying research interests and experience.

The programme plan sought to develop a community of practice that actively devised research techniques through three key phases of questioning, activity and analysis, each phase of activity being informed and guided by the work of the previous phase.

The questioning phase concentrated on gathering current views on what is unique about gallery education. The phase used the Generic Learning Outcomes (GLOs) and learning theories developed for the Learning Impact Research Project (LIRP) as a framework for facilitated discussions.

The activity phase consisted of projects in each of the cluster galleries and associated CPD that developed relationships between gallery educators, teachers and artists to create a fuller understanding of the value of gallery education, explore best practice and encourage critical debate. The lines of enquiry and methodology employed in the activity phase were devised from the questioning phase and therefore embraced the existing conditions and reflected the views and opinions of those participating in and delivering contemporary gallery education in the south east region.

Finally, the analysis phase has contrasted and compared the results of the questioning and the activity phase with wider research findings and academic work in fields relevant to the *enquire* programme. This includes, for example, arts in education, creativity, young people and culture, professional development of artists and gallery educators, education and the curriculum, and cultural policy.

Research tools

Questioning
The first phase of the programme, the questioning phase, used primarily qualitative research tools including researcher-led discussions and workbooks. The GLOs were used to frame questions to:

- make best use of existing research, especially work carried out in the cultural sector in a domain that has obvious links to learning in the contemporary gallery environment;

- test the appropriateness of the existing GLOs to the contemporary gallery sector and identify where there is alignment or contrast with the GLOs;

- create a forum of enquiry from which the second phase of the *enquire* project, the activity phase, could draw on to focus the action research element;

- establish, potentially, a set of learning outcomes for the contemporary gallery sector which could be measured in addition to, or alongside, GLOs, therefore safeguarding and deepening the growing body of research evidencing the impact of culture sector activity on learning.

The research questions were designed into a workbook format (see page 112) that could be used to open a dialogue with gallery educators, artists, educators and learners, either in or outside of formal education settings, working in a contemporary gallery environment. Where necessary the workbook was modified so as to be accessible to participants.

The research questions sought to:

- gauge participants' agreement with definitions of learning employed in the LIRP research and originally proposed by the Campaign for Learning;

- assess the variability of the importance of each definition of learning when conditions change;

- identify gaps in the definitions of learning when focusing on the contemporary gallery context;

- assign a value to each of the GLOs;

- identify where the GLOs can be used as an evaluative tool in contemporary gallery learning;

- begin to describe what makes the contemporary gallery a unique site for learning from the viewpoint of participants.

For the purposes of the enquire research the cluster took contemporary gallery environment to mean work emanating from the gallery. This includes work taking place in galleries as well as work carried out in schools and in the community.

The questioning phase research was carried out over a six-week period (17 March to 28 April 2005). The approach to this phase of work was consultative. The questions allowed for a stepped approach to carrying out a facilitated discussion involving small groups (six to eight participants) of:

- gallery educators – employees or freelancers working for galleries to deliver learning/education programmes in the gallery environment (on or off site);

- artists – practitioners working with learning/education projects in the gallery environment (on site or off site) as part of the development of their own arts practice;

- teachers – individuals involved in arts-based projects devised for schools through the gallery environment;

- young people – individuals in formal education and individuals currently outside the formal education system.

The workbook format was employed so that responses could be captured from each individual participant. A variety of question styles was used to allow individuals to state preferences (yes/no), assign value (important/not important) and contribute personally (open-ended) in responding to the GLOs and towards the forum of enquiry that helped to focus the action research of the second phase.

Table 1: Participants with prior experience of gallery education who took part in the consultative research of the questioning phase

Teachers	4
Artists	7
Gallery educators	5
enquire partners	5
Young people not in full time education	5
Young people in full time education	5
Total participants actively contributing to framing research questions	42

The workbook format was employed so that responses could be captured from each individual participant.

Table 2: Schools and groups that participated in project-based activity phase of research by gallery

Gallery	School	No. of young people	Year
De La Warr	Claverham Community College	15	10
De La Warr	Filsham Valley School	16	10
De La Warr	The Grove	15	10
De La Warr	Robertsbridge Community College	15	10
De La Warr	St. Richards Catholic College	15	9&10
De La Warr	Thomas Peacock	16	10
De La Warr	Bexhill High School	114	7
	Total De La Warr	**206**	
Towner	Eastbourne Technical College	35	10
Towner	Eastbourne Technical College	35	10
Towner	Eastbourne Technical College	35	11
Towner	Causeway School	32	7
Towner	Causeway School	35	7
Towner	Causeway School	16	7
Towner	Cavendish School	25	7
Towner	Cavendish School	28	9
Towner	Cavendish School	25	9
Towner	Cavendish School	25	9
	Total Towner Art Gallery	**291**	
Fabrica	St. Bartholomew's	22	2
Fabrica	Carden Primary	22	1
Fabrica	Patcham House	7	11
Fabrica	Blatchington Mill	6	12
Fabrica	Hazelwick	25	7
Fabrica	Hazelwick	25	9
Fabrica	Sundance After School Club	20	n/a
Fabrica	Shutter Speed	6	n/a
	Total Fabrica	**133**	
	Total all galleries	**630**	

The discussions were facilitated by one person from a partner organisation working with an HEI researcher. The two facilitators aimed to work as a team to achieve a balanced voice and allow for wider observation, thereby achieving a more comprehensive record of specific responses and aiding group work.

In the discussions with artists and gallery educators the final section – 'What is unique about the contemporary gallery as a site for learning?' – was recorded but as yet has not been transcribed due to cost implications.

At the end of the questioning phase the cluster partners met twice with University of Sussex researchers (Aldred and O'Brien) to develop the research methodology for the second phase. This was later refined through the involvement of the principle researcher for this phase, Judith Furner (also University of Sussex). The development of this methodology is discussed in more detail later in this report.

Activity

The second phase of the *enquire* programme, the activity phase, was centred on gallery-based projects. The three galleries in the South East cluster each involved a number of schools and artists. The De La Warr worked with six local schools, each with an associated artist. Fabrica worked with five groups from local schools and two after-school groups, seven in all, each with one or two artists. The Towner Art Gallery worked with three local secondary schools, each with an associated artist. The number of students taking part is shown in Table Two, p. 97.

The activity phase incorporated quantitative data collection into the research tools by employing questionnaires that would be completed by approximately 350 young people. The intention of these questionnaires was to discover what young people had learned by their experience of the various projects. The questionnaires included a set of generic questions and a question unique to the project on which the young people were working.

It was originally proposed that they should complete written questionnaires at the start of the project and on finishing it, but after considerable discussion with the gallery educators and artists about the use of such questionnaires, the format of delivery was altered to suit specific conditions in each project. (The importance of this process is discussed in more detail later in this report). For a full breakdown of how the data was returned

and analysed please refer to the South East cluster phase two interim research report by Judith Furner at www.en-quire.org.

Qualitative data collection was carried out through a series of observations of work in progress and focus groups. In order to obtain an overview of the many projects involved with the galleries it was agreed that the researcher would observe up to three sessions with at least one artist from each gallery. She would then facilitate focus groups with the young people concerned, to discuss their views of the project on which they had been working. A semi-structured interview questionnaire was used during the focus groups.

In addition to those tools specifically designed to measure the learning of young people and seek evidence of unique conditions present in the gallery, project partners were asked to keep action research diaries. The purpose of these diaries was twofold. Firstly, they would complement the investigation of the young people's experience by capturing data on the processes in play during the project and where or how relationships influenced outcomes. Secondly, they would demonstrate where the learning of partners could be evidenced alongside that of the young people.

The challenges

The explicitly democratic approach adopted by the cluster has been one of its most challenging, as well as most rewarding characteristics. From the outset, the different participants have worked to multiple priorities whilst delivering the outputs required by the national programme. Additionally, there has been collective ownership of the programme in that the management of the project has not been sited in any one gallery as a lead partner, but in the cluster coordinator, employed specifically, on a freelance basis.

Internal pressures have also influenced the efficacy with which individuals and organisations have engaged with the research programme. From the perspective of the University, the research agenda of *enquire* did not immediately fit into any pre-existing programme and therefore it needed to be forged out of individual research interests. Equally, within the gallery context, some projects provided an ideal context for research, whilst others required that the *enquire* methodology and research foci be adapted to suit a plan of work that was not solely devised with research in mind. Schools found themselves 'exposing' their teachers and schools to much more than an art project with a

local gallery; equally, participating artists were challenged to engage with the research as it explored their practice through unfamiliar language and, at times, intrusive activity.

Additionally, partners were disappointed that the action research did not involve or happen at the level of the young people, but only at the level of artist/teacher/gallery educator. In retrospect, the cluster felt that it would have been better to have developed projects that enabled the young people to be part of the enquiry, i.e. where the project aims were the same as the research aims. There was no agreed understanding of action research as a methodology at the start of the project. As a methodology it was chosen at national level, but no training was given across all the clusters to make sure everyone had the same understanding. After the first national seminar, the South East cluster arranged its own action research training with Janet Summerton, and it was felt that if that session had come earlier in the process it would have affected the way the project developed. But as a cluster, the South East clearly went through an action research process which has been, and will continue to be, very valuable. The degree to which this applied to the artists and teachers varied between galleries, as discussed later in this report.

The rewards

But as the aim of the cluster was to foster co-learning and to leave a legacy of research skills embedded in gallery education practice all of these circumstances were beneficial to the overall process and are, with hindsight, the arena for much of the growth both across the partnership and within individuals.

Analysing the research findings

Drawing parallels between the questioning and activity phases of the research

The cluster has produced two research reports (phase 1 [May 2005] and phase 2 [May 2006]). Both reports provide a rich seam of research data from which to draw out key themes important to programme participants. However, they only touch on the wealth of data available for further analysis. Due to the pressures of time and resources it has only been possible to provide analysis of the evidence presented in the two reports. It is hoped that researchers will be able to revisit the primary data, especially that contained in the research diaries, at a later date.

At a cluster meeting at the Towner Gallery in May 2006 the following themes were identified as particularly resonant:

- the significance of group learning and collaborative working;
- the evidence of learning that embraced the GLOs and extended this framework to include risk-taking, self-determination and voice;
- the importance of process over outputs.

The activity phase of the research was developed on the foundations of the consultation that took place in the questioning phase. Therefore, we are able to draw parallels between individual and group perceptions about the transformative power of gallery education and those evidenced through field research in the activity phase. This section of the report compares and discusses the research findings of both phases and seeks to draw parallels with academic research from related fields, as interpreted through one researcher from the University of Sussex team whose personal area of expertise is arts management.

Group learning and collaborative working

During the first phase of the research process the GLOs and their corresponding learning theories were employed to consult with individuals who had experience of gallery education projects and who were representative of participants who would be involved in the field research to be conducted in the second phase.

The learning theory on which the GLOs are based is essentially co-constructivist. It assumes individuals are working with others in a facilitated way towards a range of desired outcomes that are of benefit to all those involved (Pringle, 2005 p. 29) Testing the importance of this approach was important to establish how far collaborative experience formed part of any recognisable learning experience and, equally important, how conscious individuals were of this phenomena. Whilst it was not immediately recognised by the researchers at the outset, this participative way of working aligns itself with Lave and Wenger's research into learning processes.

As the following table from the phase 1 research shows, at the start of the *enquire* programme all participants agreed with a definition of learning that proposed learning as an individual as well as social act.

Allied to this is the recognition that changes in emotions, skills and behaviour can also form a definition of learning. The importance of this shared understanding was woven into the second phase of research by designing research tools capable of evidencing the emphasis individuals placed on working collaboratively.

Central to this dynamic, and a key theme the cluster explored is,

'What is the nature of the learning experience that gallery education provides for young people as a result of the collaboration of a gallery educator and an artist?'

Specifically, the research focused on the transactional space between the participants, with a particular focus on the role of the artist in the project setting.

This was actioned through field research that employed qualitative methods on two levels. Firstly, the action research teams involved gallery educators, artists and teachers, with a

Agree with definition of learning	focus on learners	lifelong process of meaning making	change and development in emotions, skills, behaviour	learning as a verb not noun	enjoyment, amazement, inspiration	identity building	individual and social
teachers (4)	4	4	4	4	4	4	4
artists (7)	6	6	6	6	6	5	7
gallery educators (5)	5	5	5	5	5	5	5
enquire programme (5)	5	4	5	5	4	5	5
young people (16)	15	16	16	15	16	12	16
% of potential total responses	95%	95%	97%	95%	95%	83%	100%

Adapted from O'Brien (2005)

researcher from the University of Sussex, in collecting data on and evaluating the learning trajectory of young people participating in the gallery education projects. Alongside this the key partners in each project mapped their own learning through the use of project diaries. In these diaries they kept a record of their personal reflections on the work they were doing in partnership, including their own learning. This form of reflective practice, was first written about by Schon, in 1983, and is now widely recognised as an effective tool for learning in fields where professional or technical skills need continuous updating. The key themes covered in the action research diaries include communication, learning and gain both on a personal and group level. Also they offer a more focused area of reflection around the key research question identified for each project.

By forefronting the collaboration and interaction between participants, in particular the relationship between artists, gallery educators and teachers, the project was able to develop a framework to scaffold learners, in this case all of the participants in the research, through the action research process. This process of scaffolding, which must be based on a collaborative community approach, is increasingly being favoured over a traditional skills-competency approach to professional development (Hung et al, 2005). It allows for the learner to draw

Key partners in each project mapped their own learning through the use of project diaries.

on their existing professional skills to participate in the evolution of a project which has their own learning embedded at its core.

Hung et al, (2005), point out that, 'a scaffold adapted to the level of the learner ensures success at a task difficult for the learner to do on his or her own', and provide the following diagram for what they call an evolving continuum model of learning.

Adopting an evolutionary approach to working collaboratively is also cited by Pedlar, Burgoyne and Boydell (2004 p.191) as a criteria for developing sustainable partnerships as it reflects a model with three recognisable key stages of development:

legitimate peripheral participation			central participation
learner is a novice	observer	participant	active contributor
simulation model	participation model		co-determined interactions model

The evolving continuum, Hung et al (2005)

Stage 1 = SEPARATE and ISOLATED

'They are different from us' (and we really don't want to know about or have anything to do with them) – terms are tightly set and parties protect their valuable knowledge, processes etc

Stage 2 = CURIOUS and EXPLORATORY

'They are different from us' (and that's very interesting) – here the partners have started to notice each other and ask questions about how the other does things. It is in this questioning and wondering that the initial conditions for learning emerge

Stage 3 = JOINT ENQUIRY and CO-CREATION

'We are different' (and through understanding and using these differences we're working together to generate something new and exciting) – the ultimate aim of a sustainable partnership is to create conditions that recognise that learning and innovation grow out of difference and diversity.

Stage Model of Partnership Development
Pedlar, Burgoyne and Boydell, 2004

These stages are recognisable in the cluster's approach to devising and implementing the research methodology of the *enquire* programme.

Stage 1 - SEPARATE and ISOLATED

In the questioning phase the HE partner developed research instruments based on the framework set out in the research project brief. Partners, in this case the galleries, were consulted and raised some issues around language, but for the most part allowed the tools to be used for the purposes of starting the research process. As research got underway the disparity between the partners' expectations and interpretations of the aims of the research were realised and debate opened up around the nature of the activity the partners were engaged in.

This questioning of the research methodology, in particular the appropriateness of the GLOs as a framework for research questions, was also challenged by artists who participated in this consultative phase of the research. This was critical because it raised important issues around ownership of the process and about identity. At this point the partners were not fully ready to 'inhabit each other's castles' (Somekh 1994, cited in Day &

Hadfield 2004). However, by phase 2 of the research programme, attitudes were shifting and the cluster partners began to embrace learning as a means of overcoming the perceived barriers created by different working practices. As a shared language evolved, any perceived threat to identity diminished.

Stage 2 - CURIOUS and EXPLORATORY

The interim report on the questioning phase highlighted the input of partners and pointed towards ways of taking the views raised in the consultation forward into the design of research tools for the activity phase and led to a consensus amongst the cluster about the overarching aim of the research. The session on action research led by Dr Janet Summerton provided the cluster with an objective view on how research can embrace and emerge from practice, rather than simply observe it and comment on it. This effectively demystified the research process for the cluster and renewed their interest in working collaboratively to design research meaningful to all the cluster members.

There was a marked difference in the participation of gallery partners in defining the tools used in the activity phase of the research. The overarching research question was refined to reflect the interests of the cluster and then further sub-sets of questions were devised to explore themes of specific interest to participating galleries. Alongside this, returning to the original interest the project partners had shown for a peer-led gallery education network, a commitment was made to explore the learning of the cluster participants with a view to informing the development of future CPD opportunities for gallery educators in the south east. In the meantime the project has enabled the gallery educators in particular to act as peer 'critical friends'.

Stage 3 - JOINT ENQUIRY and CO-CREATION

Evidence of the cluster reaching this phase of development is seen in the research findings of the activity phase that were captured in the action research diaries. The diaries were kept by participants in each project team although, as with all aspects of the research project, the precise application of a standardised tool was not always consistent. But as the purpose of the diaries was to act as a record of the learning that was taking place across the project at a group, as well as individual level, the diaries did provide a viable tool for reflection that could be revisited by individuals and used in the future by the cluster to devise further research.

Implicit in the diaries are some of the tensions that arose as the gallery partners took more ownership of the research methods and moved between internal and external facilitation roles (Day & Hadfield 2004). The gallery projects that formed the basis for the activity phase research happened sequentially (by accident, not design) so the conditions of the partnerships on the ground between the gallery, artist and teacher were handled differently from gallery to gallery.

The first project led by the De La Warr Pavilion had very little lead-in time and therefore the planning day that was part of the original project idea (before the research element was introduced) was used to communicate the overall aim of the research, brief individuals on the research tools and develop specific project ideas. This day was expedient in communicating information and stimulating discussion across a group, but less successful in allowing an individual to reflect on the specific conditions they would encounter back in their school and therefore to plan accordingly. The project participants were not afforded the same level of engagement with the design of the research as the gallery educator who, as a cluster member, was involved all along.

Generally, the lack of lead-in time meant the De La Warr Pavilion partner could not spend as much time as they would have wanted to work with each organisation on the research. The research element was laid on top of normal project planning so that even more time was needed; this had not been negotiated in the original planning with schools and artists. However, recognising the value of 'front loading' projects to allow for planning has emerged most strongly from this process.

In one school, where several groups of students took part in activity, tensions arose that led to one of these groups asking not to be included in the joint exhibition at the De La Warr Pavilion (Furner 2006). The cluster partner involved has provided the following description of events:

'The group that didn't want their work included was one of five groups at that school; they didn't want their work shown due to disagreements within the group and the fact that the process didn't work for them as it had for others in that project. In the context of the discussion of the importance of planning, there was another project that suffered more in this regard, with very poor communication between teacher,

artists and gallery educator, particularly over the role of the *enquire* research. However, this only really came out during evaluation discussions with the artist and when the project diaries were collated. Had there been more action research time planned in for the artist/teacher/gallery educator much of this might have been avoided. This was the main learning for the group, as the other galleries were able to learn from this and make sure that time was planned in.'

Whilst difficult to mediate, this learning process was beneficial in the first instance because it was captured in the research diary of the participant and therefore became an object lesson for the group as a whole. It was also useful to the cluster as the experience was passed along to partners who were just beginning to engage in the project research. There is the potential therefore to use action research in an evaluative capacity as it is attuned to documenting unexpected outcomes that often arise in the dynamic and creative environment of gallery education projects. This builds on the model of personal and social development identified by Woolf (1999), by embedding solutions to community problems, normally identified as an exclusively end-of-project outcome, into the overall progression of the project and its further execution.

By the third project, this time led by the Towner Art Gallery, the engagement of project partners with the research was markedly more developed. The project team felt confident enough to openly challenge the use of written questionnaires as part of the research methodology. The objection did not lie solely in the nature of the questions – although they were perceived by some to be 'too simplistic for the topic being investigated' and potentially too complicated for some of the younger school children to understand. Rather it was in reference to the reliance on a tool that was 'associated with bureaucracy and boring things like working in an office' (Furner 2006). More specifically, and important in terms of planning and devising projects collaboratively, participants concerns included:

- the time taken to complete questionnaires would impinge upon the time available for the artists' work;

- the mood induced by completing a questionnaire was incompatible with the excitement and imagination that should introduce the project;

- concern about creating resistance in pupils who did not care for writing in an art lesson;
- ineffectiveness if students did not bother to complete the questionnaire properly.

The questioning of the research methodology by project-based participants was another example of where action research can run into problems as it is applied in the field, but where it is fruitful as a tool for developing partnership working and collaborative problem solving. Its importance to gallery education in particular has been explored in the research of Eilean Hooper Greenhill (2000)

'The development of the museum as a communicator is a form of action research, where the museum curator/educator reflects upon her own practice, and in the process of this reflection, asks ever more penetrative questions that themselves force a more thoughtful and insightful practice. The progressive focusing as action research continues acts to make the curator/educator more self-critical, more self-aware, and hungry for more ideas to take the practice forward.'

Seen in this light, the refusal to employ the questionnaires was a positive act as it forced the partners to refocus and adapt the questionnaire delivery to satisfy both the research requirement for data collection and the desire to authenticate the research process for the gallery education context. The solutions devised by the partners included:

- giving the questions one at a time in an energetic and fun atmosphere (Towner Art Gallery);
- presenting the questions to young people as part of a wider group discussion and then noting down answers (Fabrica).

The natural consequence of this change to the methodology was that analysing data was made far more labour intensive which in turn had repercussions for the timetable of the project as a whole. Additionally, the academic researchers were concerned that the robustness of the data could be called into question. This is a particular problem within the cultural sector as recognised by Selwood (2000), Belfiore (2003) and Holden (2004).

However, the value of the exercise in formulating an active engagement with the research process is clearly reflected in the diary entries of participants. These entries point to a shift in attitudes amongst artists and teachers:

... didn't know evaluation could be so much fun. When there is a practical element the pupils are really keen to complete the questions.

Because the questions were posed in an appealing way and an active way the writing element was less of an issue and the questions being asked by the pupils were amazingly perceptive.'

... as well as a collective response that evidences confidence and ownership of the partners' newly developed research skills:

Everyone felt that the questions and the focus for research would have been richer if the artists, teachers, gallery and researcher had had time to sit down in the very beginning and develop them together.

The ideal situation would be to ask the pupils how they would gauge their own self-determination and to support them in self-reflection with this as a focus.

Concerns over the quality of the data produced through these questionnaires will be addressed later in this section when an analysis of the responses of young people are matched to the GLOs, and the conditions of learning unique to gallery education proposed by participants in the questioning phase.

To sum up, the adoption of action research principles and the willingness of the cluster to allow an organic approach to devising the research methodology created conditions allowing the cluster to demonstrate that gallery education projects promote the scaffolding of learning. Thus, the individual and collective acquisition of practical skills, competencies and the networking capacity of partners are increased. This 'useful knowledge' (Eraut 2005), is now embedded in the practice of the cluster partners and project participants and will be further extended through the development of CPD activities as the *enquire* programme progresses.

Evidence of young people's learning that extends the GLO framework to include risk-taking, self-determination and voice.

'In school we work – in Fabrica we drew'
Fabrica project, February 2006

One of the most problematic aspects of the first phase of research was the use of the GLOs as a framework for part of the

consultation on learning in the gallery setting. Before engaging in discussion about the GLOs, participants were given the following descriptive summaries developed from the LIRP Project Report:

Increase in knowledge and understanding

- learning new facts and information or using prior knowledge in new ways;
- knowledge and understanding includes the development of a more complex view of self, family, neighbourhood, or personal world.

Increase in skills

Knowing how to do something via:

- intellectual skills (reading, thinking critically and analytically, being able to present a reasoned point of view);
- key skills (numeracy, communication, use of ICT, learning how to learn);
- information management skills (locating information, using information management systems, evaluating information);
- social skills (meeting people, showing an interest in the concerns of others, team working);
- emotional skills (managing intense feelings, channelling energy into productive outcomes, recognising feelings of others);
- communication skills (writing, speaking, listening, presentations);
- physical skills (running, dancing, manipulating materials to make things).

Change in attitude or values:

- change in feelings, perceptions, or opinions about self, other people and things and the wider world. Being able to give reasons for actions and personal viewpoints.

Evidence of enjoyment, inspiration and creativity:

- evidence of having fun, of innovative thoughts, actions or things. Evidence of exploration, experimentation and making.

Evidence of activity, behaviour, progression:

- what people do, intend to do, or have done. Actions that can be observed or people may report that they have done.

The description demonstrates that the GLOs are deeply generic and therefore can be made to fit almost any situation or setting. However, this is at the expense of resonance and apparent 'match' with the aims of the gallery sector.

During the questioning phase of the research the definitions of learning that underpin the GLOs were examined to establish which, if any, reflect core attributes of gallery education. There was broad acknowledgement that the learning definitions used in the LIRP research are also employed in the gallery education sector. They have most resonance in formal education settings but are concepts familiar to artists and gallery educators and with which, for the most part, they are comfortable. Yet equally, as this table shows, groups of practitioners had similar views on what they lack.

The results of the questioning phase discussions indicated that the learning definitions were missing three elements that partners in the South East regard as critical to gallery education:

Teachers	Artists	Gallery educators
Learning to take risks and make mistakes as a viable vehicle for learning	Questioning authority	Space and time for reflection
Active questioning of events, situations, standards	Encouragement of self-determination linked to imagination (anything is open to be imagined)	Discovery of ideas and thoughts
Experimenting	Trusting your own thinking and then others	Creativity
	Noticing one's own thinking (as acceptable knowledge)	
	Communication (expression)	

- embracing risk-taking and mistake-making as modes of learning;

- the importance of individual thought as a trigger for learning;

- learning as an act of self-determination.

These elements were brought forward and further developed into a set of research questions that were employed in specific settings during the activity phase of the research project. This was carried out with the express aim of producing evidence that could be employed as viable learning outcomes. Therefore it could provide additional depth to the GLOs which, as was established during the research, had universal albeit limited value in assessing the conditions specific to contemporary gallery education that influence young people's learning.

Findings based on the research questions
Each gallery in the South East cluster had an individual research question, developed from discussion among those involved, and experience of the questioning phase research.

The De La Warr Pavilion's research question was:

- How does risk-taking/ experimentation contribute to the learning experience through the exchange between artist, teacher and young person?

It was clear that considerable experimentation and risk-taking had taken place in the De La Warr project. In responding to the questionnaires, young people described the new materials with which they had worked. They spoke about trying different ways of working, both in artistic techniques and in communicating with others. They found brainstorming stimulating and learned the techniques and advantages of compromise. They were surprised and impressed by their fellow students' imagination and creativity. They started to realise that 'getting things wrong' could lead to greater understanding and enhanced development. They felt embarrassed about some of the things they did, especially processing in the street and speaking to people they didn't know. Clearly, however, they had become more confident through the experience. They had benefited from their exchange with the teachers and artists, and it was clear that the risk-taking and experimentation had confirmed the experience in their minds, raised their confidence and enabled them to progress in their personal and academic development. Not only the students

but also the teachers and artists benefited from the project, and their resources and skills were enhanced by the experience.

Fabrica's research question was:

- Does working with artists in a contemporary art gallery offer a context for young people to find a voice and explore their identity?

The artists and teachers in the Fabrica project appeared to be actively encouraging the young people to explore their identity and find their own voice. It was evident that the young people were given considerable autonomy and allowed to express themselves. They appreciated being respected by the artists and found that they could discuss their work as equals; they contrasted the experience with being in school, where they were told what to do. It appeared that the artists encouraged their creativity: they found that their ideas were never 'wrong' and that discussion with the artist enabled them to fulfil the potential of their work. Their confidence rose as the project progressed, and they discussed their ideas more openly with their fellow students. The facilitation of discussion enabled them to question and to develop both their verbal skills and their thought processes.

The Towner Art Gallery was:

- interested in the moment at which a young person takes on the responsibility for his or her own ideas and moves the process of development on, independently. As well as acknowledging the autonomy of individuals we will also encourage self-determination within teams and the group as a whole.

Many of the young people in the Towner project appeared to feel in control of their work and stressed that they were able to make their own decisions. In the process of creating their artworks they were thinking for themselves and deciding how to go forward. Some felt less in control, and mentioned that the event was structured in such a way that the artist and teacher retained some control over the process. Indeed, it was mentioned that the opportunity for too much autonomy could be daunting if anyone was not accustomed to it. Assistance with the techniques of drawing clearly increased the confidence of the young people and enabled them to move forward independently. It appeared that not only their artistic skills but their powers of observation, their ability to work collaboratively, to use their imagination and appreciate local history had all been affected by the project.

The over-arching research question for the South East cluster was:

• What is the nature of the learning experience that gallery education provides for young people as a result of the collaboration of a gallery educator and an artist?

The young people in the project had generally found the experience beneficial, and many were explicit about their learning. The artists had brought a vast range of skills to the project, and the young people had been interested in investigating the new ways of working to which they were introduced. Many stressed the advantages of learning new techniques, both for their own development and for the demands of their academic work. A completely different aspect of their learning was concerned with their communication skills. The project encouraged collaboration both between the young people and in relation to the adults concerned – the artists and teachers. The young people were pleased and impressed by being able to relate on an equal basis to the professionals, and their confidence was boosted and their skills increased by the experience.

Entry and exit questionnaires were used with over 340 young people across 11 schools in order to gain quantitative evidence of these shifts in attitudes, knowledge, skills or understanding among young people. As was mentioned earlier, the deployment of these questionnaires was not standardised and therefore they may not offer a reliable data set to contrast with those emerging from the London and North East clusters. However, they are effective as a basis for drawing parallels between the views of young people in relation to gallery education expressed in the questioning phase.

Comparing the data sets
In the questioning phase young people's attitude towards the usefulness of the GLOs was measured primarily thorough a simplified version of a workbook devised to test the relevance of GLOs across a number of participant groups (see page 118). Young people were asked to respond from their own experience of taking part in art projects or visiting galleries.

The following table shows which GLOs young people identified with and for which they were able to give an example in their workbooks during the questioning phase :

young people - evidence of the GLOs (16)	Yes	No
increase in knowledge and understanding	75%	25%
increase in skills	94%	6%
change in attitude or values	81%	19%
evidence of enjoyment, inspiration, creativity	94%	6%
evidence of activity, behaviour, progression	81%	19%

For these young people 'evidence of enjoyment, inspiration and creativity' is most easily demonstrated, together with 'increase in skills'. Whilst the activity phase did not specifically measure learning through the GLOs, similar views were expressed in the entry questionnaire results. These revealed young people felt that doing a project in an art gallery or working with an artist would provide them with opportunities to express themselves creatively and to build their practical art making skills. (Furner 2006)

The dominance of a skills-based view of learning amongst young people has been common to both phases of the research. One explanation for this may be found in considering how young people are currently taught to learn. If young people are conditioned to be assessed by incremental measurement they may respond with answers that they perceive to be 'correct' (Hein 1998). In this way the measurement tool, in this case the gallery entry/exit questionnaire, carried with it a predetermined set of answers that young people had constructed for themselves based on previous and current experience. It is important to note that amongst older participants, (those most likely to be able to articulate views through discussion groups), over 60% of Year 10 pupils and 100% of Years 11 and 12 had attended a gallery within the context of a schools-based activity. Whilst the delivery of the questionnaires in a standardised manner was problematic, it would have allowed analysis based on individual responses that could examine variance across young people with prior experience of gallery education and those without, in this case, the younger participants.

The questioning phase of the research was only carried out with young people who had previous experience of gallery education. Without this experience they would not have been able to contribute to a consultative process that sought to identify conditions for learning unique to the contemporary gallery. In the questioning phase of the research, the following clusters of ideas were identified by participants as embodying this uniqueness:

- change in the environment = shifts in attitudes;
- the contemporary art work and contact with the real;
- non-formal opportunities for learning;
- self-determination and identity;
- value and valuing.

The table on the page opposite has been established by considering the verbal answers provided by young people in both phases, as evidenced through the combined data collection techniques (quantitative and qualitative). It uses the perceived unique attributes identified by participants during the questioning phase to network the two bodies of research.

Recommendations

In his seminal book on management, The New Realities (1989), Peter Drucker identifies a shift from mechanical knowledge based on received facts, to biological knowledge that attempts to configure signs and symbols, patterns, myth and language (Drucker 1989 p. 254). This mirrors the foundations of artistic practice and creativity in its proposal that individuals now 'configure' knowledge as oppose to 'receive' knowledge.

The importance of creativity to the development of communities, be they national or local, has been recognised by government as a key goal of an education system that will support innovation and increase capital across economic, social and cultural domains. The National Advisory Committee on Creative and Cultural Education (NACCCE) has developed the following definition of creativity as a framework for educators: 'Imaginative activity fashioned so as to produce outcomes that are both original and of value.' This, claims Avril M. Loveless of Brighton University, expresses, 'five characteristics of creativity: using imagination; a fashioning process; pursuing purpose; being original and judging value.' (2002)

In the questioning phase of the enquire research process all three partner groups (gallery educators, teachers, artists) found the GLOs to be lacking in their ability to evidence creative, imaginative, original or critical learning. They were found to be problematic not only because they are not effective as measures of activities that are fundamental to contemporary art-making but also, as we see above, because they fail to show where contemporary gallery education produces conditions for learning that embrace the needs of the future.

The activity phase focused field research on these more complex concepts. There are obvious parallels between the two bodies of research that demonstrate both evidence of generic learning and learning specific to the contemporary gallery environment. Given the constraints of the project timetable and resources, it has not been possible to develop these new outcomes into evaluative tools. It is recommended that resources for this work be ring-fenced in the continuation of the enquire programme.

Plans for the future

- The enquire project is informing the educational plans for the cluster.

- The cluster is applying for an ACE bid to continue CPD and a 'critical friend' scheme across the region and to consolidate other ways of working together.

- The design and implementation of an accredited course in Contemporary Gallery Education at the Centre for Continuing Education is underway with members of the cluster working with the University.

- For the longer term there is an intention to design and develop an MA programme in Gallery Education.

- The cluster also intends to continue to work together through enquire but also to explore and evaluate other models of learning, and other ways of working within, and alongside, the Sussex Institute.

- It will also explore other learning needs and opportunities.

Conclusions

The adoption of action research principles and willingness of the South East cluster to allow an organic approach to devising the research methodology has created conditions that enabled the cluster to demonstrate that gallery education projects create conditions where learning can be scaffolded. This has increased the individual and collective acquisition of practical skills, competencies and the networking capacity of partners. There is evidence that critical consciousness of the learning process and 'useful knowledge' (Eraut 2005) is now embedded in the practice of the cluster partners and project participants and will be further extended through the development of CPD activities as the enquire programme progresses.

Response frame	change in environment = shifts in attitude	The contemporary artwork and contact with the real	Non-formal opportunities for learning	Self-determination and identity	Value and valuing
Questioning phase research	Artists perceived to be more respectful, knowledgeable and approachable than teachers. Working conditions were more relaxed. Individuals could participate more freely. Having more time to concentrate on a piece of work encouraged engagement and exploration.	Exploring works of art through contact with artworks led to an openness and appreciation of what contemporary art could be i.e. not just paintings. Working through a project helped some young people to make connections with other parts of the curriculum, e.g. drama and poetry.	Working in groups, discussion, listening and meeting people. Taking risks and seeing mistakes as positive. Getting 'lost' in ideas and being responsive to creative impulses	Young people felt valued by the artist and took advantage of the opportunity to 'reinvent themselves'. Working collaboratively provided the opportunity to test individual ideas against those of others. The personal freedom and change embedded in the project process were liberating. Visits to galleries could be intimidating if you did not 'know how to act'.	Valuing their own opinion of what art can be. Recognising that art-making embraces a diversity of practice. Accepting individual expression (their own and that of others) as worthwhile.
Phase two research	Working with artist was perceived to be fun and inspirational. Guidance and direction provided by artists was received as helpful, not prescriptive. The presence of the artist made young people consider the quality of their work more. Removing the structure of the school environment forced young people to renegotiate relationships with peers and adults.	The artist was perceived to be actively engaged in making art and therefore trusted more in discussions about contemporary art. The project work created an opportunity to explore art in depth and to develop individual style. Through the project work some young people became more aware of their local environment, both the town in which they lived and the gallery.	Recognising that their imagination was stimulated through viewing works of art. Working collaboratively in groups. Questioning and negotiating with peers and with adults. Adopting a process-led approach which regarded mistakes as natural to improving the works produced.	Motivation and self-esteem were heightened during the project process. The experience of public exhibition provided a risk of 'exposure' that heightened engagement. Role definition in groups was transposed as the academic framework of 'school' was removed. This was perceived as both challenging and enjoyable. Self-determination was often equated to stamina and persistence, not necessarily an awareness of 'self' as a concept. Imagination was recognised as a thought process.	Accepting that value is not fixed and that there is always room to improve work. Valuing personal engagement and effort as well as that of others. Applying new techniques to their own art-making. Developing criticality through providing critique to peers and to adults.
Key parallels	Bringing someone new into frame creates a new dynamic that allows 'change'. The presence of the artist as the embodiment of a profession influenced the young people's participation and engagement with the art making process.	A deeper comprehension of contemporary art can be achieved through linking contact with art objects, settings and process. The artist legitimises contemporary art in the eyes of young people and creates connections with their reality and the outside world.	The importance of working in groups on projects that rely on the young people to participate in devising and producing processes and outcomes.	Personal actions (stamina, persistence, imagination) were used by young people to express their views on self-determination. Individuals had opportunities to experience instances of role change that opened up new ways of seeing their own potential.	Moving beyond a fixed idea of traditional skills being the only measure of quality in art. Developing critical skills and ability to provide critique and feedback.

Bibliography

Day, C. and Hadfield, M. (2004) Learning Through Networks: trust, partnerships and the power of action research, *Educational Action Research,* Volume 12, Number 4, pps 575-586

Drucker, P. (1989) *The New Realities,* London: Mandarin Business

Eraut, M. (November 2005) Seminar on researching non-formal learning, University of Newcastle, *enquire* Programme

Freire, P. (1973) *Education for Critical Consciousness*, New York: The Seabury Press

Furner, J. (2006) *enquire Programme Phase Two – Interim Research Report* (South East Cluster), University of Sussex/*engage*.

Hein, G. (1998) *Learning in the Museum*, London: Routledge.

Hooper-Greenhill, E. (2000) Changing Values in the Art Museum: rethinking communication and learning, *International Journal of Heritage Studies,* Vol. 6, No. 1, 2000, pp. 9 -31

Hung, D; Chee, TS; Hedburg, JG; Seng, KT. (2005) A Framework for fostering a community of practice: scaffolding learners through an evolving continuum, *British Journal of Educational Technology,* Vol 36 No 2, pp. 159-176

Kanter, R. (1983) *The Change Masters,* London: International Thomson Business Press.

Loveless, A. M. (2002) *Report 4: Literature Review in Creativity, New Technologies and Learning*, University of Brighton / Nesta Future Lab.

O'Brien, M. (2005) *enquire Programme Phase One – Interim Research Report* (South East Cluster), University of Sussex/ *engage*.

Pedlar, M; Burgoyne, J; Boydell, T. (2004) *A Manager's Guide to Leadership,* London: McGraw-Hill Business.

Pringle, E. (2005) *Gallery Education Literature Review,* London: *engage.*

Schön, D. (1983) *The Reflective Practitioner: How Professionals Think in Action,* London: Temple Smith.

Summerton, J. (May 2005) Seminar on Action Research, University of Sussex, *enquire* Programme

Willis, P. (1990) *Common culture: symbolic work at play in the everyday cultures of the young,* Milton Keynes: Open University Press.

Woolf, F. (1999) *Partnerships for Learning,* London: Arts Council England.

Notes

1 Pringle, E. (2006) *Learning in the Gallery: context, process, outcomes.* London: *engage*.

2 Willis, P. 'Symbolic Creativity' in Gray, A. and McGuigan, J. (eds.) (1997) *Studying Culture: An Introductory Reader.* London: Arnold.

3 for the SI research policy see http://www.sussex.ac.uk/si/1-7.html
http://www.sussex.ac.uk/si/1-7-10-1.html

4 See for instance http://www.sussex.ac.uk/education/profile831.html
http://www.sussex.ac.uk/si/1-7-6.html

5 http://www.sussex.ac.uk/education/profile53047.html

6 Paper delivered to the first national *enquire* seminar 19th May 2005

7 http://www.sussex.ac.uk/education/profile53047.html

8 See 'Cultural studies and cultural practice: an interview with Eddie Chambers' in *Teaching Culture: the Long revolution in Cultural Studies*, NIACE 1999; *'A Short History of the ICA'* in *British culture of the postwar: and introduction to literature and society, 1845-1999*, Routledge 2000 and *'A sufficient flow of vital ideas: Herbert Read from Leeds Arts Club to the ICA.'* Freedom Press, forthcoming.

9 http://www.casa.susx.ac.uk/cce/profile172599.html

10 http://www.artlab.org.uk/tate-sb.htm

11 http://www.casa.susx.ac.uk/cce/profile8899.html

12 *'Measuring the Outcomes and Impact of Learning in Museums, Archives and Libraries: The learning Impact Research Project End of Project Paper'* (1st May, 2003).

13 in Coffield, F (ed.) (2000) *Differing Visions of a Learning Society, Volume 1.* Bristol: The Polity Press

14 Wednesday 23rd November, 2005

Sample Questionnaires

Questionnaire used for teachers, artists, gallery educators

enquire programme - phase 1 – establishing research questions through dialogue with gallery educators, artists, educators and learners

Date _____

Name _____

Brief description of your work _____

Section A.

Do we share a common understanding of what we mean by learning?

1) Considering the list below, do you think of learning in the same way? (yes/no)

	yes/no
A focus on learners and their learning experiences	
Learning is a lifelong process of meaning-making	
Learning includes change and development in emotions, skills, behaviour attitudes and values	
Learning as verb (the act of learning) rather than a noun (learning/scholarship)	
Enjoyment, amazement or inspiration can provide the motivation to acquire facts and knowledge	
Learning is a process of identity-building	
Learning is both individual and social	

2) Now think about the work you do in a learning environment and consider the list from the following perspective:

A. If conditions for delivering the work **were ideal**is:

1= not important, 2 = somewhat important, 3 = important, 4 = very important

A focus on learners and their learning experiences	
Learning is a lifelong process of meaning making	
Learning includes change and development in emotions, skills, behaviour attitudes and values	
Learning as verb (the act of learning) rather than a noun (learning/scholarship)	
Enjoyment, amazement or inspiration can provide the motivation to acquire facts and knowledge	
Learning is a process of identity-building	
Learning is both individual and social	

B. When delivering the work, **conditions dictate that** ...is often:

1= not important, 2 = somewhat important, 3 = important, 4 = very important

A focus on learners and their learning experiences	
Learning is a lifelong process of meaning-making	
Learning includes change and development in emotions, skills, behaviour attitudes and values	
Learning as verb (the act of learning) rather than a noun (learning/scholarship)	
Enjoyment, amazement or inspiration can provide the motivation to acquire facts and knowledge	
Learning is a process of identity-building	
Learning is both individual and social	

3) Thinking about learning and the experiences you have had either as a learner or educator, what, if anything is missing from this list?

Some definitions

'Meaning-making' is used to refer to ways in which people rationalise, make sense of and/or respond emotionally to an experience, such as learning activity.

'Identity-building' is used to refer to the processes, conscious and unconscious, whereby individuals, groups and communities build representations of themselves.

Section B.

Can the effectiveness of gallery learning, or evidence of learning in the gallery, be measured through generic learning outcomes?

The five generic learning outcomes (GLOs) we start with are:

1) Please assign a value to each from the viewpoint of the work you do in galleries (scale = 1 to 5, where 5 is most valuable)

Increase in knowledge and understanding	
Increase in skills	
Change in attitude or values	
Evidence of enjoyment, inspiration and creativity	
Evidence of activity, behaviour, progression	

2a) Please take each of the GLOs in turn and write a quick list of things you do in galleries (projects, events, exhibitions), that align well with that GLO.

Increase in knowledge and understanding _____

Increase in skills _____

Change in attitude or values _____

Evidence of enjoyment, inspiration and creativity _____

Evidence of activity, behaviour, progression _____

2b) Now consider the list of GLOs from a different perspective, are any of them inappropriate to the work you do in a gallery setting? If yes, give a brief description of that activity.

Increase in knowledge and understanding

Increase in skills

Change in attitude or values

Evidence of enjoyment, inspiration and creativity

Evidence of activity, behaviour, progression

Section C

The contemporary gallery as a unique site for learning.

The Generic Learning Outcomes are about measuring and gathering evidence of individual learning. Another important area of investigation will be to establish what, if anything, is unique about the gallery as a learning environment and if it has an impact on the effectiveness of the GLOs.

1) Consider the environment and materials available to you as an educator / learner in a gallery setting. What makes this setting particularly well suited (or unsuited) to learning?

2) Which GLOs do not work well in the contemporary gallery setting because of the incompatibility of the environment and/or available learning materials?

1a) supporting material provided with questionnaires (teachers, artists, gallery educators)

enquire group discussions

The three phases of the en-quire programme are as follows:

1) questioning

2) activity

3) analysis

The first phase of the *enquire* programme will use the Generic Learning Outcomes (GLOs) piloted in the museum sector to position the research.

Using the GLOs in this first phase stems from a desire to:

a. make best use of existing research, especially work carried out in the culture sector in a domain that has obvious links to learning in the contemporary gallery environment;

b. test the appropriateness of the existing GLOs to the contemporary gallery sector and identify where there is alignment or contrast with the GLOs;

c. create a forum of enquiry from which the second phase of the *enquire* programme, the activity phase, can draw on to focus the action research element;

d. potentially establish a set of learning outcomes for the contemporary gallery sector which can be measured in addition to, or alongside, GLOs therefore safeguarding and deepening the growing body of research evidencing the impact of culture sector activity on learning.

Beginning a dialogue
What are the conditions for enabling learning in the gallery context?

Generic Learning Outcomes (GLOs) were established and piloted through the Learning Impact Research Project (LIRP) carried out by the Research Centre for Museums and Galleries (University of Leicester) on behalf of Re:source (now Museums Libraries and Archives Council) in 2003.

The research questions, drawn from the GLOs, are intended to open a dialogue with gallery educators, artists, educators and learners, either in or outside of formal education settings, working in a contemporary gallery environment. For the purposes of this study we take contemporary gallery environment to mean work emanating from the gallery. This includes work taking place in galleries as well as work carried out in schools and in the community.

Methodology
The approach to this phase of work is consultative. We want to create a forum of enquiry that will focus the action research of the second phase. The questions are gathered under section headings to provide a stepped approach to carrying out a facilitated discussion involving small groups (six to eight participants) of:

Gallery educators – employees or freelancers working for galleries to deliver learning/education programmes in the gallery environment (on or off site).

Artists – practitioners working with learning/education projects in the gallery environment (on site or off site) as part of the development of their own arts practice.

Teachers – individuals involved in arts-based projects devised for schools through the gallery environment.

Youth arts workers – individuals working in an arts setting or using the arts as a mechanism for engaging young people.

Young people – individuals in formal education and individuals currently outside the formal education system.

Participants will not be named in any research findings except by prior consent.

The Learning Context

Do we share a common understanding of what we mean by learning?

The GLOs came out of a research project, which adopted the following learning theory:

- a focus on learners and their learning experiences;

- learning is a lifelong process of meaning making;

- learning includes change and development in emotions, skills, behaviour attitudes and values;

- learning as verb (the act of learning) rather than a noun (learning/scholarship);

- enjoyment, amazement or inspiration can provide the motivation to acquire facts and knowledge;

- learning is a process of identity-building;

- learning is both individual and social.

What can be measured using these GLOs?

The LIRP Project Report provides detailed descriptions of each of the GLOs from which the following summaries have been drawn:

Increase in knowledge and understanding

- Learning new facts and information or using prior knowledge in new ways. Knowledge and understanding includes the development of a more complex view of self, family, neighbourhood, or personal world.

Increase in skills

Knowing 'how to' do something via

- intellectual skills (reading, thinking critically and analytically, being able to present a reasoned point of view);

- key skills (numeracy, communication, use of ict, learning how to learn);

- information management skills (locating information, using information management systems, evaluating information);

- social skills (meeting people, showing an interest in the concerns of others, team working);

- emotional skills (managing intense feelings, channelling energy into productive outcomes, recognising feelings of others);

- communication skills (writing, speaking, listening, presentations);

- physical skills (running, dancing, manipulating materials to make things);

- change in attitude or values;

- change in feelings, perceptions, or opinions about self, other people and things and the wider world. Being able to give reasons for actions and personal viewpoints;

- evidence of enjoyment, inspiration and creativity;

- evidence of having fun, of innovative thoughts, actions or things. Evidence of exploration, experimentation and making;

- evidence of activity, behaviour, progression;

- what people do, intend to do or have done. Actions that can be observed or people may report that they have done.

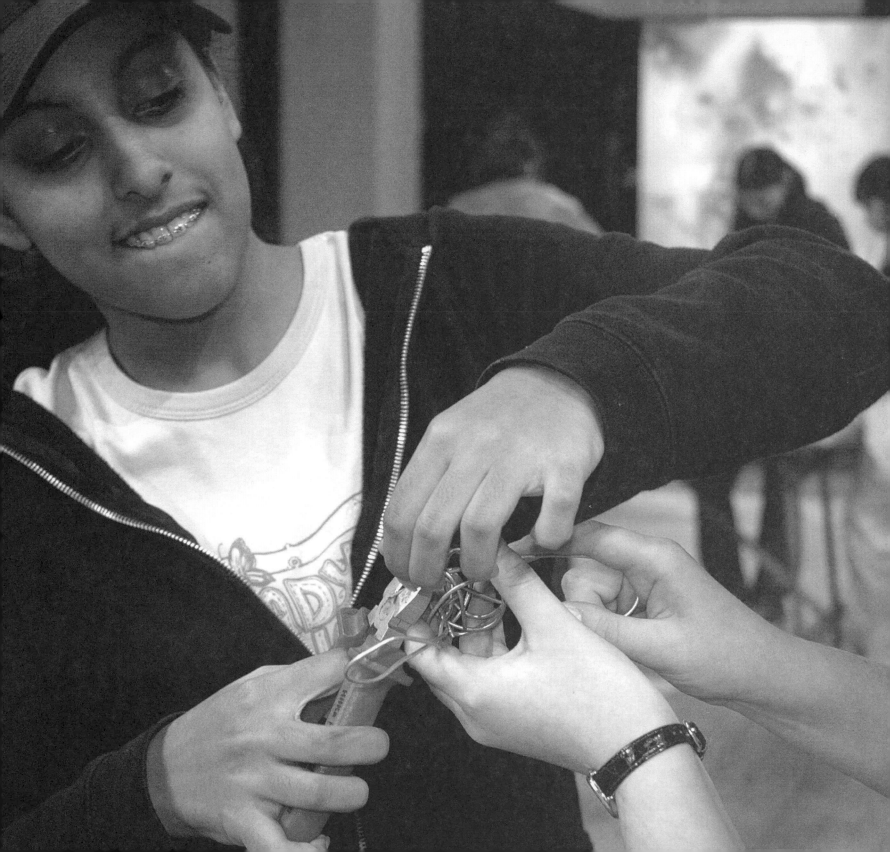

enquire programme – phase 1 – establishing research questions through talking with gallery educators, artists, educators and learners

Questions used with young people not in full time education

enquire programme – planning our research

The *enquire* programme will look at what makes learning in a gallery different from learning in traditional settings like the classroom. To do this research we need to come up with some questions that we want to answer.

We are interested in your views and that is why I am here to talk with you today.

The things I want to talk with you about are:

1) when you are taking part in an art project do you think you are learning new things?

Do you think you are picking up new skills or facts or both? What are they?

2) Does this way of learning feel different than at school?

What words do you use to describe this, can you give me some?

3) Making art is something you can do on your own as well as in a group, has it mattered that you worked with other people? That includes Jane and Richard.

Do you think you are allowed to do things during an art project that you are not able to do in other places where you are 'expected' to learn something? What are these things?

Questions used with young people in full-time education

Thursday, 21st April 2005

Name _____

School _____

Year group _____

enquire programme - planning our research

The *enquire* programme is an 18-month research project involving galleries, schools and a university across the south east region. *enquire* will look at what makes learning in a gallery different from learning in traditional settings like the classroom.

I am interested in your view of what it's like taking part in projects that bring visual art into your school or that take you out of school to galleries. In particular, I want to talk with you about what you are learning through these experiences.

This workbook provides a format for gathering your thoughts so that I can consider them alongside the views of other learners, artists, gallery educators and teachers. We will also spend some time today just talking about what you think about contemporary art and about the opportunities available to you to explore the arts, either at school or outside school.

Section A

Does everybody have the same idea about what learning is?

1) Everyone thinks and feels different about learning. Here is a list of ways learning can be described, do you think of learning in the same way?

	yes/no
Learning is about individual people and their experiences	
Learning is something you do all through your life, it is how you get to know the world around you	
Learning can change your emotions, your behaviour and your attitudes and values	
Learning develops skills	
The act of learning is as important as what you learn	
If learning is enjoyable, inspirational or amazing it helps you to remember facts and motivates you to want to know more	
Learning helps people define who they are	
Learning is something you can do alone or with other people	

2) Do you have any other thoughts about what learning is that you would like to share?

Section B.

What do you think you get out of participating in art projects or visiting galleries?

Taking part in art projects can do lots of things. You can learn new skills, get to know new people and go to places you might not have thought about visiting. They can give you a chance to express your views, have fun and be challenged by new ideas.

I would like to know about your personal experience of taking part in projects, about the things you think you have achieved and anything you think you got out of an art project or a visit to an art gallery.

Have you ever learned about something new or understood something better through art?

Can you describe what it was?

What skills do you learn through taking part in art projects or visiting galleries?

Have you ever changed your attitude to something during an art project or a gallery visit?

Can you say what it was that changed and why you think it happened?

Do you find taking part in art activities enjoyable?

How do you feel when you are working on art projects?

Do you think doing art projects or visiting galleries has helped you at school?

If you think it has can you say how?

Section C.

Art galleries and art projects – what is different about them?

In the last section you told me about your experience of taking part in art projects or visiting galleries. I didn't ask you to be specific about where you worked but now I want you to think about that.

Sometimes you take part in projects at school, for example when an artist comes in to work with you; other times you might go out to galleries. What I would really like to know is whether you notice any difference between your everyday school environment and the atmosphere or settings that art projects and visits to galleries take place in.

It is not an easy question so we are going to discuss it as a group. And in a way it is more than one question because some of you may have visited galleries with school and some may not have; this doesn't matter, just tell me about the experiences you have had.

You can use the space on this page to jot down a few of your own thoughts.

1) Does learning through activities you do in galleries feel different than your everyday learning at school?

What words would you use to describe this?

2) Does learning through art projects that take place at school
feel different than your everyday learning?

What words would you use to describe this?

3) Is there a difference between the things you can do during
activities in a gallery and the things you can do during
everyday school activities?

What are these things?

4) Is there a difference between the things you can do during art
projects that take place at school and the things you can do
during everyday school activities?

What are these things?

NORTH EAST CLUSTER RESEARCH REPORT

Report on research undertaken by BALTIC, the Laing Art Gallery, Hatton Gallery, Amino and ISIS Arts in collaboration with the International Centre for Cultural and Heritage Studies, University of Newcastle, and partner artists and teachers.

Final report by Andrew Newman and Chris Whitehead, International Centre for Cultural and Heritage Studies, University of Newcastle, in collaboration with Judy Thomas (BALTIC), Jean Taylor (Hatton Gallery), John Quinn and Sharon Bailey (ISIS Arts), Becky Davies (Laing Art Gallery), Ben Ponton (Amino), Iain Wheeldon and Nisha Duggal (*enquire* coordinators).

Contents

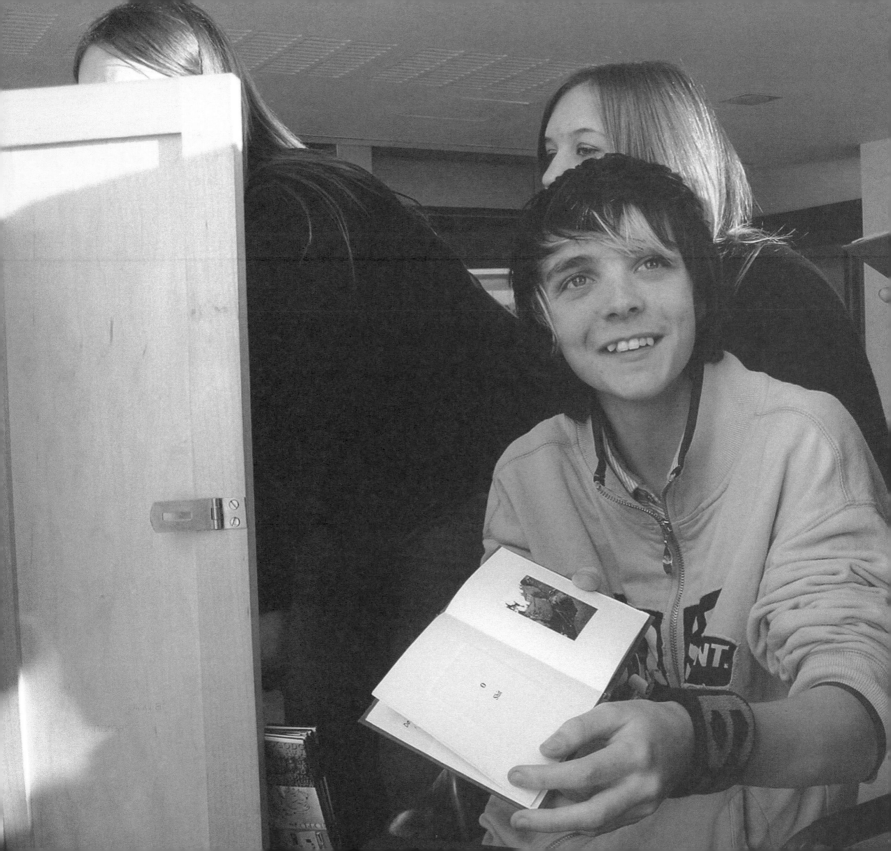

Research question

The primary research question which this project addresses is:

How do gallery learning activities contribute to participants' development of capital?

This can be further articulated as follows:

i. Are there identifiable shifts in human, cultural and social capital resulting from, or taking place within, contemporary gallery education activities?

ii. If so, how and why do these shifts take place, and what are their outcomes?

iii. Does art, and does the gallery context, provide special conditions for shifts in capital, and what are these conditions?

The context for the research at Newcastle University

The research team is drawn from the International Centre for Cultural and Heritage Studies, which has numerous research-active staff and doctoral students, a strong research culture and an emphasis on interdisciplinary, collaborative research. The core disciplinary areas are museum, gallery and heritage studies. Individual team members bring to this project significant expertise in, and experience of, conducting qualitative research in relation to museum and gallery visiting and participation in museum and gallery education activities. In particular, members of the research team have been involved in:

i. 'The Contribution of Museums to an Inclusive Community: an exploratory study' – funded (ESRC) project examining the contribution of museums to the inclusive community (ref R000223294), the findings of which also inform this project in that they provide insights into the impact of museum visiting on individuals,

ii. 'Five Arts Cities' research project (funded by Arts Council England and Channel 5) which looks at the impact upon older people's lives of participation in gallery education activities,

iii. DfES-funded Museums and Galleries Education Programme 2 (Stanley et al 2004),

iv. 'Artist's Insights' research project (funded by Arts Council England and the Museums, Libraries and Archives Council), exploring the impact of writers and visual artists working with young people and educators/facilitators in cultural sites and schools,

v. General and extensive research into theoretical and historical museology and into art theory.

Of particular relevance for this project are numbers i and ii, both of which use theoretical frameworks derived from studies in cultural capital. The ESRC-funded project on the inclusive community identified problems with cultural policy in relation to the instrumental use of museums and galleries to address problems of social exclusion, and proposed solutions using forms of capital as an analytical framework. (Newman and McLean 2004a and 2004b; Newman, McLean and Urquhart 2005; Newman and McLean 2006) The 'Five Art Cities' project evaluated the responses of over-50s to British Art Show 6 and to associated education activities (artists' talks and artist-led workshops), examining the ways in which cultural capital enabled subjects to respond (be it positively or negatively) to contemporary art (Newman and Whitehead 2006).

Theoretical frameworks: human, cultural and social capital

Rationale for the theoretical framework

This research project adopts theoretical frameworks from studies in human, social and cultural capital. While this relates to previous and concurrent work done by the researchers, it has been chosen for this project because it allows for a wide understanding of the ways in which learning processes contribute to the development or consolidation of opportunities available to individuals in broad social and cultural contexts. Using the framework of capital allows us to consider:

– why and how people learn – what cultural and social factors and knowledge potentialise learning?

– ways in which learners 'personalise' and use learning experiences;

– why individuals are unable or unwilling to learn some things;

– how learning is made manifest by individuals;

– what learning experiences might mean in terms of broader structures such as individuals' well-being and careers, social groupings and lifestyle or other choices.

In this sense, capital furnishes a theoretical framework involving highly contextual and nuanced understandings of learning as a phenomenon which may involve one or more of the following with infinitely variable degrees and ratios of importance:

– acquisition of knowledge and skills;

– shifts in behaviour, understanding and affect (DeSimone, Werner and Harris 2002);

– shifts in self-image, self-awareness and identity;

– shifts in interpersonal relations and abilities;

– shifts in aspirations and leisure choices.

Further benefits of using capital as a theoretical framework are that: i) it allows the research to make use of an established body of theory in a new context and ii) it relates to broader preoccupations in cultural policy about the wider ramifications of individuals' engagement with the arts, e.g. the broad personal, social and (ultimately) civic benefits which have long been seen to be consequent upon such engagement (Mason 2004).

In this way, the proposed research project differs from many studies into museums and learning, which have focused primarily on whether, and to what extent, visitors learn about the topics which curators (and not educators) intended that they would and upon identifiable 'outcomes' (as in ILFA) which suggest finality and do not account for ongoing learning or the active processes involved in it (Hooper-Greenhill 2004). The breadth of this view of learning is also greater than the notion of 'meaning making'

which has been used by Hooper-Greenhill et al (2001a and b) to analyse visitors' conscious responses to, and interpretations of, works of art within historical art museum contexts (this research was also purposefully limited in other respects, such as the exclusive use of lone adult subjects from social groups C1 and C2).

While influenced by the definition of informal learning generated by the UNESCO Faure Report (1972) ('the truly lifelong process whereby every individual acquires attitudes, values, skills and knowledge from daily experience and the educative influences and resources in his or her environment ...'), the view of learning suggested here also involves emphasis on learning as a constructive process rather than merely an acquisitional one, acknowledging, through the framework of capital, the importance of prior knowledge, affect and social interaction within it. In this context the study acknowledges Sfard's (1998) resistance to the development of a 'consistent global theory' of learning and her appeal for the use of both 'acquisitional' and 'participatory' metaphors for learning in research: the former suggests that learning involves the acquisition of knowledge as 'data' or 'content', while the latter contextualises learning as constructive participation in communities of practice which have their own dynamic norms and languages.

Capital

The sociologist Pierre Bourdieu described capital as representing 'the immanent structure of the social world, i.e., the set of constraints, inscribed in the very reality of that world, which govern its functioning in a durable way, determining the chances of success for practices'. In this context it has been broadly used to explore what Bourdieu called 'inequality of opportunity' amongst individuals and the importance for this of accumulation (of knowledge, skills, behaviours etc.):

'Capital, which ... takes time to accumulate and which, as a potential capacity to produce profits and to reproduce itself in identical or expanded form, contains a tendency to persist in its being, is a force inscribed in the objectivity of things so that everything is not equally possible or impossible. (1997: 46)'

The concept of capital, in its various forms, has been used in a growing number of publications in sociology and museology to describe the benefits that might be accrued by individuals through developing certain knowledge, attitudes, skills and abilities. In museological literature, Bourdieu's work on 'cultural capital' (1984) has had much currency, in part because of Bourdieu and Darbel's (1966) application of the concept to the understanding of the ways in which visitors behave in museums and galleries and the relationship between social class, education and an individual's ability to engage with high culture (fine art, theatre etc.). This has had a profound influence on museum, gallery and heritage practices, particularly in relation to the emphasis given to considerations of intellectual and attitudinal access in current policies guiding the management, interpretive practices and educational programmes of cultural sites.

However, a further body of literature explores the interdependent nature of forms of capital (e.g. Bourdieu 1997, Coleman 1998; Cote 1996), suggesting that viewing human, social and cultural capital as discrete and autonomous forms may be artificial and potentially misleading. It should also be noted that understandings of the forms of capital with which this research is concerned are varied; for example, Bourdieu's understanding of cultural capital has been critiqued for its overemphasis on social class structures (du Gay et al 1997: 98), while more recent research (e.g. Newman and McLean 2005) has taken a broader view of what, beyond 'high' culture, can constitute cultural capital. This brief introduction to capital will look at each form singly before noting some of the ways in which their interdependencies have been modelled. Finally, it will discuss the relationship between forms of capital and notions of learning within the gallery and outside.

Human capital
Human capital has been defined as 'the knowledge, skills, competencies and attributes embodied in individuals that facilitate the creation of personal, social and economic well-being' (Healy et al., 2001: 18). It is often also seen in terms of 'economically salient personal resources' (Gershuny, 2002: 8) where investments have, or may have, a direct financial 'payoff' in terms of employment.

Côté (2001) states that the term 'human capital' was first used in the early 1960s by economists such as Schultz (1961) who considered the idea of viewing human beings as a form of capital who are invested in and who invest in themselves. He stated that human capital was increasing at a much greater rate than non-human capital and this was responsible for a significant proportion of post-war economic progress.

Becker (1993) used the economic returns of educational attainment as a way of measuring human capital. He showed that the average income of those with higher education was greater than the income of those without. However, Côté (2001) criticised such an approach as it ignores the complex nature of human learning which occurs over a lifetime. Much research has focused on the economic benefits of the acquisition of knowledge and skills but other research has demonstrated its wider social benefits (Behrman and Stacey, 1997). The acquisition of human capital appears to have a beneficial impact upon health, reduces crime and increases civic participation.

Social capital
Social capital has been the focus of an extensive body of research and literature. For example, Putnam (2000), charting the decline of political and community participation in north American society, presented evidence linking social capital with health and happiness, democracy and safe and productive neighbourhoods. Veenstra (2001) has also undertaken research linking social capital with health. 'Social capital' is based upon the relationships between people and the concept has called attention to the importance of civic traditions (Côté, 2001).

Three types of social capital have been identified: bonding, which refers to links with members of families or immediate circle; bridging which refers to links with distant friends, associates and colleagues; and finally linking, which refers to relations between different social strata, or between the powerful and less powerful. It is viewed (Healy, Côté, Helliwell and Held, 2000: 39) as relational, not being the property of a single individual and produced by investments that are not as direct as investment in physical capital. A further source of social capital is seen as civil society and the development of associations and voluntary organisations. The greater the investment in social capital amongst a group the greater the social cohesion of that group

will be. Notably, the existence of high levels of social capital can also be seen negatively; in particular the prevalence of bonding has been related to the development and maintenance of insular communities (for example, Putnam (2000) discusses high-social-capital groups such as 'exclusive' golf clubs and the Klu Klux Klan and notes that investments in social capital are not always benign or benevolent).

Cultural capital

Cultural capital was described by Bourdieu (1997) as existing in three forms: in an embodied state, an objectified state in the form of cultural goods, and in an institutionalised state that confers original properties on 'cultural capital' that it is presumed to guarantee, for example educational qualifications. Gershuny (2002: 8-9) defines it as, 'knowledge related to the participation in, and enjoyment of the various forms of consumption in society', where 'specific knowledge about consumption contributes to an individual's satisfaction with their consumption'. As stated, Bourdieu's work on cultural capital has been particularly influential in the field of museology, in part because the consumption of art museum experiences was a focus of Bourdieu's own research in 1960s' France. Bourdieu and Darbel (1966) stated that, 'it is indisputable that our society offers to all the pure possibility of taking advantage of works (of art) on display in museums, it remains the case that only some have the real possibility of doing so.' They go on to say that the time a visitor takes to view a work of art is directly in proportion to the ability of the viewer to decipher the range of meanings that are available to them. Works of art, when considered as symbolic goods, can only be fully understood by those who have sufficient 'cultural capital' to interpret the coded meanings held within them and this may be correlated with educational attainment.

At the same time, the museum or gallery itself as an environment and an institution represents a 'test' for visitors, who are expected to engage in certain intellectual and behavioural practices which may be 'second nature' or may be highly unfamiliar (e.g. forms of aesthetic appreciation, the comprehension of messages encoded in display and decorousness in body language and physical and verbal actions) (Whitehead 2005). In this context a visitor's cultural capital can make the difference between his or her experience of the museum or gallery as a comfortable environment or as a daunting and confusing one (see Bourdieu and Darbel 1966).

Interdependencies between human, social and cultural capital

The relationship between cultural capital and human and social capital is complex, but it is widely believed that they are fundamentally contingent upon one another. Bourdieu (1997) saw human capital as being dependent on cultural capital, and that the volume of social capital is dependent on the size of the networks that can be mobilised and on the volume of the other forms of capital held by those with whom the connections are being made. He also emphasised the fundamental importance of family (i.e. social) relations in the transmission of cultural capital. Willms (2001: 55) pointed out that, 'people become members of social networks by learning the language of the culture, and using it to engage in social relations'. Coleman (1988), (also quoted in Healy, Côté, Helliwell, and Held, (2001)) states that, 'the role of strong communities and trust among parents, educators and pupils in fostering education and learning can support habits, skills and values conducive to social participation.' In this sense it is possible to think in terms of capital formations in which human, social and cultural capital are in dynamic interrelationships; as it were, a shifting map of individuals' abilities to access opportunities. The ramifications of the interdependency of these forms of capital for methodology, data collection and analysis will be discussed below.

Forms of capital and notions of learning within the gallery and outside

The learning outcomes suggested by the use of human, social and cultural capital in the framing of this research include, but are not limited to:

- changes in capital formations,

- increased understanding of art as a body of practices, products, technologies and heuristic/intellectual approaches (e.g. valuing subjectivity, trial and error and calculated risk-taking),

- increased familiarity with, and ability to use, the experiences of making art, viewing art and visiting art galleries,

- increased social interaction through engagement with art (i.e. making, critiquing, showing and displaying) with family members (bonding) peers (bonding and bridging), and others, including gallery staff and artists (linking),

- increased understanding of role of art in social, professional, economic and personal life,

- increased understanding of possible economic or employment benefits of engaging with art,

- increased self-interrogation about career plans in relation to engagement with art and the contemporary art gallery.

Clearly, the other important focus in this context is the extent to which such outcomes were anticipated or intended (consciously or unconsciously) by teachers, education staff and artists involved in the delivery of gallery education projects.

Definition of terms

Human capital: the knowledge, skills, competencies and attributes embodied in individuals which facilitate the creation of personal, social and economic well-being and; economically salient personal resources where investments have, or may have, a direct financial 'payoff' in terms of employment.

Social capital: Putnam defines social capital as the 'norms of reciprocity and networks of civic engagement' as well as trust, all of which 'can improve the efficiency of society by facilitating coordinated actions' (1993: 167). Numerous other definitions exist, most of which focus on networks of relationships (and the development thereof) between persons, groups, communities and institutions, and engagement in collective, collaborative or shared activities to achieve mutual benefits.

Cultural capital: accumulated knowledge of, and familiarity with, (bourgeois or other) cultural practices which enable individuals to behave appropriately (i.e. according to social norms) within given contexts and to decode stimuli (e.g. artworks).

Capital formations: the dynamic interrelationships between human, social and cultural capital within individuals; the nature of the contingency of different forms of capital upon one another in relation to individuals' ability to access opportunities of various kinds (e.g. building skills, accessing networks and bodies of knowledge, learning behaviour etc.).

Research ethics

Ethics were of prime importance in the planning and conduct of the project, in particular because it involved human subjects. The following principles were applied.

1. Honesty to research staff and subjects about the purpose, methods and intended and possible uses of the research, and any risks involved.

2. Confidentially of information supplied by research subjects and anonymity of respondents.

3. Independence and impartiality of researchers to the subject of the research. The project was managed in accordance with Newcastle University's Code of Good Practice in Research (1) and the British Sociological Association Code of Conduct, the Social Research Association Ethical Guidelines and the Market Research Society Code of Conduct.

Introduction

The organisations that undertook educational activities funded by the *enquire* programme in the North East were:

- Laing Art Gallery, Tyne and Wear Museums

- BALTIC Centre for Contemporary Art

- ISIS arts

- Hatton Gallery, University of Newcastle

- Amino

Research was undertaken on projects run by the BALTIC, Laing Art Gallery and ISIS arts. The Hatton Gallery and Amino were not involved because their projects did not coincide with the research period. Summary baseline data for the three organisations who took part in the research programme has been included as an appendix (page 154). The research for the North East cluster was carried out between December 2004 and March 2006.

The following describes the organisations, activities and schools in detail, taking each of the host organisations in turn.

Laing Art Gallery (6)

The Laing Art Gallery is part of Tyne and Wear Museums which is a federation of 11 museums and galleries on Tyneside and Wearside. Collectively, they attract over one million visitors a year (1,277,739) in 2002/2003). The Laing was founded in 1901 by Alexander Laing, a Scottish wine and spirit merchant. The building was opened in 1904. The Laing houses an extensive collection of British oil paintings, watercolours, ceramics, silver and glassware. The collections are of national and international significance and are of Designated Status.

The specific activities are detailed below:

April 11-14 What do artists do?

http://www.ofsted.gov.uk/reports/108/108480.pdf
http://www.twmuseums.org.uk/laing/ [accessed 20/4/2006]
Pupils visited the Laing to look at contemporary and historical art and begin discussion about art, artists and the studio visits.

Summer term week beginning 25 April 2005
Artists in the City

Eight half-day visits/workshops were arranged for pupils with the artist studios at 36 Lime Street, Newcastle. Pupils were given the opportunity to explore the ways in which artists' lives and work are influenced/inspired by their environment, in this case the inner city. Pupils participated in question and answer sessions and hands-on art activities and documented their visits and findings using project books and blue digital cameras.

Summer term week beginning 11 July 2005
Artists in the countryside

Eight half-day visits/workshops were arranged for pupils through the Tynedale artists' network, Northumberland. The aim of this was to give pupils the opportunity to explore the ways in which artists' lives and work are influenced/inspired by their environment, in this case the Northumberland countryside. Pupils participated in a hands-on activity and question and answer sessions with the artists. The pupils documented their visits and findings using project books and blue digital cameras.

The exercise evaluated was part of the Artists in the Countryside project. It involved pupils from Thomas Walling Primary School visiting an artist (Jim Dearden) working in his studio in Ashington, Northumberland. The activity involved the pupils making simple animation in the form of thaumatropes and kineographs (flicker books).

The project fits in with the specific aims of the Laing Art Gallery of working with local communities and increasing participation and providing opportunities for audiences to engage with and understand art.

The learning outcomes for the pupils were to:

- develop knowledge and understanding of the work of artists;

- explore the meaning and place of the artist in society;

- learn to respond to and evaluate art;

- develop investigation and communication skills;

- learn new skills;

- encourage creativity, inspiration and enjoyment.

The learning outcomes for teachers were to:

- provide inspiration for follow up work done as part of the project;

- develop increased confidence in working with artists and the gallery;

- provide an opportunity to share and develop ideas with other teachers, artists and gallery staff;

- achieve repeat visits to gallery as individuals or with class.

Thomas Walling Primary School was last inspected in January 2003; it is bigger than most primaries and admits pupils aged three to eleven. It is situated in a large estate of, mainly, local authority-owned housing on the west side of the City of Newcastle upon Tyne. There is very high unemployment and a high level of deprivation. The school is housed in a modern building on two sites. There are now 360 pupils on roll, with 173 boys and 152 girls in the main school and 35 pupils who attend the nursery part-time. Children enter the nursery with a broad range of attainment but most have very low language, literacy and social skills for their age. The school is part of an Education Action Zone (EAZ) and has been chosen for a Sure Start site aimed at developing pre-school education and links with parents. There are seven pupils identified as having English as an additional language, and all are at an early stage of acquiring English. There are eight pupils from asylum seeking families. 59% of pupils are eligible for free school meals, well above the national average.

The Ofsted inspection report states:

'Thomas Walling Primary School provides a satisfactory education for all its pupils. However, there are some weaknesses. The leadership and management of the school are mainly sound and the acting head teacher has worked well with the governing body to begin to identify needed improvements. In past years, key staff have had a very limited role in identifying, managing and monitoring the implementation of priorities. The effectiveness of many initiatives has not been evaluated sufficiently over time to ensure their impact on the work of the school. Teaching is satisfactory overall, with good teaching in the nursery and reception classes (the Foundation Stage), and in Year 2. Although standards by the age of elevan are well below average in English and mathematics, there are high numbers of pupils with special educational needs in the current Year 6 and this adversely affects the school's performance.'

BALTIC Centre for Contemporary Art (2)
Housed in an ex-industrial building on the south bank of the River Tyne in Gateshead, BALTIC is the biggest gallery of its kind in the world, presenting an international programme of contemporary visual art. BALTIC has no permanent collection.

BALTIC is funded by Arts Council England, North East; Gateshead Council; European Regional Development Fund; and English Partnerships through One North East (the North East Regional Development Agency). One third of BALTIC's income is raised through corporate sponsorship, support from individuals and charitable organisations, directly contributing to its programme and education work.

High Spen Primary School Project
For *enquire*, a class from High Spen School visited BALTIC and took part in a workshop with Miles Thurlow (BALTIC Freelance Artist) who then delivered a session at the school.

Twenty Year 6 pupils came to BALTIC with teacher Ruth Whiteside. For nearly all of the pupils it was their first visit to BALTIC. The pupils worked in a studio session exploring materials and the sculptural form. Within the visit the pupils also had exhibition tours of all of the galleries and an exploration of the quayside.

As a follow up to the BALTIC visit, Miles Thurlow ran a studio session at High Spen School on 19 April working with the same 20 Year 6 pupils and with teacher Ruth Whiteside. No special groups were targeted.

The aim of the project was to develop relationships with High Spen Primary School. The project supports the BALTIC's mission which is to:

'Encourage and support people of all ages to explore, experience, create, enjoy, be challenged by and participate in the art of our time.'

The intended learning outcomes of the project were:

• practical ways of working with an artist in their school and at BALTIC;

• continuing to work with the same group of pupils so that they are comfortable in a gallery setting working with contemporary art as their starting point.

The intended learning outcomes for the teachers involved were:

• benefits of being involved with research.

High Spen Primary School has 145 pupils on roll, and a further 18 children attend an attached nursery. The pupils come from a wide range of backgrounds. Attainment on entry is varied but below the average for the Education Authority. Nearly all pupils are white and British. A higher than average number of families move into or leave the area each year. The school was last inspected (3) in January/February 2006 the report states:

'The school stands at the very heart of the community and is held in high esteem by parents, pupils and the local authority. Good teaching is the norm. This leads to pupils learning well from the start of the Foundation Stage. The curriculum is good and includes many exciting activities. Exceptional care and guidance contribute to pupils' outstanding personal development and well-being. It is especially effective in aiding the emotional development of children in the Foundation Stage, preparing them particularly well for entering Year 1. The school recognised that 'every child matters' long before the phrase became so well publicised.'

ISIS Arts (4)

ISIS Arts develops and manages artist-led residencies, exhibitions and events. With an active new media studio, ISIS provides a valuable environment for the creation of new media artwork. ISIS Arts is a not-for-profit organisation and receives revenue funding from Arts Council England, North East; Northumberland County Council; and Newcastle City Council. The new media studio has been made possible by support from the Lottery and Northern Rock Foundation.

Big M Media Labs Project

http://www.berwickhighschool.co.uk/ [accessed 20/4/2006]

http://www.isisarts.org.uk/index2.html [accessed 20/4/2006]

The project centred on the inflatable gallery space the 'Big M' and involved artist/ teacher/ student labs to produce new media work. The project involved a group of young people from Berwick Community High School (5). These consisted of two groups working together, one group taking 'A' levels and the other taking GNVQs and about to leave school. The project involved these pupils making video art together with artist Kelly Richardson. The project was planned to coincide with Berwick Film Festival, part of which involved the 'Big M' showing video art.

The project supports the organisation's mission statement:

'To promote access, experience and understanding of contemporary arts practice. To produce high quality artistic and educational experience.'

The intended learning outcomes of the project for pupils were to:

• gain experience and understanding of contemporary arts practice;

• gain access and ownership of art as culture.

The intended outcomes for teachers were to:

• gain experience and understanding of contemporary arts practice.

Berwick Community High School is a comprehensive school that was last inspected in October 2001. It is situated on the south side of the River Tweed, and serves the town of Berwick and the rural communities in the locality. There are 787 pupils aged 13 to 18 years, 396 boys and 391 girls. The school is virtually the sole provider for Sixth Form pupils in the region and offers a good range of AS and A Levels subjects, but a small range of vocational qualifications at present. About 10% of pupils have special educational needs (SEN), of which 3% have a statement. 11.4% of pupils are entitled to free school meals, which is below average. The area the school serves is mixed, with some significant social deprivation. The most recent Ofsted report states:

'This is an improving school although some of the improvements have only begun recently. Through determined and purposeful educational leadership and management the school is now effective in promoting good behaviour and positive attitudes and relationships. However, it has yet to see the benefits of the new approaches to improving students' attainment reflected in examinations and test results. It is now providing an overall satisfactory quality of education for its pupils.'

Methodology

Research question

How do gallery learning activities contribute to participants' development of capital?

The above research question has been used to address the aim of the *enquire* programme – to explore and identify the conditions for maximising the transformative potential of gallery education for young people.

The research has been qualitative in approach, which is considered the most appropriate method for the analysis of complex feelings and attitudes. The methodologies used consisted of interviews and focus groups. These took between 35-120 minutes and were digitally recorded and then transcribed. The resulting transcripts were analysed using QSR Nvivo 1.20 software, which is designed to identify patterns within the data. The projects have been fully documented and images and video used when possible.

The data collection and analysis were guided by frameworks derived from the constructs of human, cultural and social capital, as explored in section 2. As stated therein, the forms of capital, while distinct, are related. For example, investments in social and human capital might result in forms of cultural capital that have a range of benefits to the individual and group.

In order to resolve the research question it is important to determine the impact of the involvement in gallery learning activities on participants' lives as far as possible given the timescale and the qualitative mode of research. Therefore, the research consisted of three main elements. Firstly, a 'baseline' upon which the rest of the research can be grounded was established. In order to do this the amount and types of capital held by respondents was determined. The nature of the participants' cultural consumption and their knowledge of, and attitudes towards, contemporary art was explored. This involved developing an understanding of participants' home and social lives. Data was collected using focus groups or semi-structured interviews (the researcher used a series of questions, some of which would be common to other interviews to provide a point of comparison). The sort of baseline questions asked related to:

Children and family groups

- Work / educational attainment
- Neighbours/membership of organisations/volunteering
- Socialising
- Transport
- Housing
- Trust/community life
- Health
- Politics/voting
- Belonging
- Motivation/confidence
- Alienation
- Activities/leisure time
- Art Galleries
- Attitudes/knowledge about art (esp. contemporary)

In particular, two interrogative frameworks were developed for use within focus groups. The first of these aimed to capture data relating to capital in broad ways; the second relates specifically to the practice, consumption and understanding of art. While the frameworks guided data collection, it was not possible (or desirable) to use them in a rigid way. The semi-structured nature of discussion meant that some topics were not encountered in the order suggested below; also, the age of the subjects influenced which of these lines of enquiry were pursued and how questions were framed. The final question in interrogative framework 1 was intended to act as a bridge into interrogative framework 2, which is articulated in pre-activity and post-activity configurations in order to capture data relating to shifts in capital over time.

Table 1: focus group interrogative framework 1

Work / educational attainment	Attitudes towards school – like / dislike
Socialising	Friends – how often see them? Where?
Organised leisure/ etc. participation	Clubs; Scouts; dance; sport; church Parental involvement?
Transport	Car at home? How do you get about? Is it easy?
Housing	Experience of crime?
Health	In good health?
Belonging	What do you feel about where you live?
Motivations/ esteem	Do things on own? What things do you think you are good at? How do they make you feel?
Alienation	When and where do you feel uncomfortable?
Activities/leisure time	What do you like to do?
Politics/voting	What do you think about politics, the political parties and voting? Who do you think you might vote for in future?
Art Galleries	Have you been to an art gallery before? With whom? Why? How did you feel about it? How frequently do you visit?

Table 2: focus group interrogative framework 2

Pre-activity	Post-activity
What do you think about art?	Did you enjoy the activity? Why?
Do you like doing art? Why?	What did you do with the work you produced?
What artists do you know? Do you know any who are still alive?	Did you do any others? How many? With whom? Did you show them to anyone?
Do you have a favourite artwork?	What was the technique you were using? (e.g. animation)
Do you watch TV programmes about art? Which ones? How often?	Do you know how else that technique is used?
What do you know about the activity next week with the artist? What do you expect? Are you looking forward to it?	Did you enjoy working with the artist and with others? In what ways?
How do you think artists work?	What did you think about the way s/he worked?
What will you ask the artist?	What did you ask the artist?
Would you like to be an artist?	Would you like to be an artist?

Further data was collected through semi-structured interviews with teachers, artists and gallery education officers (although in fact only one of the three artists was available for interview). Here, questions included:

The aim has been to provide a rich sense of the complexity of subjects' lives, experiences and values and the importance of gallery-based learning activities to these.

Teachers/facilitators/artists

- Success in learning outcomes

- Perceived impact, e.g. change in behaviour – transformative impact

- Relationship to existing classroom work

- The ways in which this project is different from others

- The impact of context

- Whether pupils gained satisfaction from the project

- Whether pupils demonstrated increased confidence in gallery context and increased self-esteem

- Whether teachers/facilitators/artists would change anything if the activity were to be repeated

Further data was collected through (non-participant) observations of the activities in which the pupils engaged.

It should be noted that the qualitative mode of research, and, in particular, the reliance on data from focus groups and interviews, meant that the coding of data is dependent on the researchers' judgment. The subjectivities and personal interpretive acts involved in this must be acknowledged, particularly when dealing with very young subjects whose articulacy is relatively undeveloped. However, researchers undertook blind inter-coding and achieved high levels of congruence. In addition, the short timescale did not always aid in the identification of shifts in capital formations, which can be complex, slow and accumulative processes; this gives researchers' observations a somewhat speculative cast on occasions (although this is not to imply that such observations are without value in the context of the aims of this research).

It is also important to clarify that, given the small number of subjects involved in the research, the data and analysis cannot be generalised. This is also a consequence of the unique (if not bespoke) nature of the gallery education activities undertaken as part of the programme. However, it can be stated that subjects' responses and/or actions indicate possibilities within specific circumstances, in a fashion similar to the emphasis in some qualitative research on social practices which are possible rather than on universally generalisable data (Peräklyä 2004).

The qualitative mode was adopted primarily because of the complexities of the research questions, which are not amenable to quantitative interrogation. In order to capture data relating to individuals' affective responses to complex experiences, it was necessary to adopt methodologies that allowed subjects to express themselves as freely and at as much length as possible, rather than being constrained by the limitations of a questionnaire or other surveying methods. The consequences of this approach are that no quantitative information has been generated and that no attempt has been made to classify or typologise individual subjects through their responses or behaviour. Rather, the aim has been to provide a rich sense of the complexity of subjects' lives, experiences and values and the importance of gallery-based learning activities to these.

Data collected

School/Lead organisation	Date	Activity	Researchers
Berwick upon Tweed Community High School	15/9/2005	Pre-event interviews with participants, 12 pupils	Andrew Newman Iain Wheeldon
	20/9/2005	Activity review visit. Observation of 12 pupils and artist working	Andrew Newman Iain Wheeldon
	16/2/2006	Post-visit interviews with participants, 12 pupils	Anna Goulding
	16/2/2006	Interview with teacher Martin Paterson	Anna Goulding
John Quinn ISIS Arts	11/4/2006	Interview	Chris Whitehead Andrew Newman
Thomas Walling Primary School pre-activity	8/7/2005	Pre-activity interviews with participants – 4 pupils	Andrew Newman Chris Whitehead Iain Wheeldon
	9/7/2005	Interview with teacher	Andrew Newman Chris Whitehead Iain Wheeldon
	9/7/2005	Activity observation 30 pupils working with artist	Andrew Newman Chris Whitehead
	19/7/2005	Post-visit interviews with participants, 10 pupils	Andrew Newman Chris Whitehead
Becky Davis Laing Art Gallery	13/4/2006	Interview	Andrew Newman Chris Whitehead
High Spen Primary School	31/10/05	Pre-activity interviews with participants	Chris Whitehead Iain Wheeldon
	8/11/05	Activity observation Pupils working with artist	Chris Whitehead Iain Wheeldon
	29/11/2005	Post-visit interviews with participants	Chris Whitehead
	29/11/2005	Interview with teacher	Chris Whitehead
Judy Thomas BALTIC	13/4/2006	Interview	Chris Whitehead Andrew Newman

Discussion of findings

This section discusses the findings relating to each of the projects in turn. Each case study will commence with an examination of schoolchildren's existing levels of capital, drawing on data from focus groups with the pupils and from the interviews with teachers. They will then proceed to identify and analyse shifts in capital on the basis of data collected during the observation of activity and subsequent focus groups with schoolchildren; where appropriate this discussion will also refer to additional data collected through subsequent interviews with teachers, artists and gallery education officers.

It is clear from the data that the activities under consideration in each of the following case studies were part of a series in which the pupils had been involved. This means that shifts in capital, contingent upon these single activities, are difficult to segregate from ongoing processes of accumulation, and caution is required when trying to identify discrete shifts arising from one event. Shifts in capital need to be contextualised in relation to a broader network of events and in relation to broader longitudinal timescales than this research project was able to focus upon.

'What do artists do?' Laing Art Gallery and Thomas Walling Primary School

It was evident from the data collected using the first interrogative framework (see methodology above) that the schoolchildren's capital formation was complex and varied. All pupils lived in the immediate area of the school and expressed positive feelings about where they lived. The schoolchildren came from diverse family backgrounds: most, but not all, of the pupils' parents were employed, examples of occupations being: careworker, printer, bar worker, retail worker and fish and chip shop worker. There were low levels of car ownership and pupils stated that they moved outside of their immediate environment infrequently; for example their visits with family to Newcastle city centre were infrequent, and when they did visit it was primarily for the purpose of shopping, but some had visited the Laing Art Gallery and the BALTIC Centre for Contemporary Art with their parents. However, the pupils did travel with family for other purposes, primarily to visit relatives elsewhere; for example:

> me brother used to be in the army so I used to go out to like Catterick and Ireland and everywhere to see him.

The pupils had active social lives, and all were involved in organised leisure activities of various kinds, including playing for a football club, gymnastics, 'girls club' (7) and break dancing club. Unstructured leisure activities mentioned by pupils included playing computer games, roller skating and sketching. Family relations, and in particular sibling relations, were also highly important in terms of socialising and spending leisure time. Pupils' attitude to school was mixed, but all were positive about their engagement with art in school and their attendance on trips and 'fun days'. As pupils drawn from the Gifted and Talented Art Register (8) they gave the impression of being highly motivated and confident in their abilities in relation to artistic practice; notably, all of them were frequent viewers of art-based TV programmes such as Art Attack and SmART. Prior to the visit to the artist's gallery and studio, the pupils had been on organised visits to the Laing Art Gallery and to Lime Street Studios in Newcastle city centre.

The second interrogative framework focused specifically on the pupils' understandings and attitudes to art in relation to forms of capital (see page 125). When asked to recollect the names of artists they were able to mention Van Gogh, Monet and Paul Klee, all of whom had been covered within class work at the school. They also mentioned favourite works of art, including Van Gogh's *Chair*, Sam Taylor-Wood's *A Little Death* and William Holman Hunt's *Isabella and the Pot of Basil*. All of these were then on display at the Laing Art Gallery which the pupils had visited the day before the focus group. While this demonstrates a positive experience of engaging with art within the gallery it may also suggest that pupils had relatively limited stocks of art historical knowledge, and the capital which this represents, upon which to draw, as they only mentioned works of art which had been seen very recently. (However, it should be noted that the ability to recollect artists' names or particular works of art cannot be taken to be emblematic of their art historical awareness and understandings in general.) Pupils' understandings of artistic practices were mostly related to traditional technologies and media (e.g. sculpture and painting. When asked what artists do, pupils responded:

[S/he] paints...does little sketches, and maybe just go out and paint pictures sometimes.

Just ask people to stand there and paint them.

Painters might make some colours, different colours

They might ...when they go out they might find a big block of wood and like carve something out of it.

Other responses included references to less conventional forms of making:

Sometimes they just take pictures and sketch over them.

They could pick things up what they find, and then they could like make... when they get back they could make like collages out of them.

In terms of artistic processes, pupils discussed the ways in which artists generate and develop ideas:

They might just ... be doing something and they might be another artist painting it and they think that looks like a good idea.

They might just have a nice feeling and just want to...

They could just be walking round, and they could just, they could go like into an art gallery and get... and see a painting and they could think that they're going to do something like that.

They could do it in their imagination.

They could do the still life projects that's going on down at an art gallery.

They might see someone doing a painting or drawing or something and like get inspiration from it.

This may suggest that the pupils tended to see certain artistic processes in terms of their own experiences, in that a frequent pedagogical framework used within the school was exposure to an artist's work or a body of art (e.g. 'Chinese Art', 'Aboriginal art', 'Origami' etc.) followed by the development and production of new work. In relation to intellectual approaches to making art, pupils showed limited understanding of, and engagement with, abstraction and conceptual approaches. For example, in discussing their own work, pupils gave much emphasis to drawing realistically and accurately, privileging a view of art rooted in notions of skill and imitation:

Sometimes if me brother and his girlfriend go out and they get their picture taken or something, I like doing a sketch and see if I can get it to look like it.

I just watch like a cartoon, and just try to draw it, like get the shapes right.

Also, it was evident from comments made by the pupils' teacher that they found it difficult to think in terms of experimentation, trial and error and risk taking. In particular, pupils were encouraged to work in sketch pads in an experimental fashion (their work in the pads was not assessed):

None of my class are very good with their sketch books, they're all quite frightened of making mistakes in them, and whereas you know, I just want them to... I don't even mark their sketchbooks, they're just there because I want them to be messy in them and experiment.

The teacher was subsequently asked whether she encouraged pupils explicitly to make use of their sketchbooks in this way and to see that making 'mistakes' is acceptable:

Yeah, yeah. That's what I want their sketchbooks to be. Because I did...I did Art A Level and degree, so I think that's the way that they should be used purely just to experiment in, and ... but they find that really, really hard, much harder than sitting with a... a piece of paper and drawing their finished piece, just actually being allowed to make mistakes and stuff seems to be something they really struggle with.

Pupils also demonstrated a marked ability to use their experiences of making art. For example, when discussing Van Gogh's depression in relation to his artistic practice, the following exchange took place:

When I'm not happy I just draw a nice picture.

[Interviewer] – And that cheers you up?

Yeah.

This indicates an instrumental and therapeutic use of making art within the personal context of affect. Other pupils made use of art in order to alleviate boredom:

> Sometimes if I'm just feeling bored and me brother is on me [computer] game or something, I would, I would...I would probably just grab my sketch book and do a drawing.

During the interview the teacher noted that the pupils had shown no signs of feeling intimidated or anxious before or during their school visits to galleries, indicating a relative lack of awareness of the codes and norms of behaviour associated with the art gallery which can become intimidating and exclusive in later life; their comments on the use of galleries by artists also demonstrate an understanding of the gallery as a resource for current art practice.

Pupils' art production had a complex relation with socialising and socialisation. In the domestic environment pupils' engagement with making art appeared to be a relatively solitary experience based on sketching and drawing, although there were instances in which this involved social contact in some form, for example through sketching from photographs of family members, or through asking family members for help:

> I used to watch a cartoon, I used to love it but I couldn't draw that well then so I used to get me ma to draw it and I used to colour it in.

On the other hand, art activities within school activities, and especially within gallery-based work, did involve significant socialising. While the teacher noted that ordinary classwork involved a high level of interaction, she made particular reference to one activity held at BALTIC which she had seen as significant in relation to socialisation:

> When we went we... when I did this workshop with them there was about seven different schools there, and I thought at first because there's a couple that I took that are quite sort of shy and not very confident anyway, and I was a bit worried that 'cause there were so many schools there they perhaps wouldn't mix well together, and they did, they like... within like a couple of minutes like all the schools had all mixed together, and they were all like working together, and moving round these stations, which... it was really good actually, 'cause I didn't think they would've... do that at all. They mixed a lot

more easily with all of those children than perhaps they do even within their own sort year group at school.

The teacher also discussed the very particular opportunity for investing in social capital represented by the segregation of the 'Gifted and Talented' pupils from the rest of the class for specific gallery visits and activities:

> I mean whenever they [i.e. the 'Gifted and Talented' children] like, come back into the classroom after they've been they always want to like discuss with the rest of the class what they've done. And I know they went on one particular one where they did origami I think, and they actually came back and had their own little workshop thing where they taught... like taught it to the rest of the children. So we had them like on two ta- three tables, and they did the teaching to the group, which was really, really nice.

[Interviewer] Was that their initiative?

> Yeah, yeah they wanted to because they came and showed what they'd done to the rest of the class, and the rest of the class is quite impressed, and they actually came and asked me if it would be alright if they showed the rest of the class how to do it, so we spent an afternoon letting them teach which was fun, it was nice.

This can be seen as a particularised investment in social capital by way of the reconfiguration of a specific social network (i.e. the assumption of a pedagogical role on the part of some pupils within the classroom) and the sharing of new skills for mutual benefit. The benefit for the class was the acquisition of new artistic skills, and the benefit for the 'Gifted and Talented' pupils was the opportunity to demonstrate their artistic ability, to take control of a teaching and learning situation, and to play an authoritative role, all of which may have had a positive impact on self-image, identity and self-confidence.

Pupils showed a good understanding of the role of art in professional and economic life and in terms of material culture and consumption. When questioned about their views of the importance of art in these contexts, responses included:

'cause like if...if you're going to be a builder or something when you're older, you need to get a design for your house or whatever. And if you're not a very good drawer your design will just look rubbish.

You would need to know art if you were a printer, because if you didn't know how to mix the colours, or how to work any machines.

Everything is design, even this table.

However, none of the pupils aimed at a career involving art: career aims at this stage included: 'a nurse or a doctor'; 'vet'; 'footballer'; 'playing in a band'; 'mechanic'. One pupil noted that:

I would like... if I couldn't get a job in anything else I would try and be a cartoonist or something.

And another stated that he would wish to continue to make art as a hobby.

Shifts in capital in relation to 'What do artists do?'
The activity involved a visit to the gallery and studio of the artist Jim Dearden in Ashington, a small ex-mining town in the south of Northumberland. Notably, the visit took place in the afternoon, as the school group had spent the morning at Plessey Woods – a nearby nature reserve. During the gallery activity the artist demonstrated basic animation techniques to the pupils (thaumatropes and kineographs), whereupon the pupils produced their own work using these techniques. The activity included Year 5 pupils as well as others from Years 2, 3 and 4.

An attempt was made to introduce the artist's professional practice to the pupils and to discuss this with them, but because of numbers and time constraints this was limited in nature, the majority of the session being dedicated to the animation exercise. The education officer responsible for brokering this project noted that a specific aim was to 'humanise' art by introducing schoolchildren to living artists and to their artistic practice and to stimulate their engagement with art as a consequence – to enable them to learn, as she put it, 'about who artists are, what they do, what their practice is and what kind of art they produce':

One of the things that was on the original proposal was the kind of the shock that not all artists are dead people, they're alive and they still... they still make a living by you know, making art and selling it as well.

The most identifiable shifts in capital related to:

- an increased knowledge and understanding of the techniques and everyday importance of animation as an artistic medium, and

- social interaction and a risk-taking approach to making art.

It was evident that pupils responded very positively to the activity, and reflected on their own work with a sense of achievement:

It was good when we made them... the ... the little ... the paper, and you had to draw a picture on each side, a happy face or a sad face, and then you put a pencil on it and just keep on...

[Interviewer] And it worked, didn't it?

Mm hmm. Good!

And:

On the front [my thaumatrope] had a dog with its ears down, and another one had a one with its ears up.

I had a dog where... I had a dog that was eating his food, and then when I thingied it it was there and then it wasn't. Like the food kept disappearing.

Upon enquiry it emerged that the pupils had experimented further with the techniques introduced during the activity in their free time at home, although their endeavours were directed towards perfecting their drawings rather than diversifying in terms of subject matter:

[Interviewer] Was the second one you did the same – was it still a dog?

It was the same but I drew it better, without rushing.

And:

I copied off the same [inaudible] and made it better.

However, some of the pupils noted that their engagement with this technique had ended here:

[Interviewer] Do you think you'll do any more animation in your free time?

Do something else.

Most significantly in terms of human capital, the pupils were clearly able to understand the relationship between the basic animation techniques which they had learned and animation within popular culture and everyday life. For example, they made links between their activity and TV and film animation (e.g. The Simpsons, Jimmy Neutron, Toy Story, Finding Nemo, Shrek etc.) and with the Smart board animation which they saw used in classroom activities. In this sense it was clear that the pupils had developed some understanding of the places of animation within popular and professional culture. However, the pupils' engagement in the animation activity did not necessarily increase their ability to 'decode' other types of artwork or to behave comfortably and confidently around them. The Laing education officer noted that on a visit to the 'Revelation' exhibition (subsequent to the data collection period), the pupils had showed some uncertainty about how to interpret and understand the works on show (by artists such as Damien Hirst, Grayson Perry, Rachel Whiteread etc.):

> I think when they went to see the artist at the artist's studios, that was… obviously they were kind of… you know, they were real people and they could see the art they made and ask people questions about that, but then the groups that came to the Revelation exhibition, that was certainly something, because some of the things to them was so you know, not what they'd perhaps had… had when they first [inaudible] to the Laing seen as being the kind of the art that we had there, then…it was much harder I think to get them to discuss and so… you have to…say things like 'it's okay if you don't like it, you can say that and say why you don't like it, or if it reminds you of a drainpipe nobody's going to say that's wrong'. I think that was very interesting that…the groups that had been confident when we went out on the visit, and when we first came to the art gallery were kind of less so with the Revelation exhibition.

Social interaction was a prominent feature of the pupils' behaviour during the activity itself, and in particular researchers observed numerous instances in which pupils shared and compared the results of their efforts and positively critiqued one another's work. In relation to social capital this can be seen as bonding. During the focus group, pupils discussed their views of the importance of this for the success of the activity:

> A: it wouldn't have been as good if it was by yourself.
>
> B: 'cause everyone was wanting to look at your work to see what it was like, and everything, and you were having a look at other people's.
>
> A: And if you thought it was horrible, everyone still says it's really good.

From this, and from observation, it appeared that the socially supportive atmosphere which had emerged may have enabled them to engage in more experimental work, in particular when they had begun to replicate the activity after their first attempts. In this context it is useful to recall the pupils' anxiety about making mistakes which their teacher had identified. In a related comment, the teacher also noted that the pupils who were most willing to adopt artistic approaches relating to risk-taking and trial and error had been involved in a previous gallery activity, highlighting the importance of institutional and social support for enabling pupils to think in this way:

> And the ones that have been, seem to be a little more keen to do that, because I think they got given sketch books at some point from the… from the Laing Art Gallery, yeah where they were allowed to do whatever they wanted to do in them. And they seemed more comfortable, the ones that had been using their sketchbooks that we've got now.

Schoolchildren also noted that they had shown examples of their animation work to their parents, which also reflects a process of bonding. This relates to the perceived special status of work associated with creativity, and the corollary importance of showing finished artworks to parents or other family members for the purposes of self-expression, demonstrating the development of one's skills, abilities and personality and eliciting and receiving praise.

'Comfortable and Uncomfortable Spaces': High Spen and BALTIC

All pupils involved in the evaluation lived in the immediate area of the school and expressed positive feelings about where they lived. Responses to the first interrogative framework showed that the schoolchildren came from diverse family backgrounds. All of the pupils' parents were employed, examples of occupations being: careworker; administrator; engineer; television engineer; parking administrator; nurse; landscape gardener; and hairdresser. Pupils stated that they moved outside of their

immediate environment frequently, often visiting art galleries (e.g. Laing, Shipley, BALTIC) and museums (e.g. the Discovery Museum) with their families as well as visiting parks, taking picnics and walks, camping and shopping. It was evident that some of the pupils' families were extended, included step-sisters and step-brothers.

The pupils had full social lives. Organised leisure activities included playing for a football club, swimming, ballet, jazz and disco dancing. Unstructured leisure involved playing with siblings and other pupils from the neighbourhood in the streets and the nearby woods. Notably, one of the pupils discussed how she spent some leisure time watching her sister, who was studying for a degree in fashion at Edinburgh College of Art, producing artworks.

The pupils' attitudes to school were mixed, and subjects such as maths were unpopular; however, they were highly positive about Art and Design and Technology:

A: Ah I love art.

B: Yeah I love art.

[All] Yeah.

C: Art and DT are the best, Art and DT are the best.

D: Yeah they're cool.

E: Yeah. ICT and Art.

[Interviewer] Right, so you all like Art.

D: Well Art and DT are kind of the same things aren't they?

A: Yeah.

C: The only bummer in Design and Technology's where you've got to write your plans down.

One individual explained her enjoyment of art as follows:

I like it 'cause you just mess on, and at the end you've made this wicked picture... when you're finished and you let it dry and it looks wicked, all the swirls and like curls...

The pupils were not drawn from the Gifted and Talented Art Register, but still gave the impression of being highly motivated and confident in their abilities in relation to artistic practice; notably, all of them were frequent viewers of art-based TV programmes such as Art Attack and SmART. When asked to recollect or discuss artists or artworks of interest they were able to mention Picasso, Whistler's *Arrangement in Grey and Black, No 1 (The Artist's Mother)*, Anthony Gormley and Chinese watercolour painting. Prior to the visit to the artist's gallery and studio, the pupils had been on organised visits to the Shipley Art Gallery in Gateshead town centre and to Seven Stories: the Centre for the Children's Book in Newcastle city centre.

The pupils also had experience of working with art across the curriculum; for example, their teacher had used Henri Rousseau's *Surprise!* in the context of an overarching school focus on the rainforest. She also noted that pupils were used to working collaboratively and that art activities facilitated positive social interaction:

if... you're working with a bunch of children... a group... if you split your class into groups, and they're working on a large piece, whether it's a large sculpture or a large chalk drawing or whatever it might be, I mean that... that's really good for cooperative learning and social bonding, because obviously they're having to negotiate, they're having to negotiate who's doing what, how you know, from how heavy the brushstrokes are to whatever [inaudible] you know. So that's...there is definitely a case to be made for that, that social bonding does go on within the group setting.

Shifts in capital in relation to 'Comfortable and Uncomfortable Spaces'

The project involved artist-led activities in class at school and then at BALTIC. During the classroom-based activity, the artist Miles Thurlow (assisted by a member of education staff at BALTIC) encouraged the pupils to create comfortable and uncomfortable spaces using the furniture available; after this, the pupils were given materials with which to make models of comfortable spaces in groups. These exercises were linked to the theme of collaboration, teamwork and cooperation between the pupils. This related to specific initiatives at the school, including the development of a 'buddy space' in which pupils were intended to engage in peer counselling. The activities in this sense concerned, to some extent, the interrelationships between physical space and human interaction and wellbeing. At BALTIC the pupils visited British Art Show 6 in the company of an artist before working, in one of the gallery's education spaces, on a model city/urban environment. The education officer involved in

brokering this project stated that specific aims included creating links between BALTIC and the school and creating links between art activities and new practices at the school including the aforementioned 'buddy space' scheme.

The most identifiable shifts in capital related to:

- increased awareness of the nature of space and its affective qualities;

- increased awareness and appreciation with relatively unconventional art forms;

- subsequent sharing of experiences with peers and family members.

It was evident that pupils responded very thoughtfully to the practical activities undertaken both in class and at BALTIC. For example, the pupils were observed to make numerous comments about how they were feeling in relation to the comfortable or uncomfortable spaces they were making (i.e. calm in comfortable spaces, anxious in uncomfortable ones); they also commented that their cooperation had been smooth and ordered when working on comfortable spaces as opposed to uncomfortable. They were also prompted to reflect generally on the nature of space in relation to affect:

A: I like it outside better 'cause you're free and well... just to do what you want to do.

B: In dark and small [spaces], you feel really claustrophobic

C: I preferred the uncomfortable space

In this context, the pupils' teacher commented that some of the themes and their interrelations had been slightly too sophisticated for the pupils to grasp in their full complexity, but noted that, nevertheless, the session had contributed to their stock of capital in ways which might be turned to good account in future:

They understood the space issue on their own level – maybe not quite getting the more sophisticated levels of meaning, but the understanding may develop over time and become useful later on. In some respects the artist pitched too high, but the pupils nevertheless got a lot from it on their own terms.

Similarly, the education officer who had brokered the project noted that pupils 'definitely' understood the ramifications of the project work in relation to the affective values and nature of physical space, but that this understanding may have been 'subliminal'. The latter part of the class-based activity involved the making of models of comfortable environments using card, coloured paper and other basic materials. The pupils' models were largely based on their notions of ideal domestic space, commonly including large beds, sofas, televisions and computer gaming facilities. In some ways, the pupils had understood the abstract notion of 'comfortable' space in a very literal manner, i.e. in terms of the kind of surroundings which they would like to inhabit. This can be seen as the employment of a specific stock of cultural capital (one which also relates to popular culture, such as the current swathe of TV programmes on celebrities' homes) to decode the meanings of the activity.

In a similar vein, when researchers broached the subject of comfortable space with the pupils during the second focus group, one pupil began enthusiastically to discuss the merits of his new bed. Decisions about what makes an ideal domestic environment within individual groups of pupils were also based on reaching a consensus; this appeared to be a bonding process involving the comparison and reaffirmation of individuals' likes, dislikes and values.

The visit to the British Art Show 6 was seen very positively by the pupils, who enthusiastically discussed a number of the works on show (e.g. by Tonico Lemos Auad, Phil Collins and Hew Locke). The challenge to the pupils' notions of art is exemplified in the following statement concerning Siobhán Hapaska's *Playa de los Intranquilos*:

They [i.e. the art works on display] are interesting because like... like you understood them, you would think of making a picture or something, you wouldn't think of like making rocks on a sandy beach, watching the telly, make cracking coconuts or something. You'd think of drawing a picture or making a sculpture or something.

While their teacher noted:

It [i.e. the British Art Show 6] helped them to develop some openness about what art and artistic activity is.

The education officer who had brokered the project also discussed its positive impact on the pupils, in particular in relation to subsequent visits made (after the data collection period) by the same class:

> I think just the presence of the building and the space itself... it's something very physical, it's very big, it's very different to school, it's very unusual, it's quite challenging, they're seeing things they're perhaps not familiar with, it's exciting, you know, the building's exciting as well as the work's exciting. ...There's photos of when they came the other week looking at *And You Shall Know Our Velocity*, and they're all looking at the pieces of fruit that are rotting and sending off bad smells and you can just see they're really made up with it, they're really excited, it's unusual, it's funny, it's sensory, yeah. There's one photo and it's like a Martin Parr photo, it's quite comical 'cause they're all very animated, so they're really completely engaged I think. And they haven't got the normal distractions of school or the... yeah, it's a bit of a wow factor.

In relation to further activities the education officer noted:

> What happened is the students came back to BALTIC and had further visits, they were very, very confident, and ... I've got pictures that I can give to you, and it's really evident just from the photographs of the engagement, or the level of engagement of the young people involved, and they were able to work with Nisha. So I think with that project those students had input from different artists, they had three different artists working with them, they also had Karen working with them, I think it's given them insights into different ways of working, it's given them skills-based activities, which I think has been really good, as well as thinking skills.

Lastly, it was clear that pupils had used their experience of the exhibition visit and the activities within subsequent social interactions:

> I went to my mates and said like it's wicked art isn't it, like? And how... how it was good, how it [inaudible] to the BALTIC and stuff.

> I talked to like me sisters and stuff about it.

While these can be viewed as bonding social capital, the pupils also engaged extensively with the artist, asking questions about the artworks on display:

> [I was asking] like how did they make this? Why have they got that there? And like what's this all about? And stuff.

'Big M media lab': ISIS Arts and Berwick Community High School

The respondents involved in the evaluation of this project came from two groups: some were final year A Level Art and Design pupils and others were GNVQ pupils. All but one (who lived ten miles away) lived within the immediate locality of Berwick. Their attitudes to Berwick as an environment were relatively negative; when asked, they stated:

> A: [It's] Boring.

> B: It's a nice place if you come as a tourist, for like a weekend, but anything more it's...

> C: There's nought really to talk about, it's right boring. [There's] just nothing to do.

> D: Half the shops are charity shops.

> E: There's not really much to do, the [Berwick Film] Festival's like the first thing that's been here ever, to do stuff.

Their attitudes to school and to education were varied; the GNVQ pupils were relatively negative and the A Level pupils, who were all in the process of making plans for their higher education, were more positive. The following exchange is illustrative of some of the pupils' political attitudes to politics and voting:

> A: [I] don't like all those black people coming in.

> B: Aye, I agree with that.

> A: Not in a bad way but all the... there's so many people coming in the country and I just don't...

> C: You mean immigrants?

> A: Immigrants.

> B: Illegal immigrants.

> A: Illegal... illegal. Immigrants. I think they should maybe stop it for a year. I think they should bring the death penalty back an' all,
> (laughs)

> B: Because there's quite a lot of crime and stuff going on.

Notably, six out of eight pupils stated that they would not vote in a general election:

[Interviewer] Why won't you vote, because quite a lot of you said you wouldn't do?

It doesn't matter anyway, they knacker it up anyway.

Notwithstanding the negativity and disaffection evident in some of their comments, the pupils engaged in complex leisure activities, including playing and watching rugby and football, photography lessons, and playing in a band:

I play guitar in a little band kind if thing, just trying to write stuff at the moment, getting more into the kind of jazzy side, than the normal rock kind of thing everyone usually does. That's fun, I like doing that.

Most of the pupils had visited galleries in Newcastle (e.g. BALTIC), and Edinburgh (e.g. the Scottish National Gallery of Modern Art); some expressed interest in the works of Salvador Dalì and Edvard Munch and in graffiti art. One pupil in particular practised photography in his own time, and numerous pupils made a point of their preference for analogue methods:

A: Well yeah, I just take pictures of just ra - I mean not random things, but... I mean always carry a camera with me just in case, but I do take pictures outside of school as well.

[Interviewer] So do you prefer digital photography or...?

B: I like film photography, not digital... 'cause I think digital's more expensive, because you've got to... I don't think it's the same, 'cause once it's taken on film that's it, but when it's digital you can go back and fix what you don't like.

C: Digital's... just seems too easy really.

B: You can always make your photo perfect and there's less skill involved in digitals.

A: And on most digital cameras you see the picture as soon as you've taken it, but with film you have to work for...... you have to work all the stuff, and it takes you ages, and I like that.

Pupils also demonstrated a high level of engagement with, and enthusiasm for, material covered over the course of their schooling. The following exchange, in which pupils discuss a project on the photographers Lewis Hine and Andreas Gursky, contrasts strongly with their apparent disengagement from curricula:

A: Lewis Hine did the American Depression, and just America in the 30s. He was the only photographer on the Empire State Building when they were building it. [inaudible] And Gursky just ...

B: He really does everything, just contemporary stuff. He does all sorts of...

A: Lots of colour.

B: Yeah, colour, all sorts of things.

[Interviewer] You said earlier that he was 'a bit freaky'.

A: Yeah he's... he can just take a picture of an... it's the camera he uses, it's really...

B: Like repetition things, a lot of his work...

A: It's the stock exchange, and all the different coloured shirts, he would take a picture from above, you can see everyone, pictures of all the people, and the different colours.

A: You could have two of his photos and they were like totally... you wouldn't think they were from the same artist.

Shifts in capital in relation to 'Big M media lab'

The project involved visiting the Big M Gallery at the Berwick Film Festival with artist Kelly Richardson (one of whose works was on show there), after which the pupils continued to work with the artist by discussing further video pieces and developing their own individual works. These were edited for the pupils by the artist for subsequent display in the Big M. The education officer who brokered the project noted that its aim was to encourage pupils to develop awareness and capabilities which, while contextualised in artistic practice and activities, might have a broader positive bearing on their general self-confidence and self-belief, in turn potentialising access to a greater range of life choices (within and outside the sphere of art *per se*). A further aim of the project was to 'humanise' art, artistic practice and artists by involving an artist to expose the pupils to her work and the work of others, to lead the pupils' work and to help them realise their own pieces. As stated by the ISIS educator:

To give them a first hand experience of the art form, and to give them access to the artist, who was involved in that. I mean that's... that was not only there, but to bring them down to the BALTIC was key to that, you know, because that's... that puts what they are... are doing into the context of the larger world.

The intentions of the ISIS education officer were highly congruent with the notion of capital as an enabling means, i.e. as a set of abilities allowing individuals to access opportunities. In this context he discussed the importance of including the artist Kelly Richardson within the delivery of the project:

> I think it brings it down to a real level, a human being is there, and somebody's made this, and somebody does this as a job, and this is what somebody believes in and is passionate about, and I think that's such a crucial thing for young people to experience, that all these... otherwise everything else is just out... out there, it's all done magically by somebody else somewhere far off that's not connected to them and they will never be in that realm to experience that. Whereas if they meet somebody in their place, somebody comes to them who does do that it suddenly opens up... not just the possibility of them becoming a film artist, but the possibility of them becoming whatever they want to become, and rather than... I've got this amount but actually the world is over there somewhere.

He went on to discuss the importance of introducing the pupils to gallery space:

> I think in terms of the gallery spaces and the gallery education which is the point of the enquire project, I think it's about the again stepping over that line between your world and the rest of the world. And especially things like a gallery is a cultural you know, barrier, that you know, most people don't go to galleries, or if they do, they go on a Sunday afternoon to the BALTIC and walk round saying, 'Tax payers are paying for this' and you know, 'what's all this about?' and switch off to it. Or else they think... see... either they don't understand it and go 'Well [inaudible] waste of time, waste of money' or they go 'Anyone can do that, you know, what's the point?' like that. So I think taking young people to the gallery with artists that make the stuff and they see it in the place, opens that line of, 'somebody I know has done this,' and it opens up the world that they can do whatever they want to do, but also makes them engage with the culture, and see that they... you know, even if they don't become artists, they've had an insight into how it operates, why they do it, what it is, how... what it's about, what it's trying to say, how it works, whether it's good or bad but actually how it operates and why it's there. And that's important to do because it's... otherwise they are cut off from the culture.

It is notable that in this statement the overall impact of a gallery visit or activity need not, for this education officer, be translated into a desire on the part of individuals to engage professionally with art; rather, the aim is to develop individuals' insights and awareness in a manner which will allow them to make considered personal and career decisions. According to this vision, access to certain forms of cultural capital leads to the exponential expansion of the range of choices individuals are able to make in life.

The most identifiable shifts in capital related to:

- a greater ability to engage with the techniques and practices of video art, leading to an increased awareness of artistic and professional opportunities and choices;

- an increased capacity for enthusiasm in relation to making art.

The following quotations give a sense of the sort of work which the pupils produced through the project:

> Mine's about football , and just like the... I support Rangers so I done a Rangers and Celtic game, and like all the like passion about it and stuff like that, just two different clips from it and stuff like that, and used some of the like lyrics what are quite offensive and stuff...

> Mine was I painted somebody's face just like with a paintbrush, and then it was the speed of it was like... bits of it were taken out so it was like [inaudible] when it played like [inaudible].

> Mine... the one I actually used for the project it was ... it wasn't... it was just supposed to be a joke, this man who walks around Berwick with an umbrella... umbrella, and he's a little weird, so I went and asked him if I could interview him. And at first I thought it was funny, but then we watched it over and over and just got really serious, (laughs) so I used that, for my piece.

The general development of capital within the pupil group is clearly conveyed in the teacher's description of the impact of the project:

> It got them excited, which is quite an achievement with some of them, and interested and sort of getting a feeling that they could be creative. Some of them already were... there were two kinds of student, there were the disaffected, not really

interested students, and I think it had a positive impact on them, more so perhaps than with the others, because most of them...who were kind of 'didn't-want-to-be-here' and were disaffected became rather less disaffected and quite interested and excited. I can think of one student in particular who has gone through the whole of the school with an attitude of 'it-isn't-cool-to-be-interested-in-art or anything', who got very taken with it and spent quite a lot of time producing the piece that he wanted to produce. And is still... he's trying to kind of maintain this façade of being completely uninterested, but is continually asking me when the DVD's ready, and he wants... you know he's sort of quite excited by the fact that he's produced something. The more able students thoroughly enjoyed the project and found it stimulating, but they were already completely interested in video art and filmmaking, and wanted to do that kind of thing at university anyway, so the effect was less noticeable on them, than it was on the others.

Although the project involved the production of individual and not collaborative artworks, it had also allowed for shifts in social capital:

Nigel who wants to do film at university and is completely interested ... wants to be a camera man, cinematographer whatever, he was very keen to... he'd probably take over everybody else's project, but I don't want to put that next to him because he's very cooperative and enabling and helpful, he's really... he's very good for that, so he was... he was involved with, if not most, at least half of the projects one way or another that he... he was sort of wanting to be involved... and they were happy for him to come along with their ideas. Because also the... part of the creative process was to talk to... the students, talk amongst themselves about what they were doing, so it naturally turned out that there were kind of groups forming, and they worked as actors or I mean figures in each other's projects too.

However, the ISIS education officer made the following observations about one participant (who had produced a piece about Celtic and Rangers fans):

... one, once he knew that he could make a film about something that was really important to him, and he was going to have control over it, he was off, and he was you know, and it's... for Kelly [Richardson (the artist)] that's one of the best films, and he was... and he wouldn't have done... done that if he hadn't have had... if he was in a group, he wouldn't have

done that, but because when he came down to it one to one, he suddenly saw that he could do... he could say something about what he really felt, you know.

On the basis of this observation it might be argued that this individual had difficulty taking the opportunity to make work which was meaningful to him through access to the social capital of the group; however, his investment in 'linking' social capital through contact with the artist on an individual level was empowering in this sense, and through these means he was able to overcome his initial inability. This shows that the activity did not necessarily facilitate group interaction in all individuals, nor was the activity's objective most effectively achieved by all through contact with peers.

The teacher also noted specific increases in skills (human capital) and attitudes and approaches to artistic practice (cultural capital):

In the case of some of the GNVQ people it would be fair to say that their creative skills were pretty close to zero in that they'd never wanted to... have never created anything before, or done anything like that before, and they were rather slow to grasp the possibility... I mean they weren't used to thinking creatively at all, I think they just didn't think creatively. And so for the first few weeks there was a sort of sense of inhibition, and they... whenever they came up with something it was like an information video kind of thing.

[Interviewer] – They came up with stuff like information films...?

Yeah, because that's what they thought that doing this kind of thing was, because I don't suppose they had any idea of art and creativity and [inaudible] in a sort of... creating an interaction with a... viewer sort of seeking out meaning and all those things, I mean they wanted it all to be 'This is about this and I'm going to tell you about it', and without any sense of ambiguity or the... the sort of creative interaction between viewer and screen, which is... or viewer and image which is what art to a large extent has to be about.

The teacher focused on one individual in particular whose accumulation of capital he saw as exemplary, in that it demonstrated the consequences of his acquisition of a series of understandings: of creative practices; of the roles of personal experiences and personal expression within art production; and of distinctions between creative artwork and other genres such as documentary:

And then they began to loosen up and [I'm] thinking particularly of [one student] who was totally against it, and hated... hated art, hated everything and then gradually began to sort of loosen up, and he was... his original idea... he's totally into... the only thing that matters to him, or he claims matters to him is football, so he was going to make a kind of 'This is how you become a successful footballer' little video, and gradually his didacticism was worn down, so ended up making a rather interesting impressionistic study of hatred between Rangers and Celtic fans, which is a tremendous step for him.

All of the pupils stated that they had enjoyed the project and the process of producing video art, one pupil noting:

> I'd never really done anything like that before, like thought about using videos as art, so it was interesting.

Some of the pupils were also interested in the display and reception of their pieces in the aftermath of the project:

> M: It will be nice to see what other people think of it.

> L: If they think the same... if they think... if they think the meaning of it is what you meant it to be, sort of, or if they get something different.

> K: I don't think anyone will be interested in mine, 'cause [they won't be] interested in what I'm interested in.

Their accounts of family members' responses to their work reflect a sense of cultural disengagement from parents and intergenerational incomprehension; however, it is not clear that this was necessarily seen in a negative light by the respondents, who may have been able to use parental responses as a means to distinguish themselves as individuals:

> A: It was pretty stupid, they [i.e. the pupil's parents] didn't really know like why we were doing it, sort of.

> B: My mother didn't get it.

> C: No.

> D: Neither did my mum. My brother got it, I think my dad understood it.

> [Interviewer] And will they get to see your films?

D: Well I try and show them but they don't pay attention for much longer than thirty seconds, so...

Indeed, the pupils showed greater proclivity to bond with their peers over the course of the project (notwithstanding the fact that they were not a closely knit group), reflecting their choice to invest in certain types of social capital rather than others. This may be seen as part of the process of respondents developing a sense of an independent adult self.

The pupils were also able to access the artist's stock of capital, and their engagement with her can be seen in terms of bridging social capital. For example, in a discussion of the pupils' experience of working with her, one pupil noted:

> Like you didn't have to be like embarrassed if you had an idea of what you [inaudible], you just tell her and she was [inaudible].

The artist had also used some of her own works (9) as teaching aids, and pupils' discussion of this showed a positive engagement with them:

> A: There was a tyre on the ground, and it popped up and bounced...

> B: It was like... [inaudible] filmed and it was rolling [inaudible] the film was going backwards, so... but it looked like... it didn't look like it was played backwards, it looked like it was moving...

> A: Yeah...

> B: [inaudible]

> A: ... plus she reversed the sound, so that the sounds would fit the thing, instead of being like...

> B: Like backwards, it was like it was forwards, but it was actually backward, the tyre rolling inland...

Given the age of these pupils and their places within their school careers, semi-structured discussion relating to aspects of human capital was particularly illuminating, in terms of the pupils' future education and career plans and their understanding of options within this. Firstly, it was evident that the pupils' experience of the project had continued to resonate:

> [Interviewer] Since you've done the filmmaking projects, have you thought about it since you finished it?

A: Yeah.

B: Yeah, quite a lot.

C: I thought about it for a while after but I've forgotten all aboot it to tell you the truth until today (10).

Some of the pupils also appeared to demonstrate an increase in cultural capital in relation to gallery visiting:

I was in Newcastle the other day, I went in to the Laing Art Gallery, but that was… that was just popping in and having a look around, for like half an hour, it was just to kill time. But it was good, I enjoyed it.

[Interviewer] What was on there?

Bloody hell. [laughs] I can't remember exactly. It was something obscure, something kind of abstract, it was not really my thing but it was enjoyable, I can't remember who it was.

A number of pupils stated that the project had influenced their ideas and decisions about further education and future career plans:

A: I want to do something with either film or audio, but I don't know which one, and I've not really had a look around that much. Next year I'm just going to… I'm going to get a job and save up some money, while looking for some nice course to do. Or I'll do a course, I don't know.

B: I know that I'm going to art course somewhere. like I don't know which one yet because I haven't heard back from them all, but I don't know what I'm doing after that, I don't really have a plan for a job or anything.

C: [I'm going to] go to uni, yeah. I know what I'm doing.

[Interviewer] And you're definitely going to do a…

C: Film Production course, yes.

D: Yeah, well I applied for more of an arts course, but its like Fine Art so you can do… you can get the chance to do film as well if you want, like you can choose sort of different stuff to do and probably… think I would do more film if I got the chance again.

One pupil in particular demonstrated the outcomes of having developed new forms of capital (most especially human and cultural) through her participation in the project:

Oh well, it's kind of messed up my choices that I want to do, like what I want to take on. Because I really enjoy making [art], you know even if it's just like little sketches and stuff, I really like doing it, but I never got the chance to do it until this year, and I was just going to try and do something with audio, like sorts of different things I'd like to do. But now there's the also the film kind of thing, so there's two things, that… it's almost like…

A further pupil, who initially demonstrated high levels of disengagement from curricular and cultural activities, but whose engagement in the project had been seen to be profound, discussed his immediate plans as follows:

Still don't know [what I'm going to do] but I think I'm going to stay on at school and do PE next year, hopefully.

Although it was evident from observing this pupil's progress over the course of the project that he had developed significant new forms of capital, this did not result in a reassessment of his career choices or his attitudes to leisure activity. For example, the same pupil noted that he had enjoyed the practical part of the project but not the gallery-based work:

It was good, that's all I'm saying…I liked all the making parts of it up, but I didn't really like gannin' to the… like having to walk to Berwick to go to the Big M.

He also stated that he continued to dislike art in general and would be disinclined to visit museums and galleries:

And gannin' to Newcastle to go to that museum [i.e. BALTIC], like it's good that I had a day off school, but like in my own time I wouldn't like choose to go to an art gallery, just 'cause its not like… it doesn't interest me that much (11).

These statements show that organised access to capital (i.e. through the project) does not necessarily result in an obvious employment of that capital on the part of individuals. It may, however, be possible that this individual might employ capital accrued through the project in ways which have not been detected by this research.

Conclusions

The activities researched have led to changes in capital formations which appear to have a profound impact on some of the participants, despite the fact that some of these experiences were relatively transient. As previously stated, this general conclusion also needs to be qualified in that the activities were situated within longer (if not continuous) learning processes which this research has not been able to study at length because of the constraints in terms of the timescale for data collection. Broadly speaking, it can be stated that the data analysed above shows that activities have led to:

- changes in capital formations (12);

- increased understanding of art as a body of practices, products, technologies and heuristic/intellectual approaches (e.g. valuing subjectivity, trial and error and calculated risk-taking);

- increased familiarity with, and ability to use, the experiences of making art, viewing art and visiting art galleries;

- increased social interaction through engagement with art (i.e. making, critiquing, showing and displaying) with family members (bonding) peers (bonding and bridging), and others, including gallery staff and artists (linking);

- increased understanding of the role of art in social, professional, economic and personal life;

- increased understanding of possible economic or employment benefits of engaging with art;

- increased self-interrogation about career plans in relation to engagement with art and the contemporary art gallery.

However, there are clearly complexities associated with all of these which pertain to different age groups. For example, the instrumental use of art within family relations differed fundamentally between primary schoolchildren and the young adults at Berwick. In this sense the subjects can be seen to be using art in different ways in relation to the specific requirements of their social and personal contexts, for example, the primary schoolchildren used art to develop bonding social capital with family and siblings, whilst the older pupils appear to have used it more to construct an individual and independent identity.

Likewise, while this is not intended to be a comparative study of different age groups' responses to activities, it is clear that the primary school pupils used newly developed skills and abilities in a different way from their older counterparts, i.e. as part of a range of developing assets for sporadic or short-lived use in leisure time and in relation to social bonding, rather than as a direct exploration of potentials for further academic study and/or professional choices.

It can also be concluded that schoolchildren's/pupils' artistic practice does not necessarily potentialise the development of social capital or indeed encourage socialisation (for example, the replication of work done in activities was often undertaken by pupils on a solitary basis, while one Berwick pupil appeared to have difficulty producing meaningful work in a group setting). However, the involvement of artists in brokering group work or group critique as well as individual work, and the gallery as locus for organised exploration, do appear to potentialise these aspects.

While the research has evidenced clear shifts in capital, it is difficult and problematic to predict their long-term consequences, and how, in future, they influence health, general well-being, quality of life etc.

Limitations of the project and suggestions for further research

The key limitations of the current research project were the short timescale for data collection, the limited number of subjects and the limited depth of research into subjects' capital formations. As a consequence of budgetary constraints it was not possible to develop an appropriate longitudinal project whereby shifts in capital could be meaningfully identified over a longer timescale. For example, there was no opportunity to work again with the subjects at later stages in their school careers, thereby to attempt to gauge the longer-term impact of gallery education activities.

In terms of depth of research, the view which researchers were able to obtain of subjects' capital formations was relatively superficial, although it may have been accurate in itself. Further research might address this shortcoming by allowing for contact with subjects and, potentially, with their relatives and social acquaintances, outside of the context of the focus group itself. This is particularly important when attempting to understand the

The activities researched have led to changes in capital formations which appear to have a profound impact on some of the participants, despite the fact that some of these experiences were relatively transient.

transfer of capital between different generations. These ideas for research bring specific issues with them – for example, the need to organise sustained, recurrent access to subjects, to schools and to others, and ways of resourcing and facilitating such access would need to be identified.

In general it was felt that schools had a relatively low sense of ownership of the research, meaning that, although they gave freely of their teachers' and pupils' time, their contact with the research team was limited and the team was concerned about impinging upon school activities.

This research project focused entirely on the pupils' experiences of gallery education activities; it did not examine the experiences of teachers, gallery education staff and artist educators except insofar as they helped researchers understand the pupils' experiences. In further research this imbalance may be addressed by examining the learning processes undergone by these parties, particularly as these processes are not entirely separable from those experienced by the pupils. A further aspect of some importance is the role of the artist as educator; future research could usefully focus on the impact on children and young people of interaction with artists, the pedagogies adopted by artists and the learning processes of artists engaged in education work with children and young people.

Lastly, it is evident from observations and from the data analysed that the adoption of further theoretical frameworks might help to shed light on the impact of gallery education on young people. In particular, these include theories of intrinsic and extrinsic motivation and informal learning. For example, it would be helpful to analyse the nature of pupils' motivation during gallery education activities in comparison with class-based, curricular activities; likewise, gallery education activities may be seen to represent slippage between the categories of formal and informal learning, and the ramifications of this for pedagogy and impact would constitute useful findings.

References

Becker, G. S. (1993) *Human Capital: a Theoretical and Empirical Analysis, with Special Reference to Education,* Chicago

Behrman, J. R. and Stacey, N. (eds) (1997) *The Social Benefits of Education,* Michigan

Bourdieu, P. and Darbel, A. (1966), *L'amour de l'art: les musées et leur public,* Paris (translated and republished in 1997 as The Love of Art, Padsow)

Bourdieu, P. (1997) 'Forms of Capital' in A. H. Halsey, H, Lauder, P. Brown and A. S. Wells (eds), *Education, Culture, Economy and Society,* Oxford, New York: 46-58.

Coleman, J. (1988) 'Social Capital in the Creation of Human Capital', *American Journal of Sociology,* 94 (supplement): 95-120.

Cote, J. E. (1996) 'Sociological Perspectives on Identity Formation: the Culture-Identity Link and Identity Capital', *Journal of Adolescence,* 19: 417-428.

Côté, S. (2001) 'The Contribution of Human and Social Capital', *Canadian Journal of Policy Research*, 2, (1): 29-36.

DeSimone, R.L., Werner, J.M., and Harris, D.M. (2002), *Human Resource Development,* Cincinnati, OH

Du Gay, P., S. Hall, L. Janes, H, Mackay, and K. Negus (1997) *Doing Cultural Studies, The Story of the Sony Walkman,* London

Faure, E. (1972) *Learning to Be – the world of education today and tomorrow,* Paris

Gershuny, J. (2002) *'A New Measure of Social Position: Social Mobility and Human Capital in Britain'*. Working Papers of the Institute for Social and Economic Research, paper 2002–2, University of Essex, Colchester.

Healy, T., Côté, S., Helliwell, J. and Held, S. (2001) *The Well-being of Nations, the Role of Human and Social Capital,* Centre for Educational Research and Innovation, Organisation for Economic Co-operation and Development, Paris

Hooper-Greenhill, E (2004) 'Measuring Learning Outcomes in Museums, Archives and Libraries: the Learning Impact Research Project (LIRP)', *International Journal of Heritage Studies,* 10 (2): 151-174

Hooper-Greenhill, E. and Moussouri, T (2001a) *Making Meaning in Art Museums 1: visitors' interpretive strategies at Wolverhampton Art Gallery,* Leicester

Hooper-Greenhill, E. and Moussouri, T (2001b) *Making Meaning in Art Museums 2: visitors' interpretive strategies at Nottingham Castle Museum and Art Gallery,* Leicester

Mason (2004) 'Conflict and Complement: an exploration of the discourses informing the concept of the socially inclusive museum in contemporary Britain', *International Journal of Heritage Studies,* 10 (1): 49-73

Newman, A. and Mclean, F. (2004a) 'Presumption, Policy and Practice: The Use of Museums and Galleries as Agents of Social Inclusion in Great Britain', *International Journal of Cultural Policy,* 10 (2): 167-181.

Newman, A. and Mclean, F. (2004b) 'Capital and the Evaluation of the Museum Experience', *International Journal of Cultural Studies,* 7 (4): 480-498.

Newman, A., Mclean, F. and Urquhart, G. (2005) 'Museums and the Active Citizen: Tackling the Problems of Social Exclusion', *Citizenship Studies*, 9 (1): 41-57.

Newman, A. and Mclean, F. (2006) 'The Impact of Museums on Identity', *International Journal of Heritage Studies*, 12 (1): 49-68

Newman, A. and Whitehead, C. (2006), *Fivearts Cities: an evaluative report on the impact on over 50s people of participation in activities related to British Art Show 6,* unpublished report for BALTIC Centre for Contemporary Art

Peräkylä, A. (2004) 'Reliability and validity in research based on naturally occurring social interaction' in Silverman, D. (ed), *Qualitative Research: theory, method and practice*, London: 283-304

Putnam, R.D. (2000) *Bowling Alone: the collapse and revival of American community,* New York

Schultz, T. W. (1961) 'Investment in Human Capital', *The American Economic Review*, 51 (1): 1-17

Sfard, A. (1998) 'On Two Metaphors for Learning and the Dangers of Choosing Just One', *Educational Researcher*, 27 (2): 4-13

Stanley, J., Galloway, S., Huddlestone, P., Grewcock, C., Muir, F., Newman, A., Clive, S. (2004) *The Impact of Phase 2 of the Museums and Galleries Education Programme,* Warwick

Veenstra, G. (2001) 'Social Capital and Health', *Canadian Journal of Policy Research*, 2 (1): 72-8

Whitehead, C. (2005), 'Visiting with Suspicion: recent perspectives on art museums and galleries', in Corsane, G. (ed.) *Heritage, Museums and Galleries: an introductory reader*, London and New York: 89-101

Willms, J.D. (2001) 'Three Hypotheses about Community Effects on Social Outcomes', *Canadian Journal of Policy Research*, 2 (1): 53-62

Summary of baseline data

Name and address organisation	Project evaluated	Organisation Type	Participating School	Type of project	Links with National Curriculum	Year of pupils
ISIS Arts 5 Charlotte Square Newcastle upon Tyne NE1 4XF Tel: 0191 261 4407 e-mail john@isisarts.org.uk www.isisarts.org.uk	Big M media labs	Independent	Berwick Community High School Adams Drive Berwick Upon Tweed Northumberland TD15 2JF Martin Patterson	Pupils produced 'New Media' work with the teacher and video artist	Group was a combination of GNVQ and A level	Age 16/17
Laing Art Gallery New Bridge Street Newcastle upon Tyne NE1 8AG Tel: 0191 232 7734 www.twmuseums. org.uk/laing/	Artists in Society	Local authority gallery	Thomas Walling Primary Lindfield Avenue Blakelaw Newcastle upon Tyne NE5 3PL	Pupils, through studio visits, question and answer sessions and practical work investigated the role of the artist in society	Art at KS1 links with KS2 Art units 1b, 3a, 4, a,b &c and 5d QCA art Unit 3c English En1	KS2
BALTIC Centre for Contemporary Art South Shore Road Gateshead Tyne and Wear NE8 Tel: 0191 4404929 www.balticmill.com		Gallery	High Spen Primary School Hugar Road High Spen Tyne and Wear NE39 2BQ Ruth Whiteside Hookergate School High Spen Rowlands Gill NE39 2BX Colin Turnbull	A class from High Spen School visited BALTIC and took part in a workshop with Cath Campbell (BALTIC Freelance Artist). Cath Campbell then delivered a session at the school. This group visited BALTIC again with Hookergate School in the autumn term.		KS2 and KS3

Notes

1 http://www.ncl.ac.uk/business-directorate/strategy/policies/practice.phtml
2 http://www.balticmill.com/index.php [accessed 20/4/2006]
3 http://www.ofsted.gov.uk/reports/108/s5_108340_20060131.pdf [accessed 20/4/2006]
4 http://www.isisarts.org.uk/index2.html [accessed 20/4/2006] The 'Big M' is an inflatable gallery space that is taken to various venues.
5 http://www.berwickhighschool.co.uk/ [accessed 20/4/2006]
6 http://www.twmuseums.org.uk/laing/ [accessed 20/4/2006]
7 'We go there and we get... we do this song, and we get to write poems for we mams, and we get to play, there's loads of games there.'
8 However, as a result of school policy the children were unaware that they were classified as 'gifted and talented'.
9 The work discussed below is The Sequel (2004); see http://www.kellyrichardson.net/work.htm
10 Although this statement may seem to run counter to the others, researchers were aware of the need to balance the credence given to students' comments with an understanding of their apparent need to be perceived by others to be disengaged from cultural and curricular activities.
11 Note, however, the substance of footnote 10 in relation to these comments.
12 It should be noted that the timetable for data collection did not permit the collection of extensive data relating to general shifts in capital as they pertain to, for example, crime, housing, alienation etc.

Alphabetical list of participants

Larry Achiampong
Margarita Acklam
Nicholas Addison
Nannette Aldred
Emily Allchurch
Jacky Arnold
Emily Ash
Sue Austin
Sharon Bailey
Kulwinder Bajar
Helen Baker
Deborah Barker
Nicola Barron
Richard Beales
Steve Bell
Emma Betteridge
Annie Bicknell
Rebecca Birch
Norma Blackith
Josephine Borradaile
Dr Sara Bragg
Louise Bristow
Felicity Browning
Graham Buckley
Patrick Bullock
Lesley Burgess
Ian Burn
Ella Burns
Juliette Buss
Cath Campbell
Sarah Carne
Chris Chalmers
Danielle Chapman
Tara Chittenden
Paul Clifford
Sophie Cole
Susan Coles
Mike Collier
Ben Connors
Jonthea Cooper
Mat Cowan
Bob Cross
Liz Crump
Fiona Cummings

Kath Davidson
Becky Davies
Karen Davies
Jim Dearden
Susan Diab
Sophia Diamantopoulou
Claire Dixon
Jo Donegan
Wendy Dowling
Sandra Drew
Iain Drummond
Nisha Duggal
Christina Edgren Carter
Orville Jay Edwards
Vicky Elliot
Saj Fareed
Sue Feighery
Dan Fentiman
Tessa Fitzjohn
Peter Flynn
Jane Fordham
Judith Furner
Lee Gallon
Elidh Gardner
Polly Gifford
Cindy Gower
Catherine Graham
Alison Guthrie
Christine Harmer Brown
Catherine Harvey
Anthea Hill
Emma Hills
Henrietta Hine
Cheryl Hiscock
Chris Horn
Madeline Hutchins
Annabel Johnson
Zoe Johnson
Penny Jones
Rachel Jones
Caroline Kane
John Kefala-Kerr
Denise Kendal
Naomi Kendrick
Alex Kinsey

Benjamin Klein
Bernadette Koranteng
Anthony Lam
Jared Louche
Sophie Lowes
Anna Lucas
Jane Lyster
Sally Madge
Marilyne Marlow
Neil Martin
Graham Mason
Stuart Mayes
Emma McCallum
Catherine McConnell
Sam McGeever
Jordan McKenzie
Victoria McLaughlin
Rebekah Mells
Audrey Mullins
Andrew Newman
Rob Nice
Maggie Nightingale
Maeve O'Brien
Bernadette O'Toole
Harold Offeh
Catherine Orbach
Susannah Ore
Annabel Other
Sandy Parker
Martin Paterson
Adrian Peachment
Eve Peasnall
Lucy Pedlar
Reggie Pedro
Judy Pendrich
Ben Ponton
Sarah Potter
David Priestly
Emily Pringle
Sam Pull
William Pym
Sheridan Quigley
James Quin
John Quinn
Pauline Rice

Kelly Richardson
Michaela Ross
Abi Russell
Caroline Saunders
Guy Schofield
Naomi Scott
Professor Judy Sebba
Dr Veronica Sekules
Phyllida Shaw
Tanya Skillen
Jackie Smith
Amy Smyth
Nicola Spen
Shaun Stanbury
Vicky Stevens
Professor Mary Stuart
Dr Janet Summerton
Grace Surman
Kate Sweeney
Barbara Taylor
Jean Taylor
Emma Thomas
Judy Thomas
Miles Thurlow
Jane Trowell
Colin Turnbull
Paula Turner
Leanne Turvey
George Unsworth
Allie Walton
Natalie Walton
Julie Watson
Jude Watt
Mary Watts
Iain Wheeldon
Chris Whitehead
Liz Whitehead
Ruth Whiteside
Tamsin Williams
Jackie Wills
Danny Wilson
Vanessa Wolfe
Peter Woodage
Simon Woolham